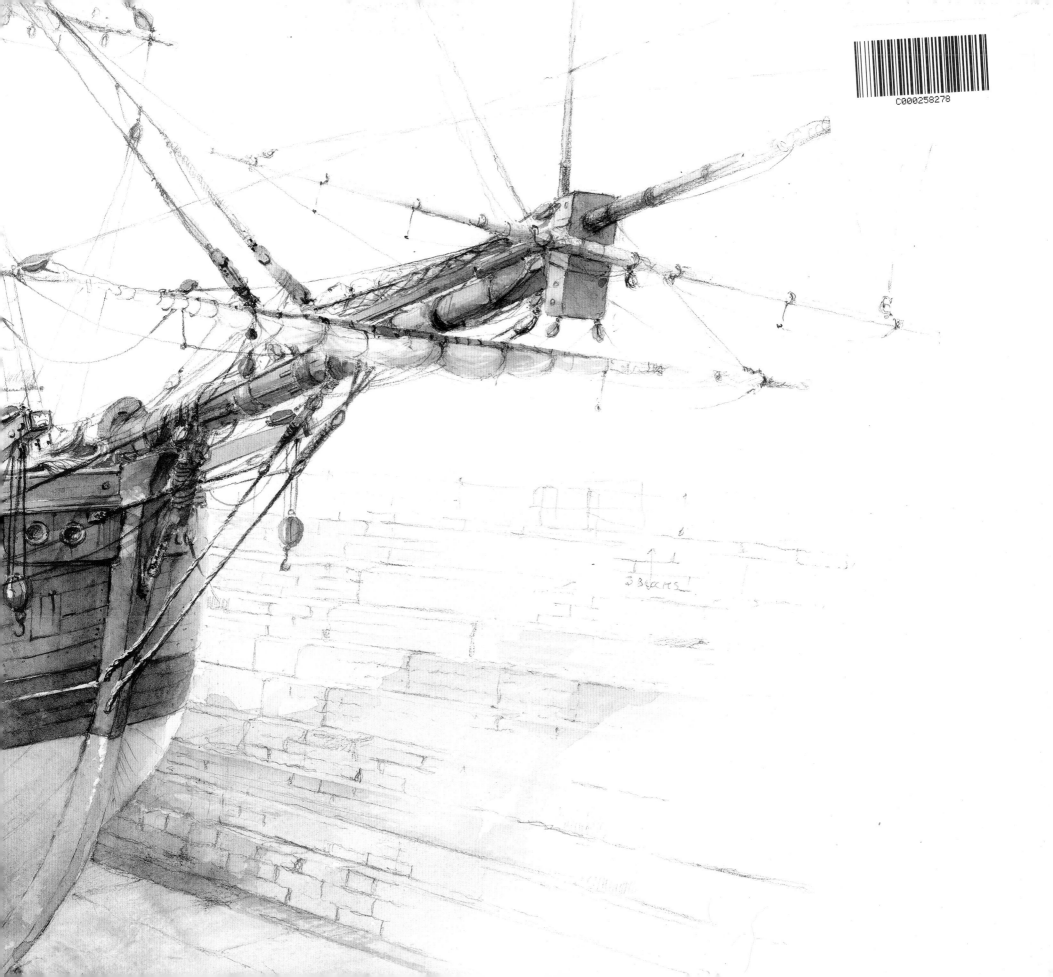

A Nautical Odyssey

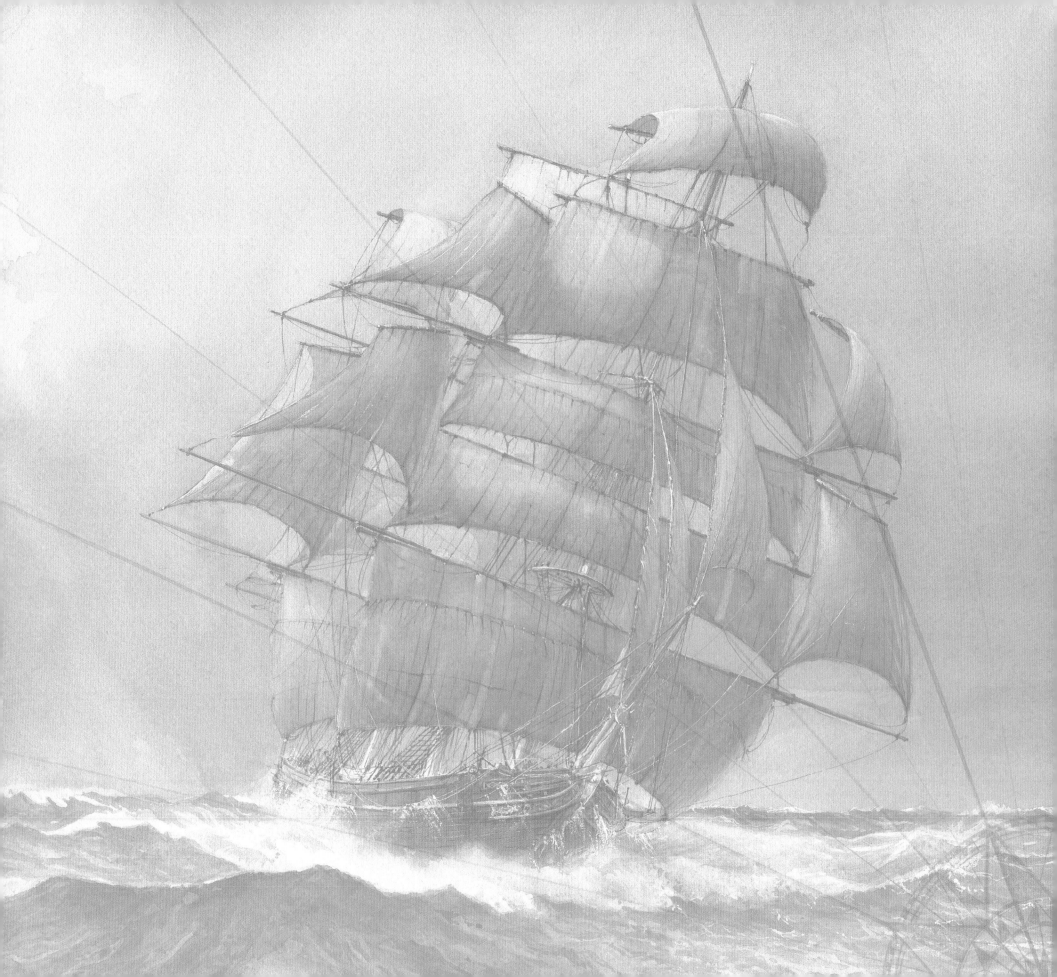

A Nautical Odyssey

AN ILLUSTRATED MARITIME HISTORY

FROM

Cook to Shackleton

WRITTEN AND ILLUSTRATED BY

DAVID C. BELL

Quiller

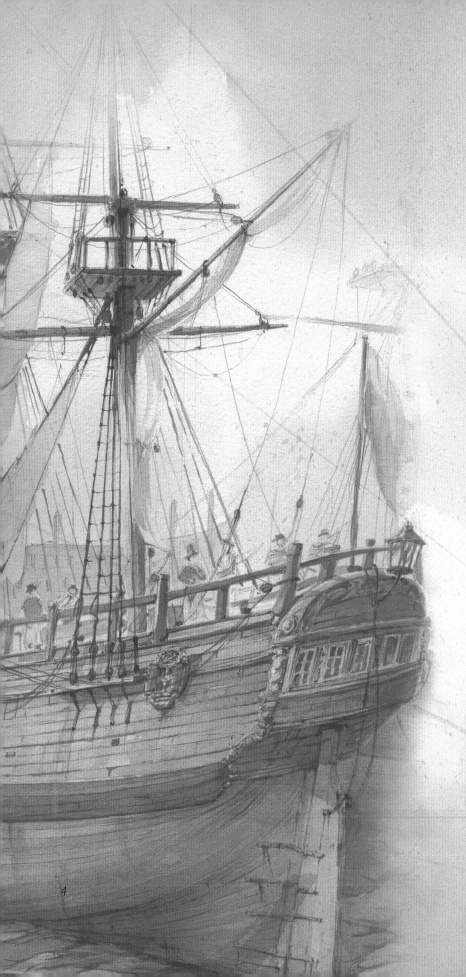

Acknowledgments

'A Nautical Odyssey' is almost entirely of my own making, including contents, illustrations, text, design. However it would have been quite impossible to achieve any result without the great assistance of friends and colleagues, in particular Matt and his team in Sleaford. My thanks also go to the late Roy Davies of M.S.C. who gave me great support on my last book, and another great patron, Mich Stevenson, from Nottingham, who has a fine and varied collection of work dating back to my very early days. Also to Phil Philo of the Captain Cook Museum, Marton, Mike Lucas at Buckler's Hard Maritime Museum for their unstinting and valuable help over the years.

Reproduced within this book are watercolours and drawings that go back many years. Most of them are still in my studio drawers but as to the whereabouts and ownership of a small number of others, to the owners of these works I hope you will accept my grateful thanks - also to all those patrons whom I cannot credit individually.

Of course my greatest accolade and admiration must be to the' honorary navigator' Jen, my wife, who has without question steered this epic journey, over several years, with a safe passage to its completion and launching.

David C. Bell

First published in the UK in 2010
by Quiller, an imprint of Quiller Publishing Ltd

British Library Cataloguing-in-Publication Data
A catalogue record for this book
is available from the British Library

ISBN 978 1 84689 081 9

Printed in China

Quiller
An imprint of Quiller Publishing Ltd
Wykey House, Wykey, Shrewsbury, SY4 1JA
Tel: 01939 261616 Fax: 01939 261606
E-mail: info@quillerbooks.com
Website: www.countrybooksdirect.com

Contents

Foreword

'A Nautical Odyssey' is a unique and beautiful book bringing together the work of a truly knowledgeable and perceptive artist. It will captivate anyone with an interest in either maritime art or history. As a maritime nation, many of us feel some sort of connection with the sea either family ancestry or a simple fascination. This book tracks some of our maritime history flagging up significant ships and places, examining the connection between them. David Bell has attempted through pictures and words to take us on a journey or odyssey through history from the voyages of Cook to the times of the last great explorers.

He has depicted the great and some lesser known vessels of our maritime heritage and has outlined the reason for their existence and some of their adventures. His works are supported by his detailed but nevertheless evocative and atmospheric drawings and paintings. David is eminently well qualified to write about and illustrate his subject having spent ten years at sea as a navigator and the rest of his life researching and painting a subject which he truly understands and loves.

David's preferred medium is watercolour which he uses to maximum effect in this book. There are also many pencil drawings and images where paint and pencil have been combined to support his text with both accuracy and artistic vision, pulling the book together to create a cohesive volume which is, in its entirety, a work of art.

Throughout the book David has drawn from and referred to some of his life experiences initially as a naval cadet before embarking on a career as a navigator. Having left the Merchant Navy and completed his BA Art Degree he has had lots of opportunities to take to the sea in ships again. He was in 1984 commissioned by the Armed Forces to complete a series of paintings in the Falklands post war. He seized every opportunity to get on, over or next to the sea. Commissions to paint several lifeboats also afforded him the chance to experience the sea in all its moods. David is also author of 'Britain's Maritime History' – a unique limited edition hand-coloured book and 'A Coastal Passage' first published in the UK in 1999.

I was delighted when David asked me to write this foreword as I have known him as a Patron for over 20 years and followed his development with great interest and delight. I am only now beginning to comprehend the extreme knowledge which underpins his skill in portraying naval subjects with such artistic vision. What a contrast that David has quietly built a reputation without intense publicity, as his work is produced to a waiting list of collectors.

David Bell is now considered as one of the foremost marine artists here in the U.K. His attention to detail, historic accuracy, ability to capture the action and atmosphere of its surroundings puts him amongst the great maritime artists of today.

R Michiel Stevenson OBE DL Hon MA

A Nautical Odyssey

Introduction

As a young lad my first drawings were of boats and ships. Why this subject? I do not know. It just happened but as I progressed with the brush, I tackled all kinds of subjects - including figure painting which, strangely, I hardly ever do these days. I still paint other subjects, particularly another passion of mine - 'steam railway engines' and will pursue this more seriously one day. But for the last thirty plus years maritime subjects are what I have known and what I have endeavoured to portray.

I wish now, when I travelled the oceans in the Merchant Navy, I had kept more sketches and paintings done at sea to reproduce here. However I do, fortunately, have many watercolours, drawings and sketches from my time later on whilst ashore and at Art College and have retrieved them, good and bad, old and very old, to formulate this book and depict an insight into my interpretations of the nautical world.

My approach is basic and my method constant. What you put in is, with a bit of luck, what you get out. Painting cannot be broken down to any formula as every artist has his own individual method and style. Some paintings race along almost generating themselves from the initial seed of inspiration to the final work, while others may be heavy going, involving checks on proportions, rigging and other important detail. Usually artists are so immersed in their work, time is not of the essence. Planning, preparation and many roughs need to be produced for any work of art to be successful and possibly exhibited. Failure to achieve this is usually due to a lack of these essentials. I produce far more sketches and roughs than I do finished works, I like working like that, and many drawings have been retrieved from the studio drawers and old college sketch books to be reproduced here.

Where does my inspiration come from ? Inspiration for me must come from an experience which may be from all sorts of areas. It could be sparked by a particularly startling sky, a coastal area visited or an historic ship boarded and examined or something just read about and registered in the mind.

A Nautical Odyssey

I also have my heroes among the great artists to whom I will always aspire, but to see a sailing ship at sea in any weather will always inspire and motivate me to put brush to paper. Whilst I have tackled many subjects as previously mentioned, from portraits to aviation my second favourite subject is railway engines, but I'm in my natural element with a nautical scene.

One thing of paramount importance is that I have to really want to paint the picture and that would be my advice to any aspiring artist. Resist making yourself paint a subject for which you have no real feeling. If it's not for you then move on. Start and paint from life, that is the only way to build the foundations of 'seeing and painting' and developing the ability to create. Where do I find the inspiration and source material? Until you have a mind full of retrievable images it's best to persevere and look for a scene or subject that inspires you. That's the hardest part. When tackling a contemporary scene, the answer is straightforward - where possible, visit the prospective subject, view it from every angle, in all light conditions and then paint and sketch it. Getting outdoors to draw is essential to build your understanding of space and form. Not to be self-conscious is easier said than done but it does lead to a more natural and open rendition. I paint and sketch loosely but meticulously, with different media on a range of surfaces. Finding your own style soon follows. Time and tide usually dictate my operations, and, more often than not these days, paintings are studio finished. I have for instance visited and painted at Staithes, North Yorkshire (the home of James Cook in the earlier part of his life) many times in all seasons and all weather conditions creating all sorts of atmosphere and lighting, for the last forty years and some of the results are shown in the first chapter. From these visits and experiences is sparked that first thought which goes on towards a completed picture.

Historic subjects present a separate challenge and require quite a different approach from the spontaneous creativity of the 'plein air' painter. I have always enjoyed reading about naval history, whether fact or fiction, and my first ever drawings as a young lad were of sailing ships. My early start in the maritime world was at fourteen when I attended Trinity House Navigation School in

A Nautical Odyssey

Hull, followed by a career at sea. This formed the foundation of my interest in all matters maritime.

Although I understand from psychologists that some people think in words I seem to envisage, or rather create and communicate far better with images, so as I digest maritime material I visualise a gallery of paintings. Logical of course but the trick is then to transfer a three-dimensional image onto a two-dimensional surface. The considerable experience I've had at sea is probably my greatest resource. Detailed research is necessary, to a point, to produce a painting which is as correct as you want to make it, and to achieve satisfaction. Training, that is in college or art classes, if possible, is an asset, and a fairly basic requirement. But hard work and a diligence to practise are essential. At one time I would never start anything historical without access to the real thing, a model or ship's plans, hence my time served drawing and recording models at such places as the National Maritime Museum and the Town Docks Museum, Hull. Now I still research but I can and do, essentially, paint and draw any maritime subject with no reference material at hand, as I do in demonstrations. Inspiration coupled with that vital quality 'vision' is all you need. I personally believe, as most painters do, that the artistic side of painting should always have the edge over accuracy. The difficulty lies in sacrificing artistic pleasure to the altar of accuracy. However careful I try to be there are always those who feel an obligation to point out errors as they perceive them in the minutiae of the painting, and perhaps, rightly so, but at the end of the day it is judged as a work of art and the visual impact of the painting, in my opinion, is the first thing that matters.

That all said, it is, as I have read about and investigated my subject carefully in every way possible - travel, books, paintings, models, plans, photographs and the world-wide web that I have realised through these pictorial journeys that many areas of our maritime history have, running through them, constant threads linking one subject to another. Just as, when working on one painting, it seems to spawn another, so when investigating one great sailor or ship it seems to draw or direct the researcher to a different vessel or naval hero, and

A Nautical Odyssey

so I felt compelled to commit this creative journey to paper - hence 'A Nautical Odyssey'.

Before you embark on this 'odyssey', I need to explain a little further the true course of my thoughts. Any painter will tell you that their paintings have a theme and portray a message that may, or may not, evoke a response. I have over the years pondered, decided and worked out my theme and message, good, bad or indifferent, before drawing or painting any subject. Invariably they are derived, and contrived, from subjects such as Nelson's Wars, a harbour scene at Staithes or just a scene from a holiday. What has become apparent during my efforts is the association or link between one painting and another. Of course, laid out chronologically, there would be an historical connection, but as this book unfolds a more personal and individual connection (tenuous at times), is revealed through the ship and sailor and with these paintings an 'odyssey' is unravelled.

Whitby and the Yorkshire coast, and very much Hull and the Humber and its fishing history have always been a keen source of inspiration to me and my first worthwhile paintings, debatable I know, were tackled on that coastline. So I have chosen, as a result of my painting archives which cover this period of time, to start with Whitby's James Cook and his ship the *Endeavour* moving through 150 years of history to Shackleton and the *Endurance*. Exploring this period of maritime history, from 1768 to 1916 is a vast undertaking in itself. I have tried to limit the narrative, certainly the historical side, without impairing the cohesiveness between the historical events and the subjects of my paintings and drawings. With these images and my time at sea covering many nautical miles and all the experiences that go with it, woven into this short but eventful period of British maritime history, is the essence of this book.

During my time at sea I visited many ports and countries and started, in a small but serious way, to paint and record what I saw at sea and ashore, this eventually directed me onto another tack towards Art College. The influences

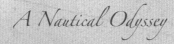
A Nautical Odyssey

and recollections at that time are apparent in my paintings and documented in the commentary.

My traditional style of work, partly innate, has also probably developed from patience learnt as a navigator at sea. The history of ships and sailors has been well documented over the years and reproduced in numerous fine publications, many brilliantly researched and written and this book does not try to compete with that type of reference. This chronicle is a personal view of those voyages at sea, highlighted with a collection of pictures painted and drawn during my meanderings as an artist to the present day. It contains the necessary historical facts to support these works. I hope my views and observations as a keen admirer of this period, tempered by my travels and by my time at art college, does represent quite a different 'picture book'.

This combination of maritime history, my travels and personal illustrated journal, forms an odyssey - put down in a factual and visual commentary which I hope is unique and inspiring. Not every aspect of naval history, big or small, has been covered here and uniting maritime art with maritime history is far from easy, but this self-indulgent book does give me the opportunity to show many works which would otherwise remain unseen in forgotten studio drawers.

Very few of of the ships portrayed in this book now survive, having long since gone to a watery grave, but those that do exist, I have, obviously, used as a source of reference. My affinity with the oceans, my time at art college and my subsequent maritime painting spliced with nautical history produces the union depicted on these pages where the vessels and their masters once sailing the high seas are inextricably woven.

David C. Bell

A Nautical Odyssey

Preface

To set the scene...

The Arab and Chinese seafarers had for centuries established a trade route crossing land and sea called the 'Silk Road', transporting Oriental riches from China to Europe via the Black Sea and the Middle East. The merchants of Genoa controlled and monopolised this profitable trade. The other route was the more maritime 'Pepper Route', from Chinese ports to India and the Red Sea, and by caravan train to the Mediterranean. This trade was the monopoly of Genoa's rivals - the great Venetian traders.

Within fifty years these routes had been replaced by an entirely maritime trade to India, Asia and especially the 'East Indies', dominated by the foremost sea powers of the time, Spain and Portugal. These new sea routes created by adventure and gain, opened up a whole 'New World' for commerce and the birth of colonial empires. To the European monarchies of England, France, the Netherlands and especially Spain and Portugal, the Orient, and partly what was known of the Pacific, were the hot-spots for an expected lucrative trade and the inevitable development of these nation empires.

The 'Renaissance' of the 14C and 15C was a period of 'art and education'. It was also a time for the inventive and technical minds to search for greater scientific and geographical knowledge.

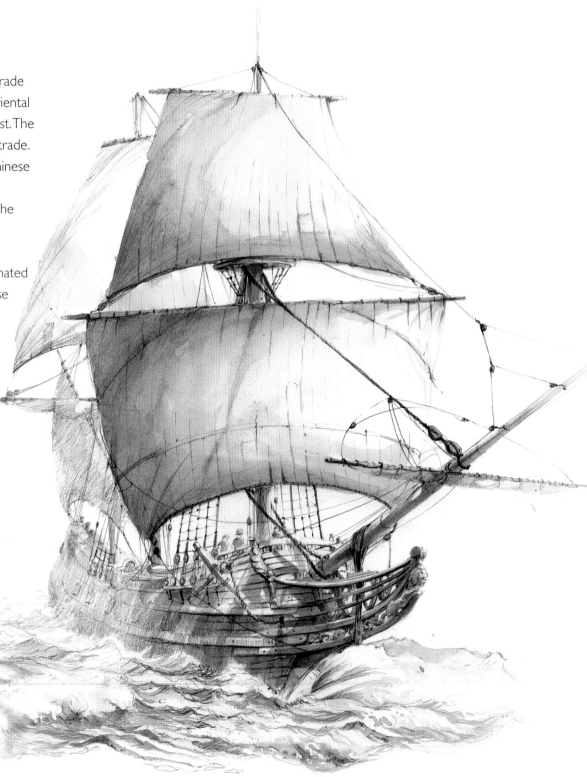

Heemskerck built Netherlands 1638. Abel Tasman was the master of this ship that landed on and claimed Tasmania in 1642. Later they actually landed on the South Island of New Zealand but decided to sail into the Pacific and its islands.

Exploration and discovery was an opportunity for the men who lived during this enlightened period of European history to push back horizons and become now familiar names in history books. Alongside and in support of this exploration, ship design developed, and this book is about the ships as much as it is the men who sailed them.

1492, the time that my painted chronicle begins, was the year in which Columbus took Spanish ships across the Atlantic to find a westerly route to the 'East Indies' and strangely discovered the 'West Indies', as it is still known today. On the second voyage he found the Leeward Islands, and on the third he landed on the southern tip of these islands, at Trinidad, and onto the shores of Venezuela.

Having crossed the Atlantic on a relatively small container-ship from the Mediterranean to the small port of Willemstad on the amazing Dutch-colonised islands of the Lesser Antilles, a stone's throw from Venezuela, and sailed around many ports in the Caribbean, I can appreciate, to say the least, the distances and difficulties of those almost impossible attempts to sail in these waters safely.

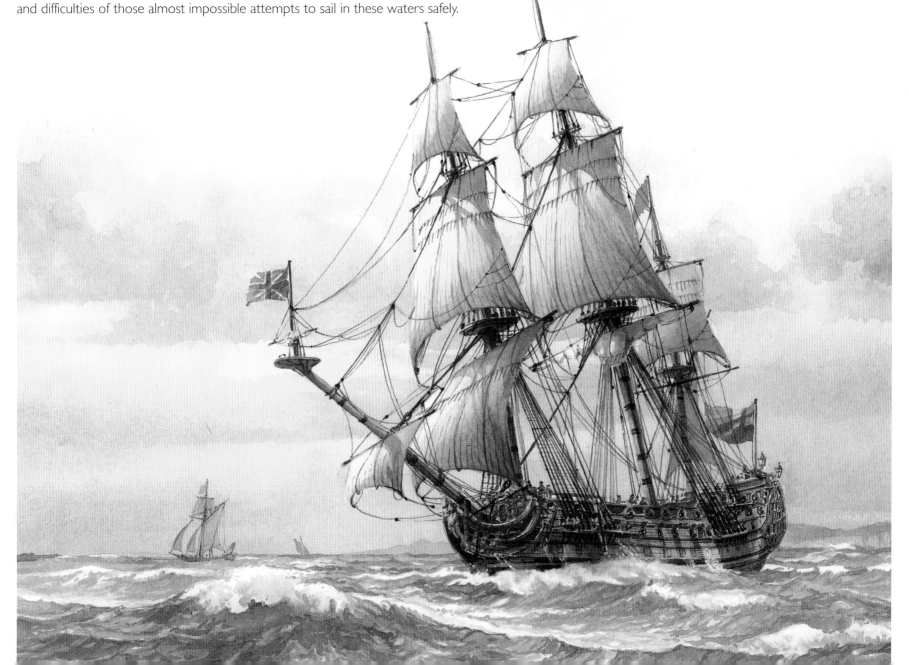

It was the personal desire for riches from the East Indies that gave Columbus the ambition to find a way to bring them back. He may have known it was possible to travel over the north-east corner of Africa near Suez from the Mediterranean to the Far East but due to the lack of geographical information available to him at the time, instead of going south he sailed west to find the east. At sea no ship goes far without the odd grumble from sailors and Columbus had his fair share, to put it mildly.

He left the Canary Isles on 6th September 1492 and sighted the Bahamas on the 12th October. This, he mistook for an island off Asia and naturally proceeded south to 'Japan', and found what is now Cuba, but at the time thought it was China! He did find one of my favourite and well frequented haunts, the island of Hispaniola (now Haiti and the Dominican Republic), where I first came across a replica of the *Bounty*, as used in the film 'Mutiny on the Bounty', loitering at a jetty next to us in Port au Prince. Such a tiny ship to even contemplate a voyage out of sight of land. Columbus's ship the *Santa Maria* was wrecked on this island. He returned home on one of the other ships in the fleet the *Nina*, convinced he had found the East Indies.

Though Columbus was geographically as far away from his goal as he could have been, he was close to Panama and close to the ocean he wanted to cross. So near yet so far. Columbus died at fifty-four a distraught and frustrated man at his failure to find the western route to the East Indies. Perhaps an Italian sailing for Spain was not destined to succeed. It would be more accurate to say he opened a way to the,'Americas' rather than being discoverer of 'the' America. At the same time, the Portuguese, with the same intentions, had found the much sought after easterly route to India via South Africa.

Leaving explorers for a moment to look at their vessels I am jumping ahead a little to the late 16C and early 17C when the 'galleon' came into its own. This came about as a development of the carrack which was a trading vessel to become the specialised warship. Slimmer than the carrack the 'galleon' was far more manoeuvrable and faster, with the forecastle almost reduced to deck level and a lower aftercastle. With armaments, the ship became longer and heavier making it lower in the water which unfortunately brought about the eternal problems of stability, as with the *Mary Rose* for example, with whose demise we are all now familiar. The 'Elizabethan' galleons of England such as the *Revenge* (1577), the *Sovereign of the Seas* (1632) and the *Prince* (1670), as illustrated, were to become the predecessors of the 'ship of the line'.

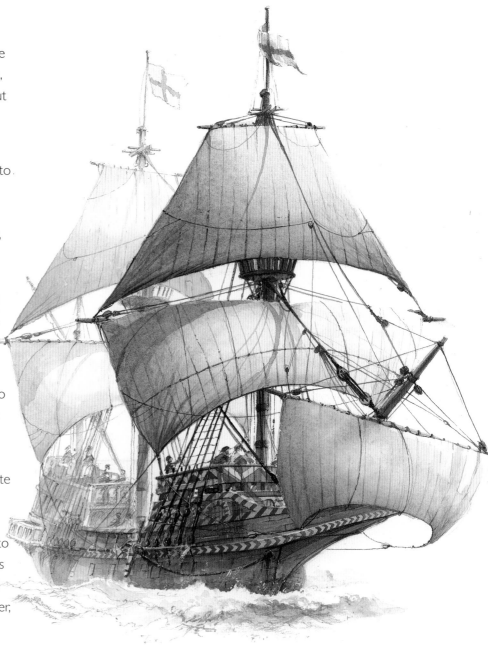

Golden Hind Built at Plymouth in 1566 as the *Pelican*. This galleon is familiar to all as the ship that the famous Francis Drake sailed around the world, in 1577 to 1580, renaming the ship en route.

An assortment of improvements such as the introduction of the bowsprit, the magnetic compass, the astrolabe, and the single rudder brought about great advances in sailing and navigation. This was also aided by the sextant which, in a way, counteracted the lack of knowledge about tides, winds, currents, deviation and variation. The exchange of knowledge north to south and vice versa resulted in bigger and better ships being built and as a result of this, the 'coastal voyage' could and would become an 'ocean voyage' thus supporting the 'renaissance' in a practical way.

The merchants of Venice and Genoa quarrelled amongst themselves, and divided they fell. But in Germany in the north a more united approach evolved. This was the 'free trade alliance', later to be known as the 'Hanseatic League', in which countries joined together to become a stronger maritime force. This extended the strong influence of the North on the Mediterranean ship-builders as can be seen in the 'galleons', 'carracks' and 'caravels' that had developed there. In return the flush planking of the southern ships was adopted by the northern shipwrights which made movement through the water easier and faster.

The square sail, which was derived from the Viking galleys, was already in use by the north European ships and was making its impact on ship design as a rig for ocean trading. The 'squared' stern to accommodate the single rudder became standard as did a broader beam and rounder bow to make the ships more seaworthy. The merchantman's fore and aft 'castles' remained, and though this made them a touch top heavy, it did enable armaments to be carried so the vessel could take on the role of a 'man of war'. These 'carracks' became the norm for the north and the south, and the 'square sail' was adopted over the 'lateen' sail. This allowed better sailing, especially in prevailing winds when making way in a head wind or following wind. The lateen sail was pretty poor in these conditions but did become established on the mizzen mast and of course as 'staysails' and 'jibs'.

Religious policies also played their part in the course of maritime exploration. In contrast to Spain's Catholicism there was the Protestant Netherlands which had rebelled against King Philip II and Spanish domination. The Netherlands developed independently therefore, into a remarkable seafaring nation in itself, creating its own navies, military and merchant, and establishing trade routes to the Orient.

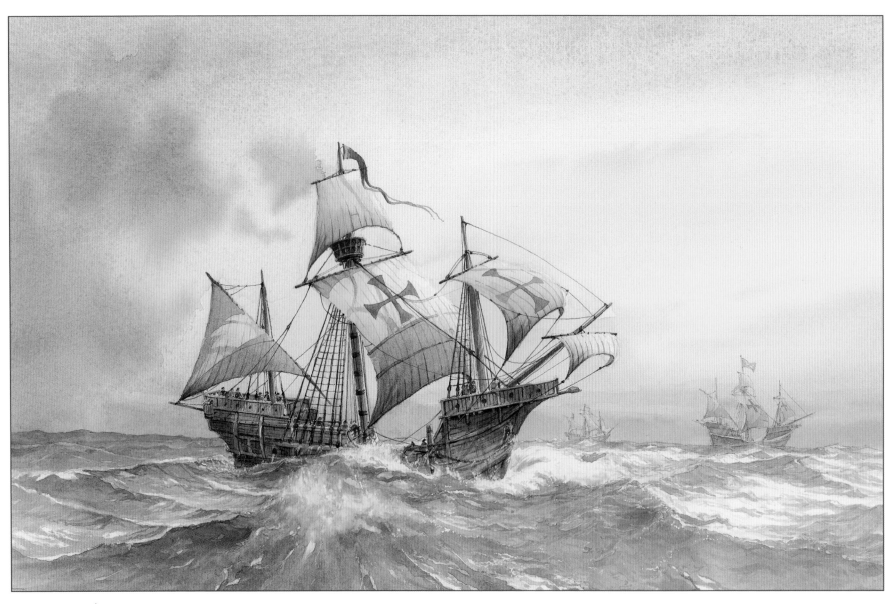

Santa María 1492

Certainly one of the most important voyages in the history of exploration, it is remarkable
that Columbus survived the first voyage in this tiny vessel let alone the following three.
A small ship and only seventy foot long, but with three masts proved to be a poor sailer.
The ship was wrecked off Hispaniola on Christmas Day 1492.

At the same time as Columbus was sailing to the Americas there were two outstanding Portuguese sailors on the high seas - Bartholomew Diaz and Vasco da Gama. Whilst Columbus went west to find the 'East' Indies, Bartholomew Diaz, following his fellow countrymen went south, reaching the Gold Coast of Africa in 1481. Seven years later he ventured further eventually making a landfall at Mossel Bay east of the Cape of Good Hope. In turning the corner Diaz had reached another milestone and opened the way for Vasco da Gama to explore further. (On my first ship as a navigating cadet on a trip from the U.K. to Japan via Aden I had the dubious honour of being nicknamed 'Vasco', not by merit - I was very keen!) Anyway earlier in 1497, da Gama with his fleet of four tiny ships rounded the Cape, sailed north to Mombasa halfway up the eastern seaboard of Africa and a wonderful exotic harbour, and across to Malabar on the west coast of India, thus opening a way to these lands and taking another step on the road to the Orient.

Also at the same time John Cabot, the Venetian, was attempting, unsuccessfully, to find a route to the east via the impossible 'north-west passage', but instead, reputedly, discovered Newfoundland. After Cabot, the Frenchman Jacques Cartier, likewise, made an unsuccessful attempt at the 'north-west passage' on four voyages between 1534 and 1542. He did however discover and explore the St. Lawrence seaway, which was, of course, to be colonised by the French. The man who did discover the Pacific was the Spanish conquistador Vasco de Balboa in 1513 when he crossed the isthmus of central America to its western shores. He saw, claimed and named the ocean the 'South Sea' (later the Pacific) for Spain. Not long after, the great Portuguese sailor Ferdinand Magellan, sailing under the Spanish flag, was to attempt, with his fleet of five ships, a passage to South America around its most southern point and into an unknown ocean and to sail across to rediscover the Moluccas - from the east, a voyage that even then was considered madness and would ultimately end in tragic failure.

But the Portuguese born Magellan was determined to find a route westwards to the Orient via the Americas. He found and sailed through a 350 mile passage at the southern end of South America, some 300 miles north of Cape Horn at 56 degrees south, to be named after him as the 'Straits of Magellan'. Magellan's quest was to find a shorter route to the Spice Islands and so defeat the Portuguese, in time at least, and gain a stronger foothold in the Orient for Spain. This intention was, in a way, a continuation of Columbus's voyage discovering and charting (in a very basic way) lands which would eventually bring about the expansion of merchants and their nation's wealth.

From his departure from Spain to arriving at and leaving the Straits of Magellan on 28th November 1520 only three of the five ships the *Victoria, Trinidad* and *Conception* survived the Pacific crossing to Cebu in the Philippines. The events that followed from April to November in the Moluccas resulted in the loss of one ship and the tragic loss of Magellan himself in a dispute with Philippine natives. The *Victoria* with Juan Sebastian de Elcano in command, did, amazingly, survive and arrive back at Seville in Spain on 6th September 1522 with only eighteen crew, after three, very long, years at sea. This was the first ship and the first men to circumnavigate the world. As it turned out the Moluccas were in the Portuguese allocated territory and Magellan's route was no shorter.

Despite this fact I still admire Magellan and his men for their amazing feat of physical endurance and endeavour. This voyage was a milestone in the 'history of navigation' and an unequalled success in its influence on future exploration. It proved there was a navigable route from the east and the west around the world and that the huge Pacific Ocean could be crossed, so disproving any previous theory that Africa or South America were joined to a 'great southern landmass'.

For the great seafarers that followed, Magellan's voyage was an inspiration. Maps were still rough at the edges, and in the middle, but the world's cartography was slowly

Sovereign of the Seas 1637

being unravelled. Though, as more and more Europeans risked all in their voyages of discovery to the Pacific, it made for a perplexing and very inconclusive picture. More discoveries were made and seas crossed but actual geographical locations were still inaccurate and uncharted.

From 1740 to 1800 in what was to be termed the 'Golden Age' of maritime exploration every voyage revealed more facts and figures, and the cartography could have painted a cohesive picture but, astonishingly didn't because each nation was seeking new markets and colonies so all discoveries became 'government secrets' and some guarded, as in Portugal's case by 'Punishment by death'. As late as 1769, Bougainville the great French explorer refused to give the exact position of Tahiti. Even Holland would not disclose any information of their colonies as they deemed these lands and markets as their sole rights.

So this period saw the Spanish, Dutch, English and of course the Portuguese established in the exploration, discovery and colonisation of the world. The ocean was the problem to overcome. The sailors of repute were to be many and the ship was to be the vehicle of their achievement as the odyssey now unfolds.

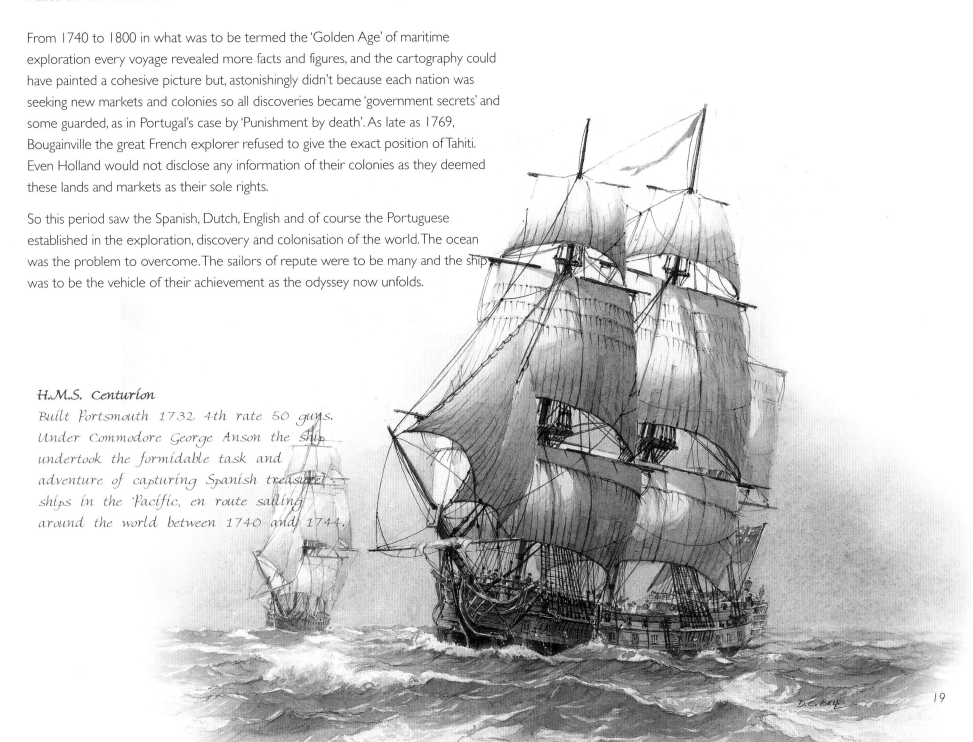

H.M.S. Centurion
Built Portsmouth 1732 4th rate 50 guns. Under Commodore George Anson the ship undertook the formidable task and adventure of capturing Spanish treasure ships in the Pacific, en route sailing around the world between 1740 and 1744.

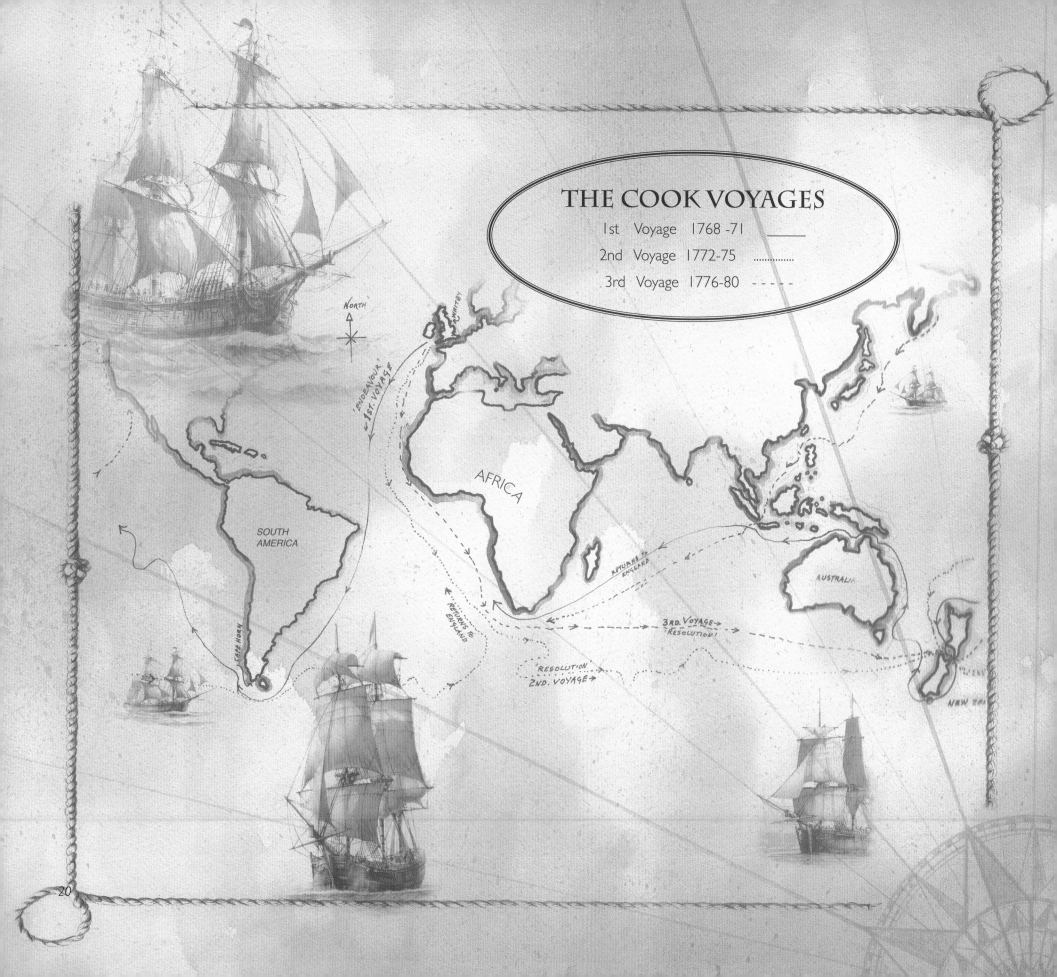

THE COOK VOYAGES

1st Voyage 1768-71 _____
2nd Voyage 1772-75
3rd Voyage 1776-80 - - - - -

NORTH

'ENDEAVOUR' 1ST. VOYAGE

AFRICA

SOUTH AMERICA

CAPE HORN

RETURNS TO ENGLAND

RETURNS TO ENGLAND

3RD. VOYAGE 'RESOLUTION'

'RESOLUTION' 2ND. VOYAGE

AUSTRALIA

NEW ZEA

20

James Cook
& His Ships

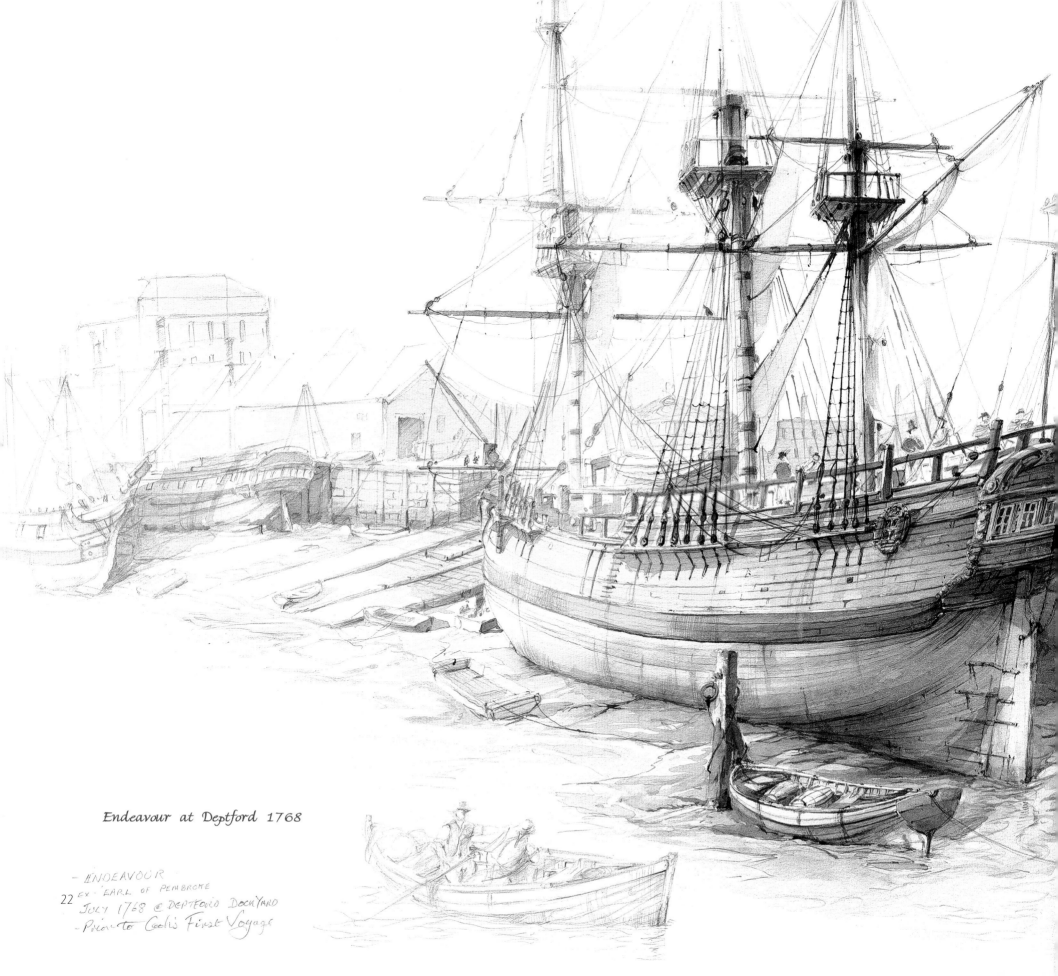

Endeavour at Deptford 1768

- ENDEAVOUR
22 EX 'EARL OF PEMBROKE
JULY 1768 @ DEPTFORD DOCKYARD
- Prior to Cook's First Voyage

James Cook 1728-1779

&

The Voyages of the Endeavour and Resolution

1768 to 1780

When James Cook, in command of the *Endeavour,* sailed from Plymouth on 26th August 1768 on his first voyage of discovery he had on board an organised and up to date, well planned and carefully acquired logistical store of people, equipment and supplies that would be unravelled and used until he returned on 12th July 1771, nearly three years later. Cook was to encompass and practise all the advancements in science on this and the next two voyages. On this voyage he was to become with his ship, one of the great seamen, explorers and navigators in history. That was just the beginning - two more voyages were to follow. To set the scene I'll continue describing Cook and his ships, along with the sketches, with the following summary.

The eighteenth century was a time of political revolution and social upheaval, Jacobite Rebellion, the Agricultural Revolution and, especially, the Industrial Revolution. This had come about in a nation with a stable and developing government, and with scholars who had a greater awareness of science. All this led to an increasing trade and the desire to expand and flourish. and especially to learn more of the 'Universe'. Astronomers at this time knew that every so many years 'Venus' would pass across the sun, and if the time it took to cross could be accurately measured then, with the odd equation or two, the distance from the sun to the Earth could be calculated. With this knowledge the question 'How big is the Universe? ' might be answered. The Royal Society of

London was committed to the advancement of scientific knowledge and knew that the next transit would be 3rd June 1769, precisely, and so decided to have astronomers observe this at various locations in the world. A possible one was in the Southern Oceans.

This destination was far from England but the Royal Society, along with the Admiralty, decided on this area after the fortuitous return of Captain Samuel Wallis with much information in H.M.S. *Dolphin* in May 1768 after his two year circumnavigation of the world.

A year after the 'Seven Years War' with France in 1764, a navy sloop H.M.S. *Tamil* and H.M.S. *Dolphin* a 6th. rate and flagship of the expedition were sent on a voyage for the 'advancement of 'Trade and Navigation', to the Southern Oceans of the Atlantic and Pacific under the command of Commodore John Byron. A momentous voyage of two years took him to the Pacific via South America and the Straits of Magellan followed by a long gruelling meander, with purpose, across the Pacific, through many islands to the Philippines and Batavia (Jakarta) and via Cape of Good Hope back to England arriving in May 1776. On entering the Pacific, Byron chose to search for the little known 'Solomon Islands' discovered by Alvaro de Mendana back in 1568, but not quite pin-pointed on any chart. Although not finding them, he did visit or pass through the Juan Fernandes Islands, Taharoa (Tramotus), Tahiti, Tokelous, the Gilbert Islands and on to the better known and charted islands of the Philippines and Batavia.

The relevance of this voyage is that H.M.S. *Dolphin* was newly 'copper-bottomed', in fact the second navy ship to be so, and on returning home, was still found to be 'fit for further service'. So efficient had the coppering been in preserving the hull, the ship was immediately fitted out for a second voyage under Captain Samuel Wallis. This time H.M.S. *Swallow* was to keep the *Dolphin* company and when they sailed in August 1766, it was to find 'Land or lands of Great Extent' in the

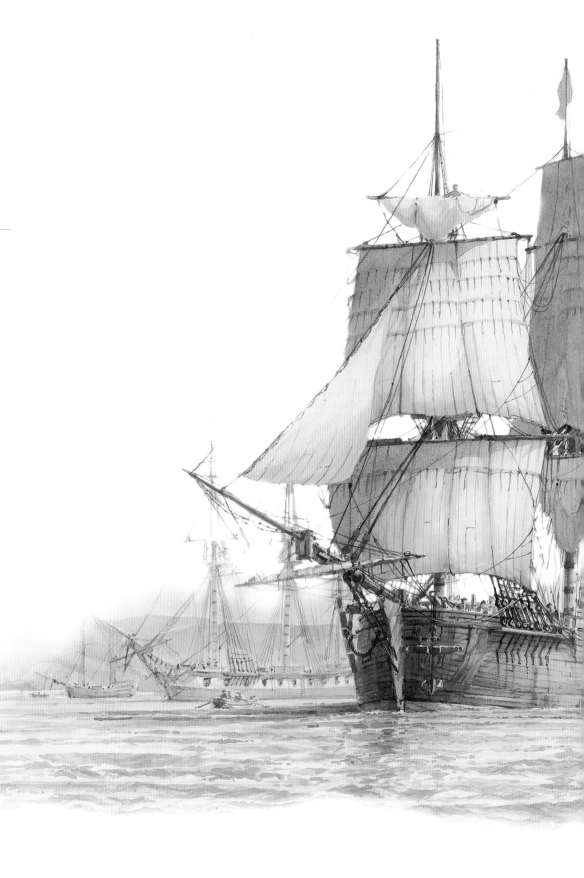

Endeavour sailed from Plymouth on 26th August 1768, with new sails, re-sparred and rebuilt internally. The ship was built to hold a big cargo and was physically full to overflowing.

Southern Hemisphere between the Cape of Good Hope and New Zealand and to find 'commodities useful for commerce' - basically to open trade routes for Britain. After a long, arduous voyage to South America, and through the Straits of Magellan, bad weather saw the ships unintentionally part company. The *Dolphin* sailed north-west into the Pacific and in June 1767, as the first European vessel to do so, it arrived at what Wallis called George Island. and what we now know as Tahiti. The sailing ship was now to be the harbinger of western culture to the Pacific Islanders. This island was to become the hub for the future explorers of the Pacific. Wallis's account of these events and his admiration for the Tahitians, with their abundance of food and friendly

nature, kindled the imagination of the Royal Society. This news was to have a significant effect on the following voyages to the Pacific. The R.S. saw not only the value of the future 'Transit of Venus', but also the potential to discover and chart new lands and confirm, or not, the true geography of previously discovered lands, especially the uncharted and little known antipodean land called 'Terra Australis Incognita'. So, the R.S. and the Admiralty agreed that Tahiti would provide the best base for all endeavours and preparations started for a calculated twelve month voyage. A possible candidate to lead the expedition was an Alexander Dalrymple. A civilian who, after working many years for the British East India Company with extensive travels to India and the Far East returned home to England where he committed his acquired knowledge to paper as a book on the 'Southern Ocean'. As a competent navigator, he

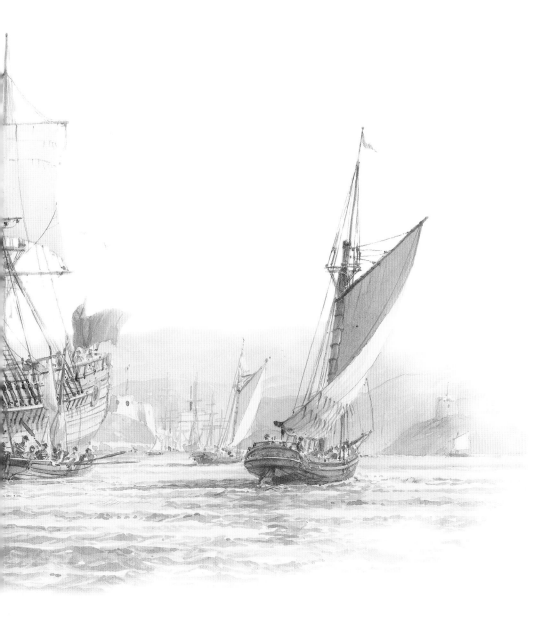

also charted this region. The Royal Society, impressed by his achievements, saw him, naturally as the man for the job and preparations were put in hand for a voyage to the Southern Ocean. In 1768 the Admiralty purchased a Whitby 'cat' built collier the *Earl of Pembroke,* some 300 tons, then berthed on the Thames, registered her as the bark *Endeavour* and had her dry-docked at Deptford and fitted out for exploration, though not 'coppered' because of its ongoing maintenance, but double-planked instead. All Cook's ships were built and launched at Whitby. The next piece in this jigsaw was that the Admiralty vetoed the choice of Dalrymple, a civilian, to command a navy ship. Consequently Dalrymple took the huff and withdrew his services completely - so leaving a vacancy to be filled. But by whom? James Cook was born in 1728 in rural north Yorkshire, with a Scottish father and an English mother. You could imagine with his poor background he could improve little on his lot, indeed, on the contrary, this quiet man of strong disposition, standing over six foot tall, and with a natural aptitude for learning, flourished early, under the guidance of a local land owner who saw his early potential. Then after a stint as a grocer's boy in Staithes, a start which gave him the chance to read and learn, he heard the call of the sea and at eighteen went to Whitby taking on an apprenticeship with a Quaker ship-owner John Walker - another 'surrogate' father who took to and guided Cook. (At school and fourteen years of age I was the only person to step forward to change tack and begin a course that could lead to a life at sea. I'm sure had I been a local lad in Cook's time I would have been the first up the gangway and off to sea!) So it was with the young Cook, who worked for around nine years on these Whitby colliers, with the occasional voyage to Europe, and certainly many trips to London, gaining enough experience to be eventually offered his own command. Which he surprisingly turned down.

The extraordinary events that brought Cook to lead the future voyages of exploration are well documented but the real desires and ambitions of this man will never be certain. It was his aptitude for learning, particularly mathematics, which was really the foundation for his success, not only personally but as an instigator for the practice of maritime exploration on a scientific level.

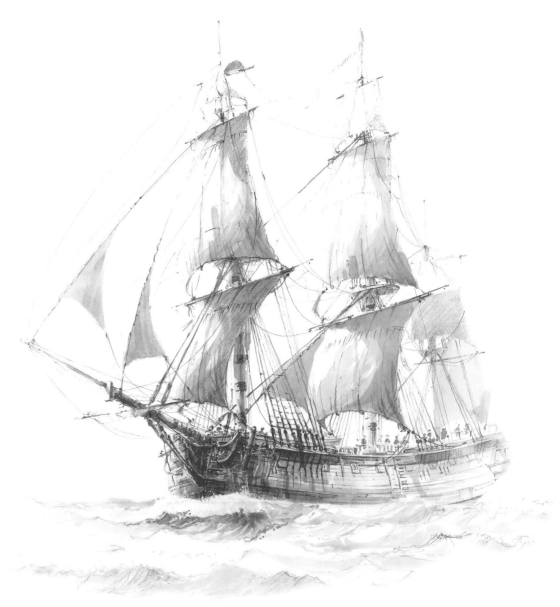

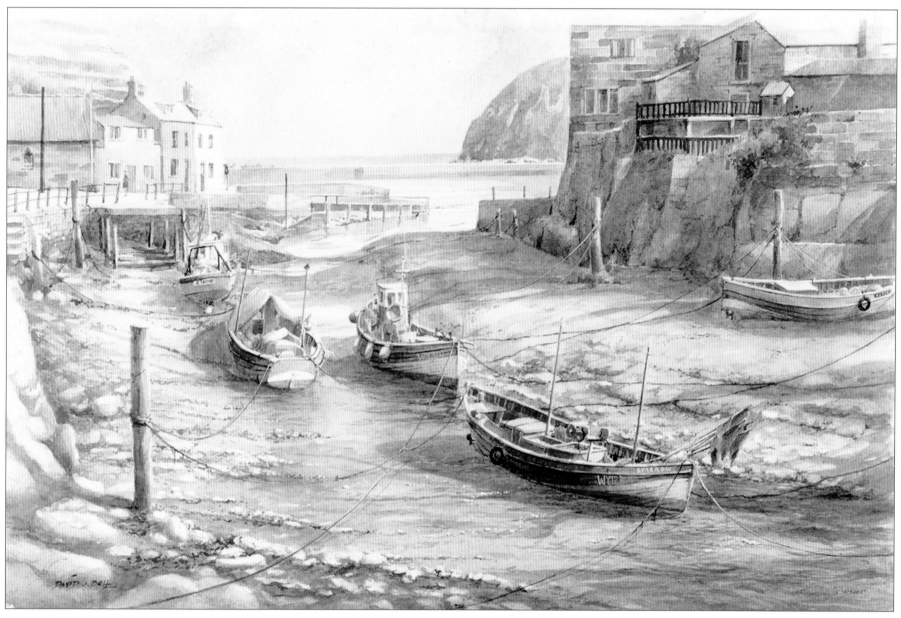

Ebb Tide, Staithes This painting is a scene from about twenty years ago when there were ample working fishing boats about at all times of the year. This was drawn at low tide from the north side of the beck looking seaward and studio finished.

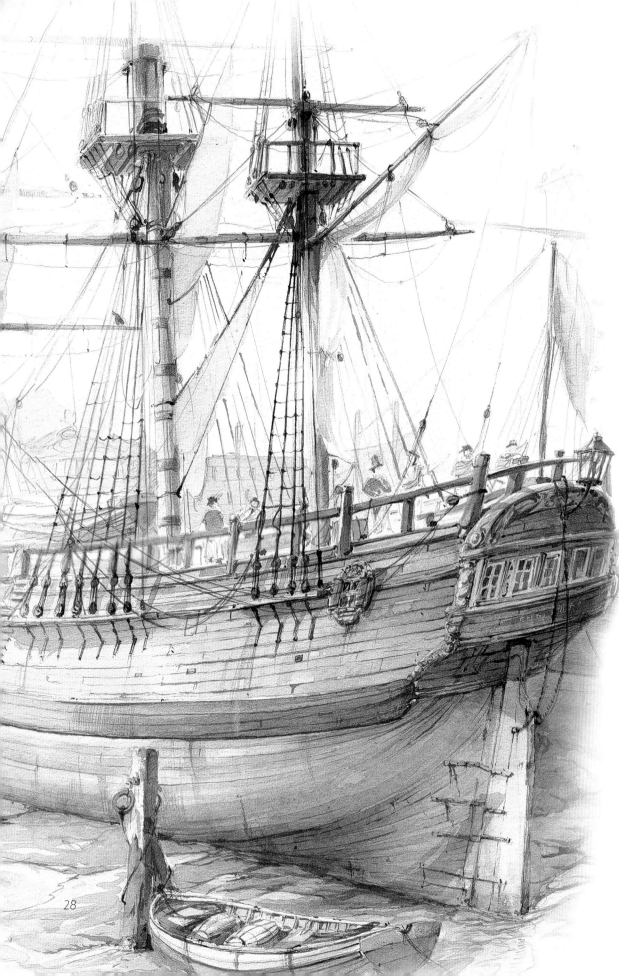

The buzz of London, the 'Men of War', the prestige and status of a navy officer and the advice from a friend may have influenced him to take the path of a sailor in the navy - but adventure alone I think, was now etched in Cook's mind and really tempted him into the navy where advancement in rank was rapid when the country was at war. The 'Seven Year War', the conflict between Britain and France for colonial possessions was beginning. So Cook, the sailor, joined the navy as an able-seaman and boarded H.M.S. *Eagle* at Wapping, London in June 1755 at the age of twenty seven.

The close, personal life at sea enabled Cook's abilities to be recognised early and he was promoted to master's mate within months. Seaman, able-seaman, master's mate, master or sailing master were the ranks of the sailor in the Royal Navy and the highest position that Cook could expect to achieve. Indeed two years elapsed before he sat and passed his master's exams.

He must have known of the achievements of his great predecessors - Mendana, Tasman, de Bougainville and many more that would have further kindled his own innate desire to excel. His quiet demeanour and obvious abilities endeared him to his superiors such as Captain Hugh Palliser, a Yorkshireman and exceptional officer himself, aboard the *Eagle* who had recognised and promoted him to master's mate.

When he joined the *Pembroke,* a 64 gun ship, as a sailing master in 1757 again a Captain John Simcoe saw his talents and gave him advice and encouragement. It was while stationed at Newfoundland that the ship and Cook undertook a dangerous but meticulous survey of the St. Lawrence River for the safe passage of General Wolfe's ships and men to seize Quebec from the French. At this time he also had the good fortune to meet Samuel Holland, an engineer and surveyor who taught Cook the skills of surveying.

Endeavour at Deptford 1768
Detail from the picture on page 22

28

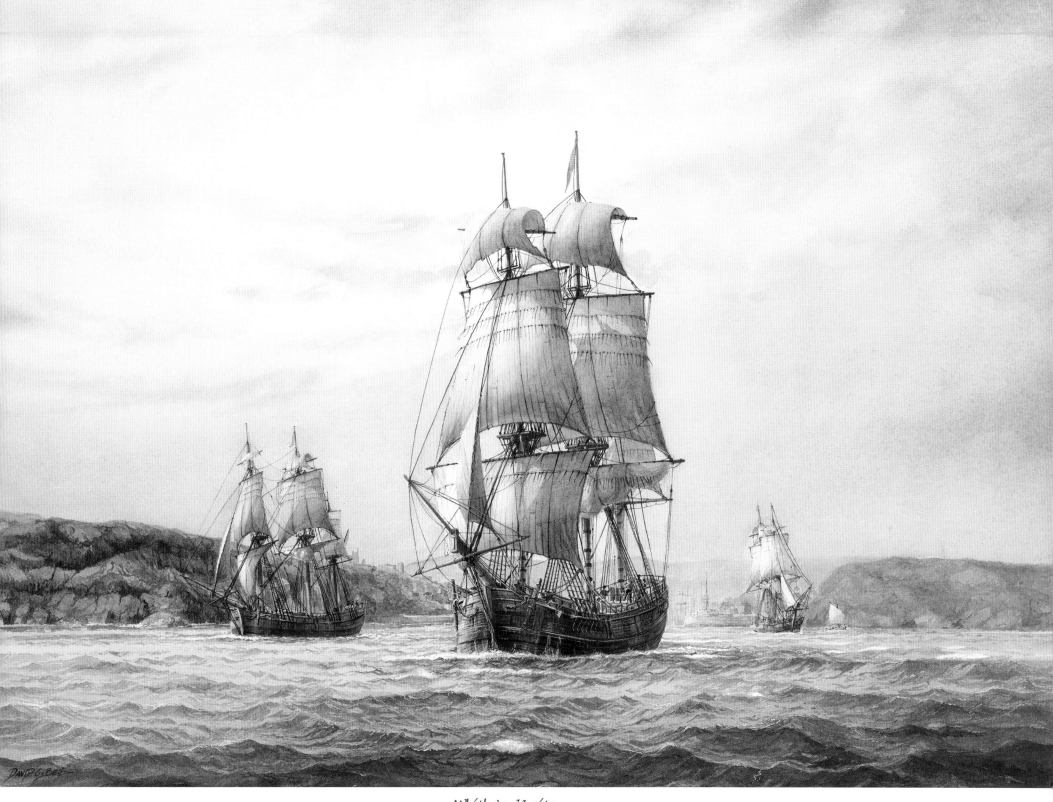

Whitby's Heritage

Sailing out of Whitby is the collier **Earl of Pembroke***, southbound and destined for a new name and new master.*

Newfoundland beckoned Cook again, this time aboard the *Antelope* for surveying and observing, a task which he performed for several summers, producing standard Admiralty Charts which were to be in use for many years to come. This was certainly a notch in his belt, but he also expressed his knowledge of astronomy by submitting his observations of an eclipse to Dr. John Reeves an astronomer and member of the Royal Society. With these papers, his name and competence became familiar. Cook, now a thirty-nine year old Warrant Officer, at the time master of H.M.S. *Grenville,* was a highly praised and endorsed navigator and surveyor, a quality that the Admiralty, with advice from the now Sir Hugh Palliser and the Royal Society, recognised and gave Cook an appointment to command, as First Lieutenant, the bark *Endeavour.*

In July 1768 the *Endeavour* left Deptford, and at the Nore, Cook received and opened his orders to proceed to Tahiti for the 'Transit of Venus' and then to search, in the southern oceans, for the Great Southern Landmass. He had with him many competent seamen, notably John Gore, an American, who had already circumnavigated the earth twice with Captain Byron in the *Centurion* in 1764-66 and Captain Wallis 1766-68. He was promoted to Third Lieutenant and his knowledge of the South Seas was invaluable to the expedition. Also shipped on board was the young botanist Banks, later Sir Joseph, and the Swedish botanist Solander, both of whom enthusiastically recorded much of the Pacific Islander's culture as well as the botany side. The Scottish botanical artist Sydney Parkinson, who sadly was to die, aged only 26, on the homeward passage, and Samuel Green the astronomer. Cook also had the charts from the *Dolphin* and the earlier charts of Gilles Robert de Vaugundy (1756). The ship sailed to Plymouth arriving 13th August.

On Friday 25th August 1768 the *Endeavour* left England's shores, bound for the South Pacific.

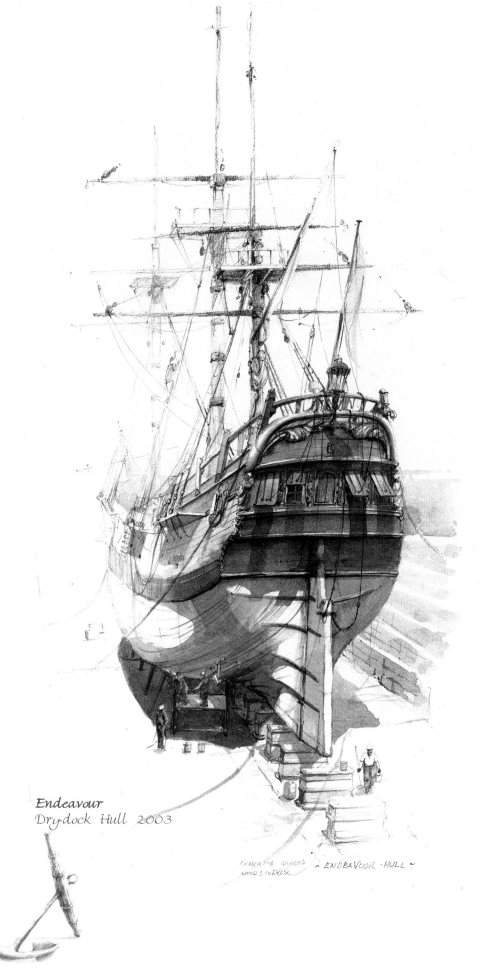

Endeavour
Drydock Hull 2003

Cook's First Voyage
Endeavour
July 1772 to July 1775

The *Endeavour* sailed across the Bay of Biscay, stopping at Madeira, and on to Rio in Brazil, then down the coast of Patagonia. Here Cook decided to pass the Straits of Magellan, and attempt a passage around Tierra del Fuego through the Straits of Le Maire and around the southernmost island of the Hermite Islands negotiating, of course, the formidable Cape Horn. This was successfully achieved in two weeks hard sailing, then on to Tahiti without incident, for the Venus transit. Here Cook proceeded in his methodical way to check out the islands around Tahiti, whose people he found friendly and welcoming, just as Wallis had in 1768. All the time he was searching for the elusive southern landmass, though without any sightings in this vast ocean but still undaunted Cook eventually headed westward.

In October 1769 New Zealand was sighted. Cook knew New Zealand existed because the explorer Tasman had made a brief visit before and had recorded his travels. The *Endeavour's* landfall was midway up the west coast of the North Island and it was named Poverty Bay. Throughout all Cook's travels, he bestowed names for every place he visited or sighted, here and in Australia, many of which are still in use today. In Poverty Bay he found the natives quite unfriendly, in fact extremely aggressive and warlike. Nevertheless water and provisions were needed and another two weeks meandering about brought them north to Tolaga Bay, where they found an anchorage in a cove, now called 'Cook's Cove', for repairs and fresh water. On my recent visit to New Zealand, and with good advice, this was my first destination. The Coromandel Peninsula is as perfect and beautiful a place as you could

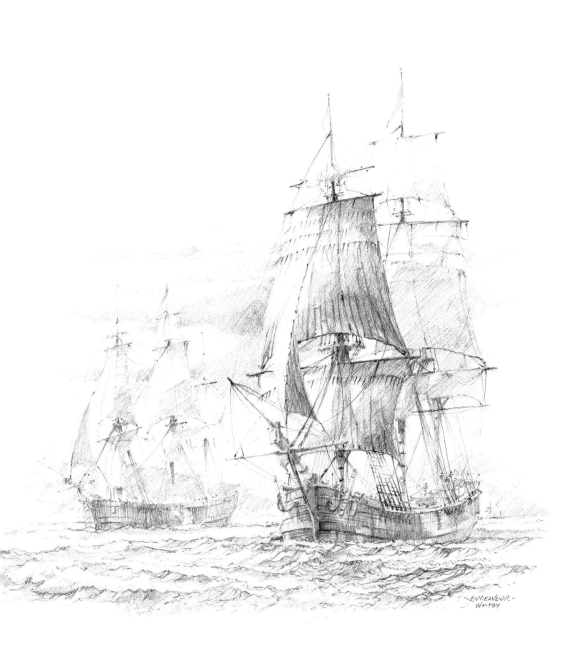

ENDEAVOUR
WHITBY

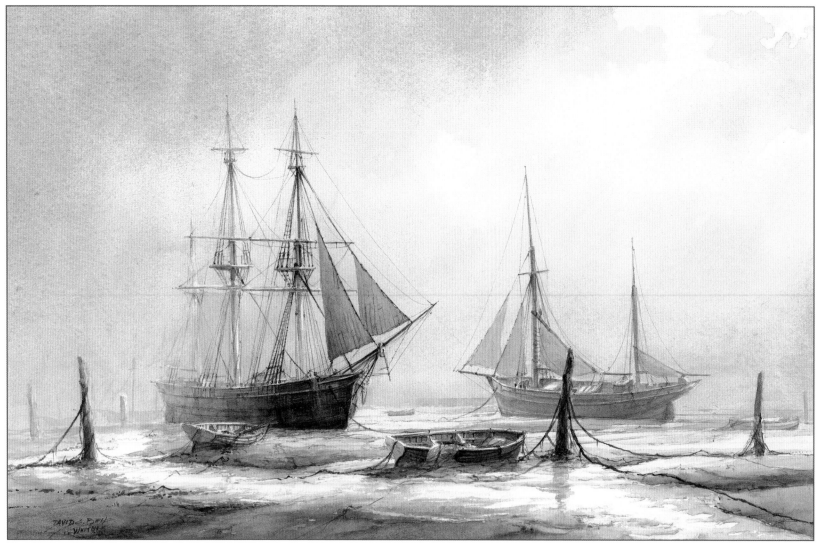

A Whitby harbour scene mid nineteenth-century

A very early and purely contrived scene and one I would rarely do these days. This working sketch, based on models, is the only painting I could find in my drawers to represent my first efforts at composition. Apart from yachts only the mud now remains.

wish to be in, all the way up this coast to the Bay of Islands and the North Cape. The ideal conditions at Cook's Beach, a popular holiday spot, enabled me to swim quite easily out to the anchorage, tucked up against 'Cook's Bluff,' and nearby, paddle in the fresh water from the Oyster River, at this time just a trickle.

Aware of another transit, this time the planet Mercury, Cook went ashore close to this freshwater stream, to observe the spectacle. On leaving Cook typically gave it a name - 'Mercury Bay'. Continuing on they then sailed around the peninsula into a large bay, calling it the Firth of Thames, and named the local village 'Thames', a similarity I failed to see, and an odd place to say the least, but on my visit, by chance, I found a rare 'Beaglehole' book on Pacific Explorers which gave me a great insight to those times. Charting this maze of islands Cook overlooked the big natural harbour of Waitemata, now the site of sprawling Auckland city. He continued on and painstakingly sailed around the North Cape and back south to Queen Charlotte Sound on South Island. This, throughout all his voyages was his preferred base. He now established that this new land comprised two islands and the water between them, at Banks' request, was called Cook Strait, probably the most recognised area relating to Cook in New Zealand.

Unfortunately, when I was there, it was heavily shrouded in fog so I was unable to witness all the beautiful bays and inlets that Cook would have been familiar with. Strangely, as Cook sailed along the west coast of South Island he never landed or even anchored anywhere because of his fear, and rightly so, of adverse winds and currents. From the Fjords in the south, which are spectacular, the coastline northward is amongst the strangest I've ever seen. There always seemed to be a mist on the horizon which made the sunset, which I never witnessed, appear earlier than it actually was. The mountains are so close to the coast that the

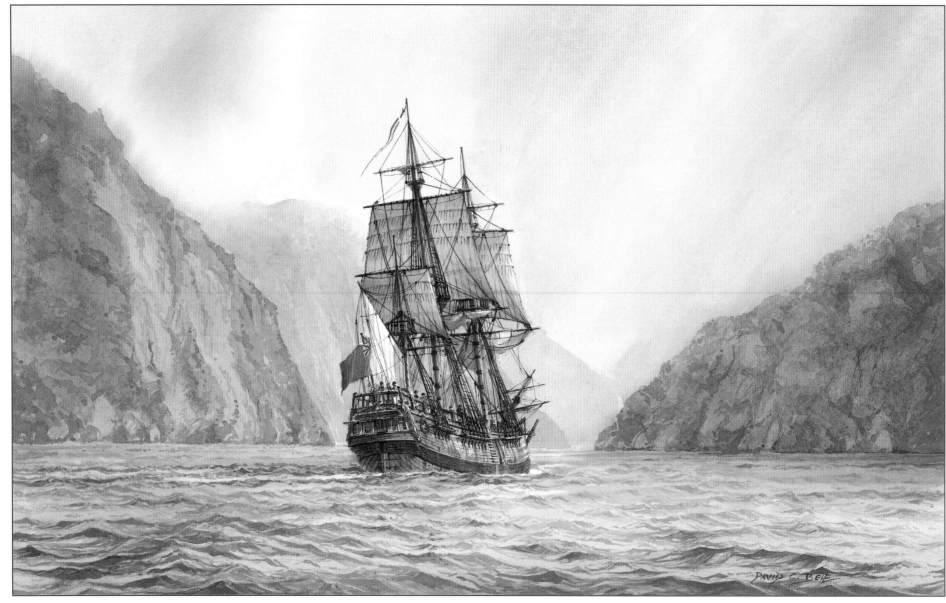

Endeavour - On the first voyage Cook made his first sighting of New Zealand halfway down the west coast of South Island. To the south the 'sounds' as they are known, are a spectacular part of this land's geography. But Cook found the terrain dangerous and inhospitable. From Haast near Fox's Glacier, northward there is little to offer the mariner until you reach the Cook Strait and, in contrast, that is where Cook established a base.

glacial and mountain streams wash many tropical trees immediately into the sea to be returned weathered and grey onto the almost equally grey, but sandy, beaches all the way from Haast Beach (aptly named the 'Edge of Wilderness') up to the port of Greytown. These masses of washed up and weathered trees are like stone sculptures laid out on the sand resembling an endless 'breakers yard' giving a surreal but enchanting feel to this area.

Onwards, and often against the local natives 'wishes', Cook charted much of the now established two islands of New Zealand, before beginning to head home to Britain via 'New Holland' and the Dutch East Indies. Cook was aware and appreciative of the knowledge that other European ships had acquired, often briefly, in these waters since the early sixteenth century. Especially the Dutch, who were always known as a leading maritime nation, with such navigators as Janszoon in the *Duyfken* 1605, Hartog in 1615, Abel Tasman in 1642 on the *Heemskerck,* and mostly, Jacob Roggeveen who in the *Arend* on a great voyage from Holland, sailed westward to Cape Horn, across the Pacific, visiting its islands and, abruptly, ending at Batavia.

The Dutch had become well established in Indonesia in the early seventeenth century and it was from what was known as Batavia (the Roman Empire's early name for the Netherlands) that the Dutch explored and from here where Tasman completed a tremendous voyage in 1642. From Batavia he sailed west across the Indian Ocean to Mauritius, back across the South Indian ocean to what is now named after him - Tasmania, and then on to New Zealand, then up to Fiji and finally west back to Batavia.

His foremost discovery was New Zealand, making a first sighting on the west coast of South Island. Like Cook on his voyages, he found the coast inhospitable and dangerous. Sailing north he did eventually anchor and attempted to land but met with such aggression from the Maori islanders resulting in fatalities in the landing party he left quickly and sailed away. It was perhaps this incident that deterred Tasman from exploring these new lands and thus prevented him from solving his eternal belief that New Zealand was part of the perceived 'southern continent'. He did sail to the top of North Island but did not attempt to land anywhere and continued to explore north to Fiji and Tonga. It is strange that, with the Dutch having established a base at Batavia that they did not explore and colonise Australia, New Zealand and the islands of the Pacific.

Back to Cook. With charts of the Dutch explorers, and heading for Tasmania, but way off course due to bad weather, they sighted the south east tip of Australia (then called New Holland) and sailed up the coast to find a safe inlet to enter and take shelter. This area was so rich in botanical species that Banks named it 'Botany Bay', which subsequently became famous for very different reasons !

*Endeavour's bowsprit
Drydock Hull 2003*

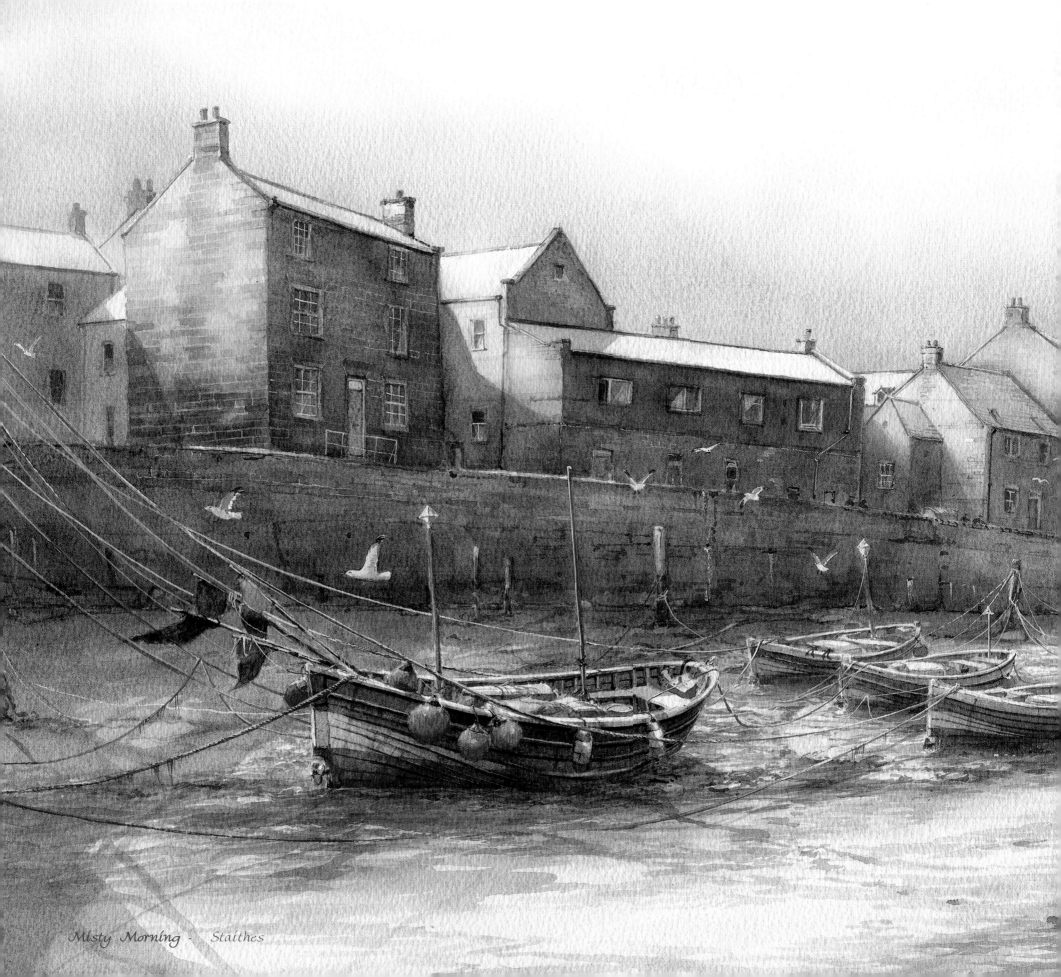

Misty Morning - Staithes

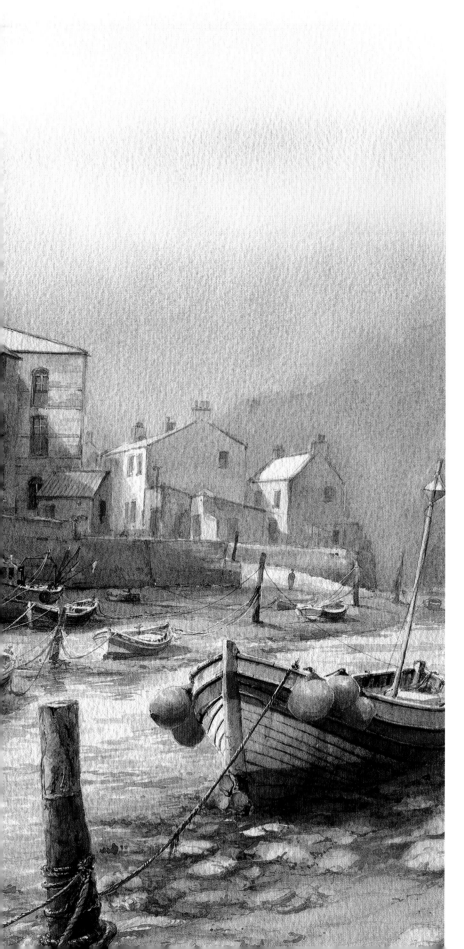

In 1974 on my second visit to Australia this time as a second mate, we arrived at this wonderful big bay, just to the south of Sydney with, at that time, discharging facilities for oil-tankers in the form of a buoy centrally placed in the big bay. Whilst moored to this buoy, the quickly deteriorating weather caused a series of calamities and a complete breakdown of the main engines. At incredible expense and with what seemed to be every tug in Australia, the ship was towed out of the bay up past Tapaia Heads and around the headland into Sydney harbour to make a long repair at a safe anchorage. Which resulted altogether in a very pleasant stay.

From there, after repairs, we sailed up the east coast, complete with the safety of a pilot, past the Great Barrier Reef, round Cape York peninsula turning west at Cape York, to, (if I remember correctly) Booby Island, and returned the pilot safely. Keeping south of Indonesia, we sailed on towards Brunei for a cargo of oil - more of that later. In 1770 by contrast, from Botany Bay, Cook and the *Endeavour* went northward, passing, unfortunately without entering and exploring the magnificent harbour of Sydney, which Cook called Port Jackson. Sailing north they charted the east coast and its islands for three weeks before entering the Great Barrier Reef, and, unfortunately grounding on this unforgiving coral. This near fatal mishap saw the *Endeavour* become stranded in early June, and only the frantic work of jettisoning ballast and cannons saved the day and saw the ship refloated. Now freed, she was partly repaired on the mainland coast, and seven weeks later sailed out with great caution and through the reef northward to find a suitable refuge, to beach and make further repairs to improve the ship's very poor condition. This place is now known as Cooktown.

Back at sea in August and after the considerable feat of sailing up Australia's eastern coast, the *Endeavour* rounded the north east tip of Australia, known as Cape York, and threaded its way through the islands of Indonesia. Stopping only at New Guinea, the ship progressed through

various passages, but with some haste for vital repairs, arriving in October at Batavia (now Jakarta). The Sunda straits are quite spectacular with the distinctive volcano 'Krakatoa' still smouldering away. An exclusion zone now exists to keep the corner-cutting mariner a safe distance away. The approaches to Jakarta, even now, are quite difficult, with many low lying islands making navigating hazardous for everyone. The city itself is at sea level, and an interesting place I'm sure, but the last place to which I would want to return. Looking back, my own passage from Cape York to Jakarta aboard *M.V. Leeds*, was, I reckon, one of the most interesting and unusual. The course was coast hugging as navigational aids were not up to scratch and visual sighting and basic position plotting was required. We passed close to many well known islands such as Bali and Timor, and with the usual flat blue seas and clear skies was quite idyllic, making it a rare pleasure to be on watch.

Back at Batavia, as Cook knew it, the head-quarters of the Dutch East Indies, the *Endeavour* was in a seriously poor condition, and docked for much needed repairs. Cook had always insisted, from the very outset, of improving and maintaining the health of his crew, particularly in avoiding 'scurvy' - the sailor's constant enemy. Testimony of this was that after this voyage's conclusion, nobody had died of scurvy. This he had done by organising the consumption of fresh fruit and vegetables and 'pickled cabbage'. A 'cleaned and aired ship' was to be the order of the day. Unfortunately Batavia saw the end of that, with its foul, stagnant, disease ridden and unhealthy atmosphere. Conditions it seems are little changed as, in 1973, a ship on which I was second mate, on a passage to Durban, stopped in Jakarta to take on fresh water, which turned out to be infected with typhoid. It resulted in much illness and a six week stay at the quarantine buoy in Singapore harbour, just a day's sailing away. A place I returned to visit recently and could not believe the considerable change, certainly in the amazing skyline of ultra-modern skyscrapers.

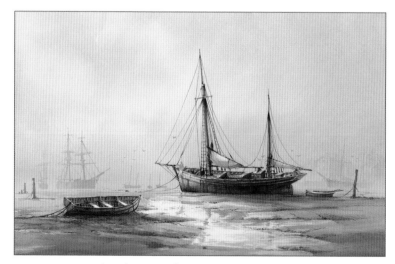

Beached Ketch Whitby c1880

Cook's crew faired far worse during the long weeks of repair with seven deaths and many of the crew taken ill. On leaving, the stop at Princes Island in the Sunda Straits, to take on water was nothing short of a disaster. The polluted water caused the deaths of more men on the passage to South Africa. A further twenty three died from illness among them Green the astronomer, Parkinson the artist, and Sporing the botanist. Second lieutenant Zachary Hicks was the last to die, his place being taken by the seaman Charles Clerke.

At Batavia the Dutch East India Company had proved to be a pain in the neck to Cook and equally so on their arrival in Cape Town. From here they eventually sailed in April to head north and home via St. Helena and Ascension Island. On leaving Table Bay they sailed past what is now Robben Island. The shipping company I sailed with, had the ignominious record of having one of its ships, the first ever I believe, to hit the island square on, on a passage to Cape Town, and become stranded. It was the ship *Kazimah* I believe, and having been successfully salvaged and towed to Japan for repairs, it returned to the briny some 100 feet longer!

Cook's voyage set a standard of navigation and exploration for the rest to follow though the voyage was not regarded as successful in achieving their object - an accurate observation of the Venus Transit or finding a southern landmass. But the charting of new lands, especially New Zealand, and part of Australia, and discovering islands of the Pacific was significant.

After nearly three years away from home the *Endeavour* finally anchored back in English waters on 13th July 1771.

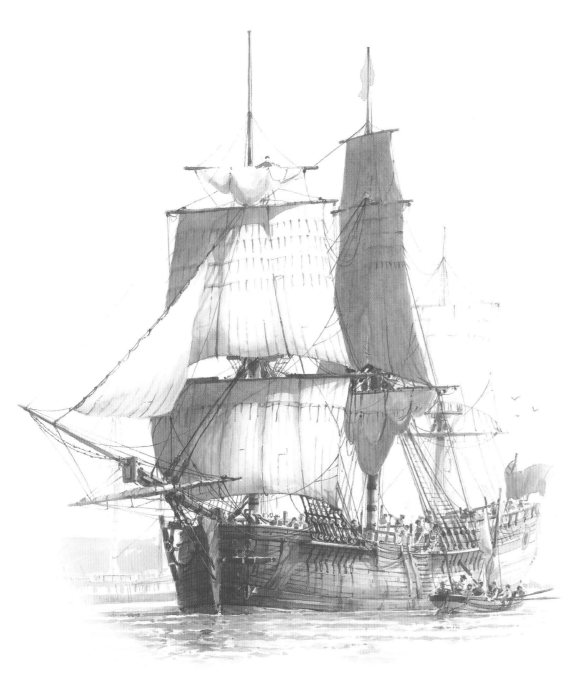

Cook's Second Voyage
Resolution & Adventure
July 1772 to July 1775

Following that monumental voyage and the achievements of charting New Zealand, part of Australia and much of the Pacific, Cook spent a year ashore, then prepared for his second voyage. His achievements earned him the title of Commander and this time he opted for safety in numbers. He took charge of the *Resolution,* bigger than the *Endeavour* at 460 tons, and Tobias Furneaux, an experienced sailor who had sailed with Captain Wallis in 1766, took command of the *Adventure.* A midshipman by the name of George Vancouver was also in the crew. Both boats were Whitby built colliers and were converted and fitted out for the expedition.

As all mariners know, latitude at sea can be found with a sextant and astronomical tables quite accurately. Longitude, however, is another matter. Basically, with a nautical almanac, if you know what the time at the Greenwich meridian is, and you are east or west of this line and also know the time, then the time difference, which is one hour to every fifteen degrees can be used to calculate longitude. If you have an accurate timepiece that is. This problem of calculation was greatly overcome by the John Harrison time pieces, or marine chronometers, which he had made and developed over the previous 40 years prior to this voyage. These were accurate and reliable enough to be used at sea. This 'longitude by chronometer' as it was called at sea, was a daily task of the navigator, and having a chronometer was essential but also knowing the daily error of it was equally vital. But even so, when I calculated noon position at sea it was accepted that the position was never

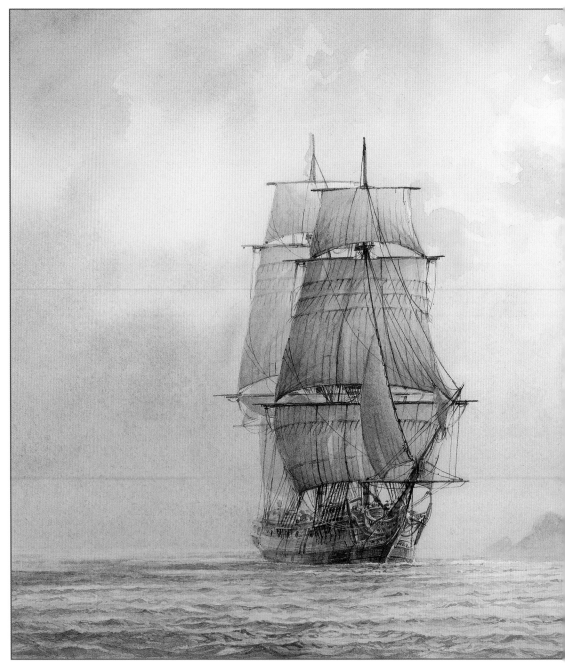

Resolution off Tahiti

In June 1773, they went into the Pacific in search of new lands. They also visited established islands - the 'Friendly Islands' now known as Tonga, and revisited Tahiti and the Society Islands. In October the ships headed back to New Zealand. Whilst at Huahne in Tahiti, Furneaux in the **Adventure** was politely pestered and requested to take 'Omai,' an islander, on board with him. He did so, thus Omai was the first South Sea Islander to be seen in England and was to be returned to Tahiti on Cook's Third Voyage. Touching base at Tahiti and receiving another warm and friendly welcome, he headed out to sea, again sighting and charting the New Hebrides.

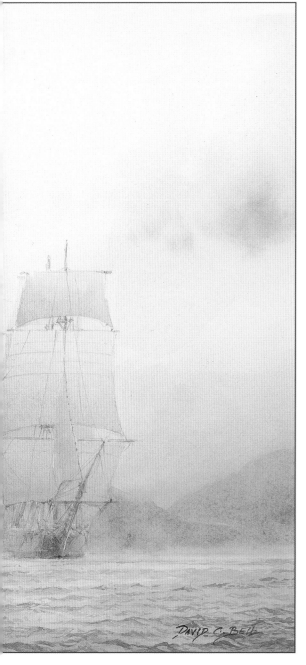

accurate to within maybe five miles, often much more. Stellar fixes were much more reliable.

However, accurate timepieces, with a copy of Harrison's H4 clock by the clockmaker Kendall aboard, enabled longitude to be calculated more accurately and, apart from knowing where you were, meant that more accurate charts could be made and thus the existence of a southern landmass, if it did exist, was nearer to being determined and possibly charted. One ship on which I sailed - a modern Japanese built ship with up to date navigational aids had a 'quartz' chronometer in the chartroom. In six months it had no accruing daily error whatsoever, such was the quality of this instrument. Cook had no such luxury.

After the first voyage, Banks' recounting of his exploits in social circles made him the man of the time, far ahead of Cook. So, with wind of the next voyage, the naturalist Banks, and his even bigger entourage, were as keen as ever to sail to the other side of the world. However, questioning the standard of accommodation on the ship, in fact dictating the alterations to be made for themselves, which weren't going to happen, they refused to go, a regrettable loss to Cook. So in not complying with the Admiralty, they were simply replaced by others, in this case the German botanists Johann Forster and his son Georg. The artist William Hodges was also signed on and proved to be adept and capable of producing many fine paintings of this voyage, some of which can be seen at Greenwich today. So, one year after returning from the first voyage, Cook and his astronomers, scientists and artists, once again set forth, leaving Plymouth, on 13th July 1772.

As on the first voyage Cook sailed southward to South Africa and then further south, basically to find, or not, as was the case, the elusive southern landmass. The *Resolution* crossed the Antarctic Circle in January at 66° 33' South, the first ship to do so, but found nothing except 'ice-islands'.

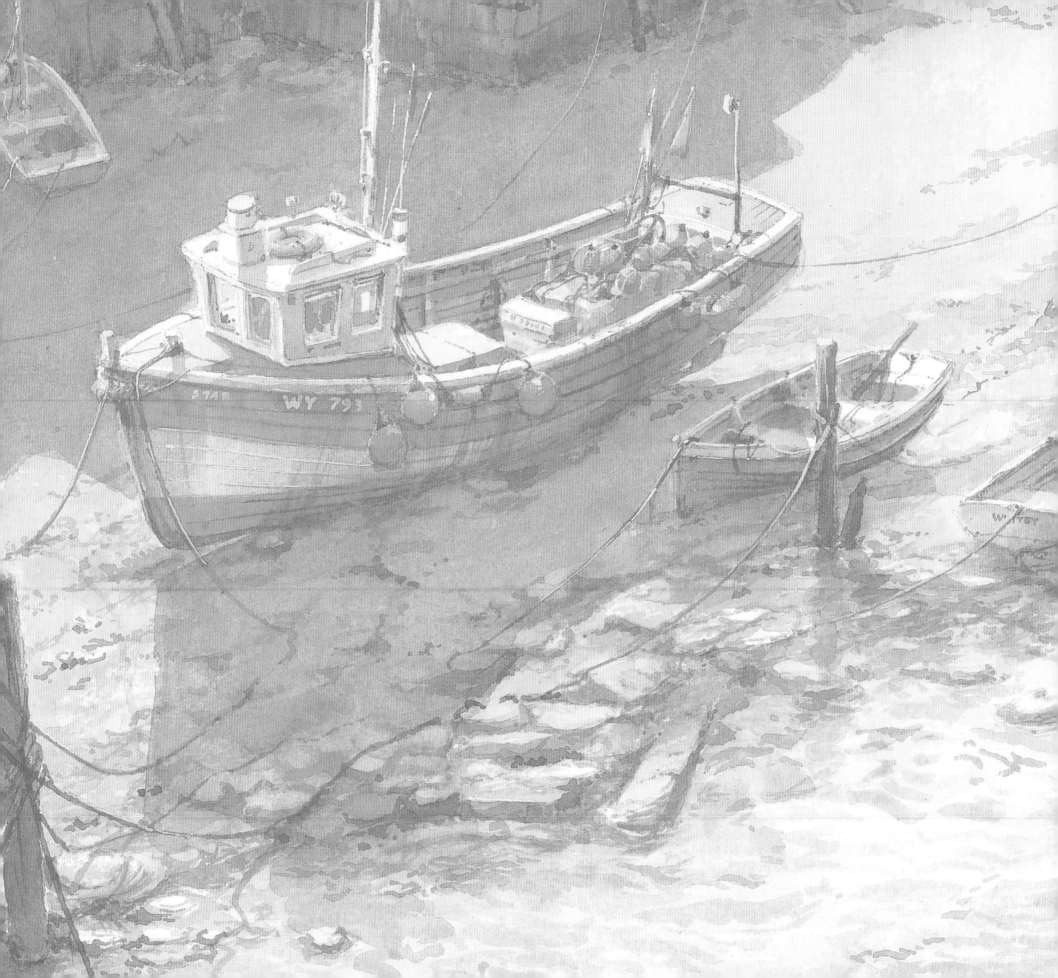

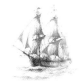

Though as they discovered, these were a great source of drinking water. Though unknowingly he was very close to the Antarctic mainland, Cook turned back and meandered east across the Indian Ocean towards New Zealand. He reached the South Island and after such a long haul at sea decided this time to enter Dusky Cove and find an anchorage to recover and as always explore the new lands. Three weeks later and back at Queen Charlotte Sound Cook quickly replenished the ship and rejoined the *Adventure* from which he had previously been separated. In June 1773, they went into the Pacific in search of new lands and also visited established islands - the 'Friendly Islands' now known as Tonga, and revisited Tahiti and the Society Islands. In October the ships headed back to New Zealand, but unfortunately again became separated in a storm; Furneaux in the *Adventure* did eventually sail for Cape Horn, all the time searching for land venturing as far south as 61 degrees, but concluded, as had Cook, tha it was not to be found and so continued home, via Cape Town, arriving England 14th July 1774. Whilst at Huahne, Tahiti, Furneaux in the *Adventure* was politely pestered and requested to take Omai an islander on board with him. He did so, thus Omai was the first South Sea Islander to be seen in England and was to be returned to Tahiti on Cook's Third Voyage.

Back in November 1773 after several weeks in New Zealand Cook sailed south to the Antarctic Circle only to be forced back by cold and ice again. Resolute as ever, he made a final attempt to find the southern landmass this time reaching 71° 10' south, before encountering pack-ice and heading back north. It was the midshipman George Vancouver who was reputed to be on the bowsprit at that point and claimed the honour of being the furthest south. There are few, if any, islands between New Zealand and South America, in those high latitudes, as Cook discovered. However he was not far from the huge ice-fields of the Antarctic - a great deal of which was explored later in the early eighteenth century by Ross, Weddel and others. Of course, the ship was

not in any way physically appropriate for these cold, harsh waters, and prudence, or fear, proved fateful in keeping him out. For he determined, rightly, that the Antarctic was under snow and ice, and going further south was pointless. Still keen to explore, Cook travelled tirelessly over the mostly southern Pacific until reaching the isolated Easter Islands, a barren inhospitable land - with its still awesome, inexplicable, huge stone idols. After visiting these islands, Cook found the Marquesas Islands, originally fdisscovered by Mendana back in 1595. Touching base at Tahiti and receiving another warm and friendly welcome, he headed out to sea, again sailing past Niue (Savage Island) on to Tonga and still further west sighting and charting the New Hebrides (now Vanuatu). These islands are inhabited by the 'Melanesian' race, as opposed to the much more friendly Polynesians. Just south of here he discovered and named New Caledonia then south to Norfolk Island. The *Resolution* continued to sail in an arc back to New Zealand and anchored in Queen Charlotte Sound, an idyllic, sheltered anchorage in the north part of the South Island, in October 1774.

Not to put Cook on too high a pedestal, it was back here that 'longitude' was double checked with the new time-pieces and Cook was astonished to find he and his charts were some 40 miles too far east! The Kendall clock was a great success and was only twenty minutes out, that is the accumulated error, in a year at sea.

With no sign of Furneaux and the *Adventure*, whom he knew had already been there, Cook himself decided to return home and sailed east across the Pacific. By the end of December he had reached the tip of South America and proceeded into the Atlantic. Still seeking new lands and almost completing his circumnavigation they then discovered the islands of South Georgia (to be recalled in a later chapter with Shackleton) and the tiny South Sandwich group of islands. At this point he finally dispelled any further idea that a southern landmass existed at all.

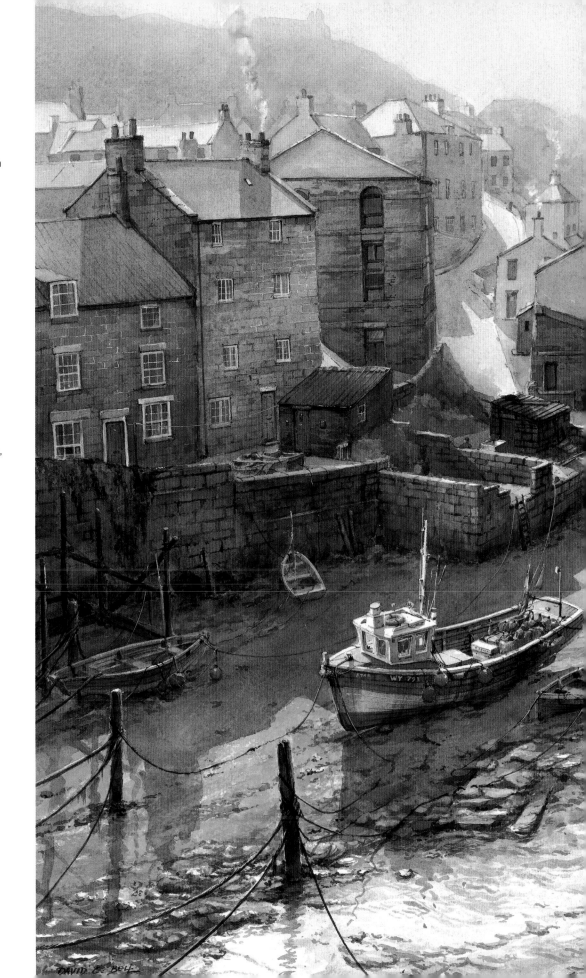

I was fortunate that at eighteen I had already crossed every line of longitude and had sailed across the endless blue oceans of the Atlantic, Indian and Pacific, in the safety of big motorised, and occasionally, air-conditioned ships. I had little awareness then of whose wake I may have crossed that had been left centuries before, until that is, I left the sea and started painting maritime subjects. Only then did I begin to truly acknowledge the pioneering mariners who had sailed before me and whose journeys I was trying to depict. It was not until decades later, as I viewed the Pacific Ocean from Cape Reinga, the northern tip of North Island, New Zealand, on a clear, cloudless day and observed a tiny boat navigating the turbulent ocean, that I was once again struck by the vastness of the oceans and the vulnerability of the vessels upon it.

Since July 1772 Cook and the *Resolution* had circumnavigated the earth, this time eastwards, had crossed the Antarctic Circle and charted many islands of the Pacific. Sailing back via Cape Town, St. Helena, Ascension Island and Brazil they arrived home at Portsmouth 30th July 1775 with the loss of only four men. In those three years the sheer endurance of staying at sea so long, the standard of navigation and the resulting collection of geographical materials makes this voyage, perhaps, Cook's most accomplished.

Simply called **Staithes**, *this painting opposite was one of the first watercolours I undertook here some years ago. The road on the north side offers plenty of shelter and solitude apart from the incessant racket from the thousands of gulls on the cliffs above. Painters beware!*

The **Resolution**, *at Sheerness, converted to Navy fashion but still maintains the bluff bows and sturdy shape of a collier.*

145

'RESOLUTION
SHEERNESS 1770

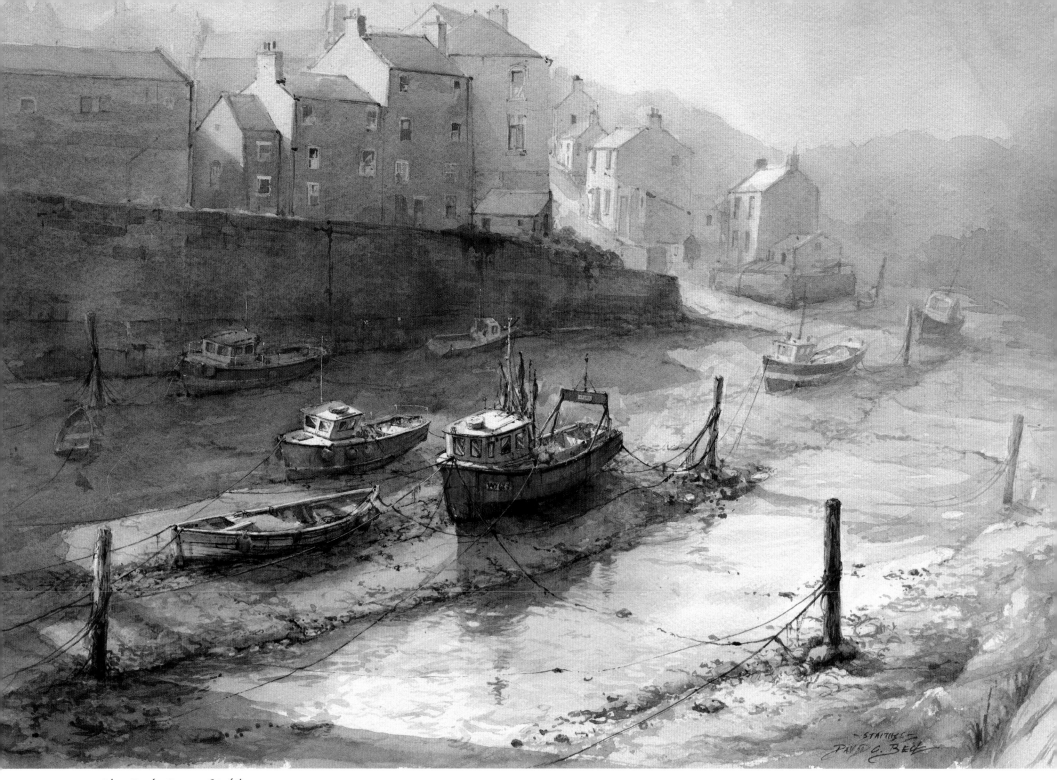

The Red Boat Staithes

The tide will always flow and daily fill this part of the beck, but the small fishing boats have fast declined in numbers. But their is still a unique and individual feel to this place that will always tempt me back.

46

Cook's Third Voyage
Resolution & Discovery
July 1776 to October 1780

As the American revolution began in 1775 and the rebellion against British rule started, the quest for a 'north-west passage' - a passage between the north Atlantic and Pacific, hopefully north of North America - resurfaced and gave impetus to prepare a new expedition, which would also allow the return of Omai to Tahiti.

After what proved a less than perfect refit, the *Resolution* was to head the expedition once more. Again, the Admiralty acquired, as consort for the *Resolution,* another slightly smaller Whitby collier, and named her *Discovery.* The seasoned sailor Charles Clerke was promoted to command the *Discovery,* and Cook, now a post-captain, in command of the *Resolution* left Plymouth in July 1776, the *Discovery* a month later.

It was a long haul tacking down to Cape Town via Brazil using the prevailing winds. Crossing the South Atlantic the *Resolution* arrived mid-October and was eventually joined by the *Discovery*. Here at Cape Town they watered and took further stores on for an expected two year voyage. Already, and ominously, they spent some time repairing their very leaky ships. This was the first of many repairs made not because of premature deterioration, but an inherent condition resulting from the slack Admiralty dockyards which eventually contributed greatly to the demise of this voyage. By December they were ready to leave and sailed across the Southern Indian Ocean to New Zealand. A stop was made at Kerguelen Island, a cold and mountainous Island discovered and named by the French explorer of the same name. Then on to Tasmania,

a place Cook had intended to visit on his first voyage in 1770, but, owing to bad weather, missed it and sighted Australia first.

So with some re-adjustment he headed for and arrived at Adventure Bay on the south-east tip of this enormous island. But after a short stay, and still unaware that Tasmania was an island as well, sailed for New Zealand. It was not until February 1777 that they arrived and anchored at the familiar base at Queen Charlotte Sound where they spent a fortnight's respite before setting off for a tour of the South Pacific, of course already explored. They headed for Tahiti, but were forced slightly north due to adverse weather, to the Cook Islands. From there they visited Tonga, to water and provision again. They eventually reached Tahiti and an eventful three month stay.

A constant problem for Cook and his crew was the native's persistent thieving and pilfering of anything and everything. This occurred throughout all his visits to the Pacific Islands. It's relevant here to mention the alarming fact that the Tongan chiefs, whilst entertaining Cook and his crew, had conspired to murder them in their entirety and 'acquire' the ships and their contents. For whatever reason the plot failed at the last moment.

The collection of data and observations about the islanders was thorough but did not reveal the deeper culture of this society that the Europeans had 'physically' seen but did not understand. Here on the small island of Huahine, Omai was reunited with his people. Cook visited another idyllic Tahitian island of Raiatea before leaving these islands for the last time. For the first time Cook sailed almost due north, crossing the equator, into the North Pacific ocean and proceeded to

search for the north-west passage. During this voyage they discovered and stayed at an uninhabited island which he aptly named Christmas Island, being that time of year, and now called Kiritimati.
Sailing to 20 degrees north he sighted the islands of Kauai and Nihau, and named them the Sandwich Islands.

These two most western islands of what is now the Hawaiian Islands, are the tips of the world's largest volcanoes, forming an archipelago of over a hundred islands. As a cadet on my first crossing of the Pacific en route to Japan from the U.S. we sailed through them, and like Cook and his men must have been, were amazed at these impressive green clad mountain islands spread out like gems in a vast ocean under, what always seemed to be, a never ending blue sky. Here in the Hawaiian Islands so far north, and strangely to Cook, inhabited by Polynesians, the welcome was warm and friendly. He now went east and slightly north in search of the north-west passage but again, dogged by inclement weather, was forced to make a landfall near Yaquina Bay on the Oregon coast of North America. This was about four degrees south of what he was looking for - the Strait of Juan de Fuca, a possible north-west passage, which is in fact the waterway to Seattle and separates the U.S.A. from Canada. From this southern landmark he sailed north into unceasingly foul weather with constant storms and fog. Seeking shelter he found, and named, King George's Sound, our modern day Nootka Sound, on the mid-western side of what is now Vancouver Island.

Repaired, he then proceeded north west, in his still leaky ships, well clear of the complex Alexander Archipelago, to again make repairs this time in Prince William Sound, a place which is tucked up below the rugged Chugach Mountains of southern Alaska. He visited what is now Cook Inlet and the approaches to the town of Anchorage, before turning back. By way of the Alaskan Peninsula, and along the Aleutian Islands,

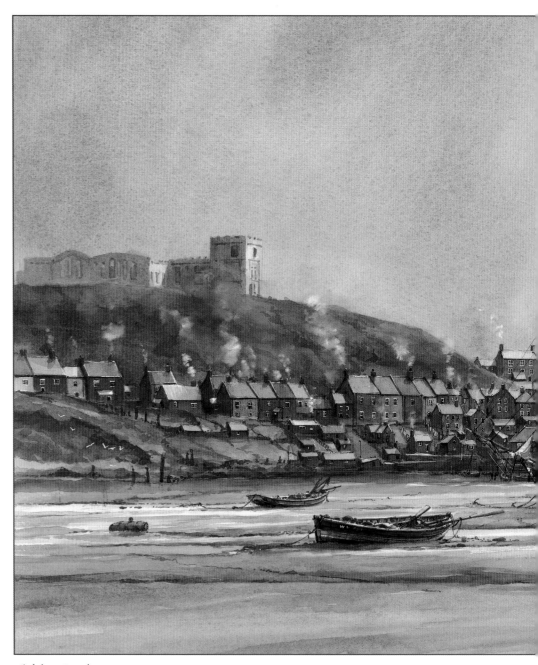

Whitby Harbour c1860
It is worth visiting Whitby just to see St Mary's, the church in the background, for that alone.

round the volcanic Unalaska Island and touching the far eastern Russian side, he made his way to the Bering Sea and through the Bering Straits. This passage took them over the Arctic Circle, and several weeks sailing took them to 70° 44' north before being stopped by ice. Undeterred, and with undiminished resolve Cook headed west through the Chukchi Sea, over northern Siberia as far as longitude 179° west, before ice halted their endeavours. Once more faced with the same conditions as in the Antarctic - intense cold, pack ice and no way forward, he sailed back to Unalaska Island again, where he traded and socialised with the local Inuits and Russian traders. Undoubtedly he would have been informed by the locals of the futility of his quest, but orders are orders and a failed attempt would be the least the Admiralty would expect of Cook. So he decided at this time to return to the Hawaiian Islands, rest and provision before making a further attempt the following summer. En route south the ships were separated in a storm, but the *Resolution* with Cook arrived at Hawaii for the first time, and made repairs and traded as normal. They found a suitable anchorage at Kealeakue Bay to make considerable repairs, eventually being joined by the *Discovery*. Discovering and charting islands was one thing, as was observing and collecting scientific data but the more personal if not spiritual understanding of the islander's culture and beliefs was quite another. Though Cook was greeted ecstatically and entertained with rituals and offered many gifts, what he did not understand, as in Tonga, was his reverence as a special 'being' almost God like, in this case the god 'Lono'.

The Hawaiians revered Lono as a god who visited rarely and went over the top with gifts and gratitude for this visit by Cook - a serious welcome in anticipation of his imminent departure. Cook heeded this and left to continue surveying and find an alternative anchorage. Unfortunately he ran straight into a gale and was forced to return to Kealaekue Bay for repairs. This was not an expected nor welcome sight for the islanders who had not anticipated the return of 'Lono' so soon.

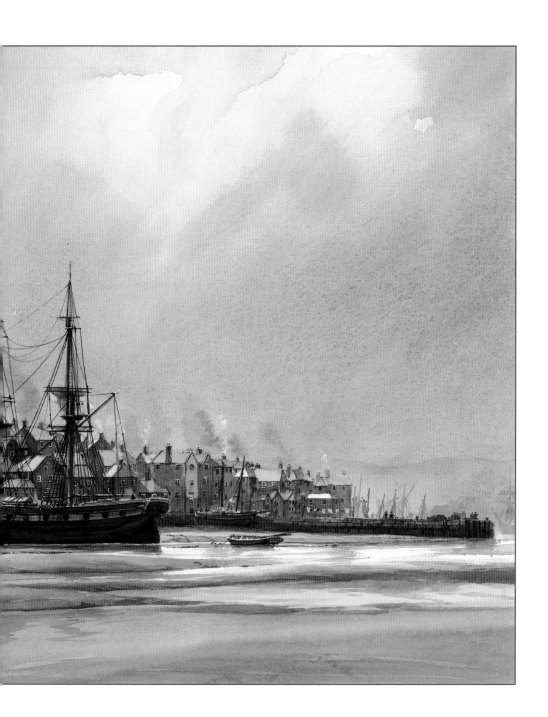

Friendliness was changed to hostility and the constant thieving continued. It was in the end the theft of a cutter that led Cook himself, who was far from well, to take an escort of armed marines ashore and demand the 'King' as hostage until the cutter was returned. In hindsight an ill-advised and fateful manoeuvre. Maybe the long years of exploration had made Cook less effective and less tolerant in dealing with these problems. The native's recent reverence for Cook as a special 'being' was to be dissipated in a few torrid moments as the fracas developed into a murderous squabble and Cook and four marines died in the ensuing fight.

This unfortunate combination of events saw the tragic and pointless death of a great sailor. Following Hawaiian custom, Cook was burnt and cannibalised, his body dismembered and distributed as revered souvenirs to other native chiefs. Clerke, who now took command, implored the Hawaiians' to return Cook's remains, some of which were and left in Kealaekue Bay.

Cook's first voyage had been mainly one of botanical and navigational purposes, assisted by the highly regarded Joseph Banks and with Daniel Solander aboard, along with astronomer Charles Green. Their achievements were judged as a consequence of this venture. His second and most successful voyage also had similar purposes and also an anthropological quest. Indeed Cook did discover, meet and observe many people. The third was a repeat of his earlier voyages with the exception of the fruitless attempt to find the north-west passage.

The European colonisation of foreign lands from the early sixteenth century saw violence and domination as the principal weapons in achieving its goals - the exploitation for imperial expansion. However Cook's first objective had always been a natural and humanitarian exploration and he considered the death of even a small number of

islanders during the three voyages, whilst almost inevitable, to be too many. He simply wanted to explore and not exploit. With his experience in his encounters with islanders, as tolerant and humane as he was, he realised his crew and ship would have to come first; he had hostile and friendly receptions on many occasions and would take any action that was deemed appropriate at the time. In taking his last long, hard voyage he lost the edge that made him unique, as it were.

It was tragic that he himself went to resolve the problem of the loss of

My first painting of 'Staithes featured below was completed some years ago. This tranquil scene was where my interest in Cook started, and opposite the dry dock scene of Endeavour marks where, unless it returns, my final artistic connection with Cook's ships will end.

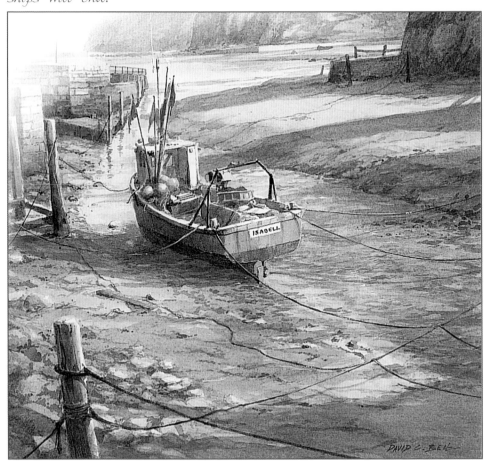

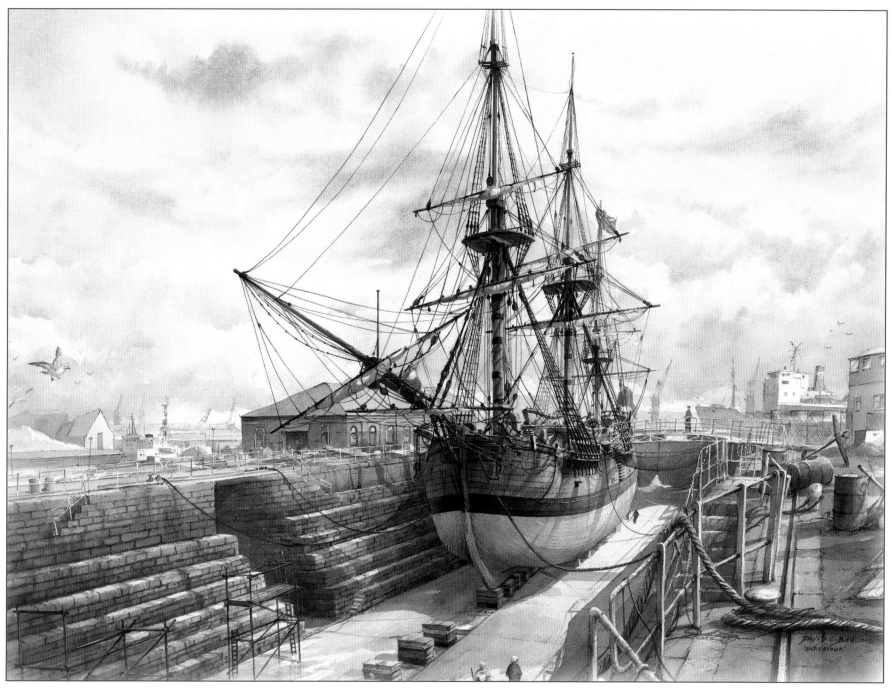

The **Endeavour** in drydock is a scene made for me. Painting it was a big task that turned out well. Dock scenes, of which there are several in the book are actually, with considerable patience, straightforward tasks, as nothing, apart from the sun, ever moves.

a small boat against the uncertain reaction of a natural owner defending his land. His levels of tolerance were simply worn down. Along with a culmination of continuous hardships and pressures of leading and making the right decisions, his miscalculation of the Hawaiians' reaction to his disapproval of their persistent thieving was fatal. The islanders assumed what was on their territory was theirs.

So Cook went from a pinnacle of greatness to a ghastly and ignominious end as the remains of this great sailor, navigator and surveyor were committed to the waters of Kealaekue Bay. Had he survived and returned to London he may well have received the celebrations and rewards of the society of his own time. As it was his memory and his achievements faded somewhat to be revived in time by later historians. Indeed reading from historians of Pacific exploration, a dilemma for Cook in the exploration and claiming of lands for Britain was an edict he was to abide by and stating that 'natives of discovered lands were its natural owners, and Europeans had no right to occupy or harm them if they defended their lands'. Of course this was not what was practically presented to him or his ships.

After Cook's death Charles Clerke, his second in command, a man devoted to Cook, took command of the *Resolution* and Gore, the first lieutenant on the *Resolution*, took command of the *Discovery*. Deeply saddened as they must have been, they sailed to the Arctic in what were constantly becoming unseaworthy ships in a pointless duty, in a final attempt to find a sea route to the Atlantic. What a turn-around for history it would have been if Clerke had succeeded. On returning to Russian shores in August 1779 Clerke died from the persistent tuberculosis that he suffered from and probably had incubated from the outset. Gore, the lieutenant, succeeded him and proceeded to navigate the ships home to England. At last, on a long passage via Macao, the

Sunda Straits, South Africa and, strangely, the Orkneys, they sailed down the North Sea, past Whitby, where it all began, and anchored in the Thames on 4th October 1780. A momentous voyage of four years and three months.

With Cook's high standards of navigation and seamanship, he was a hard act to follow for anyone. But on board the *Discovery* he had, as already mentioned, the midshipman George Vancouver, who had also sailed with Cook on the *Resolution* on the second voyage. More about him later. Also aboard the *Resolution* was a young sailing master and fine navigator by the name of William Bligh.

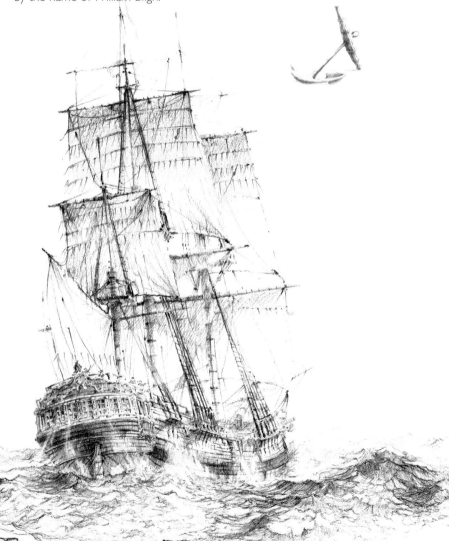

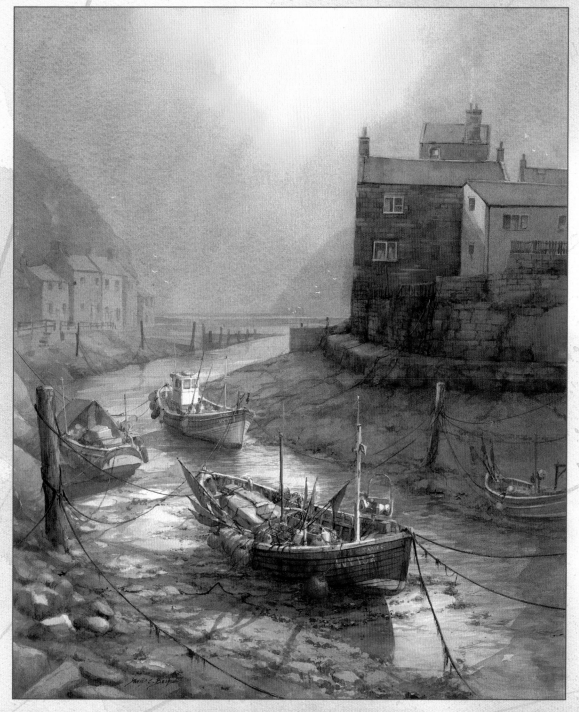

Winter Sunshine
My last picture of Staithes.
A familiar morning scene at Staithes - quiet, misty and atmospheric.

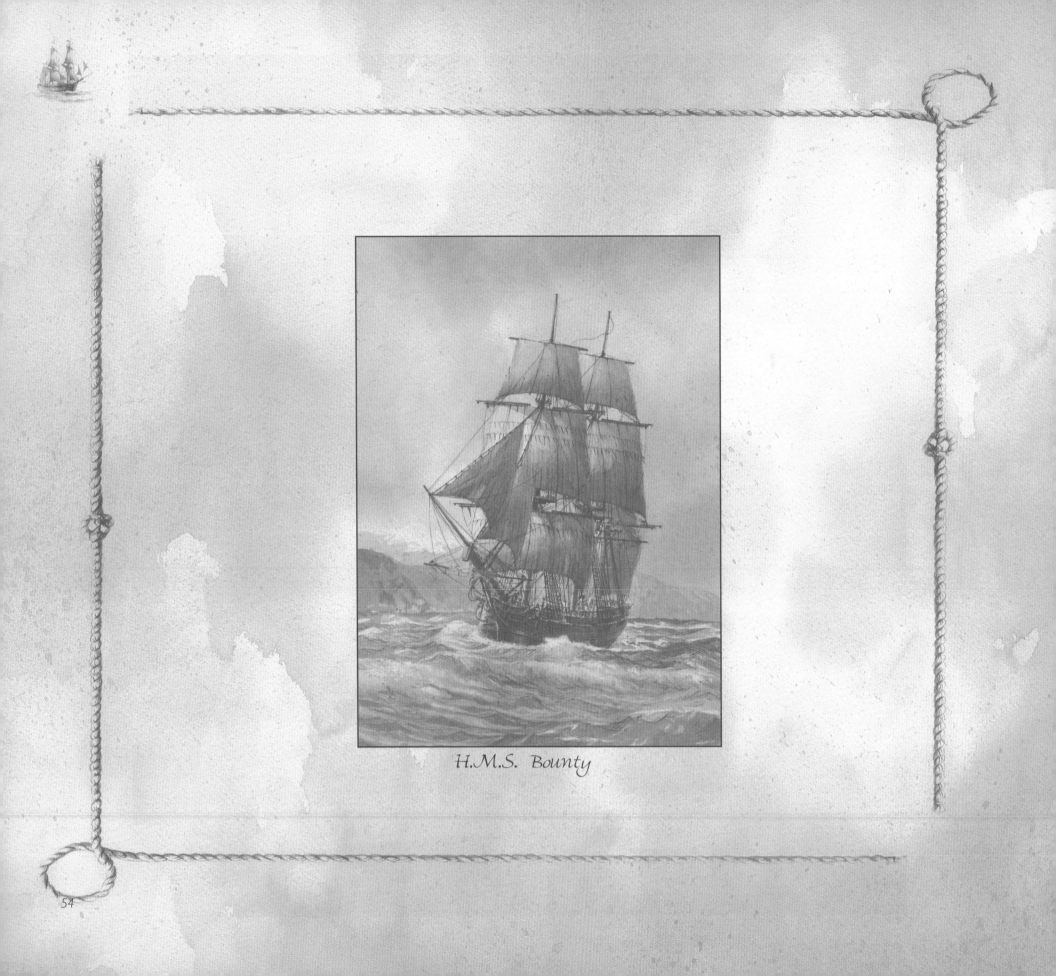

H.M.S. Bounty

William Bligh

& H.M.S. Bounty

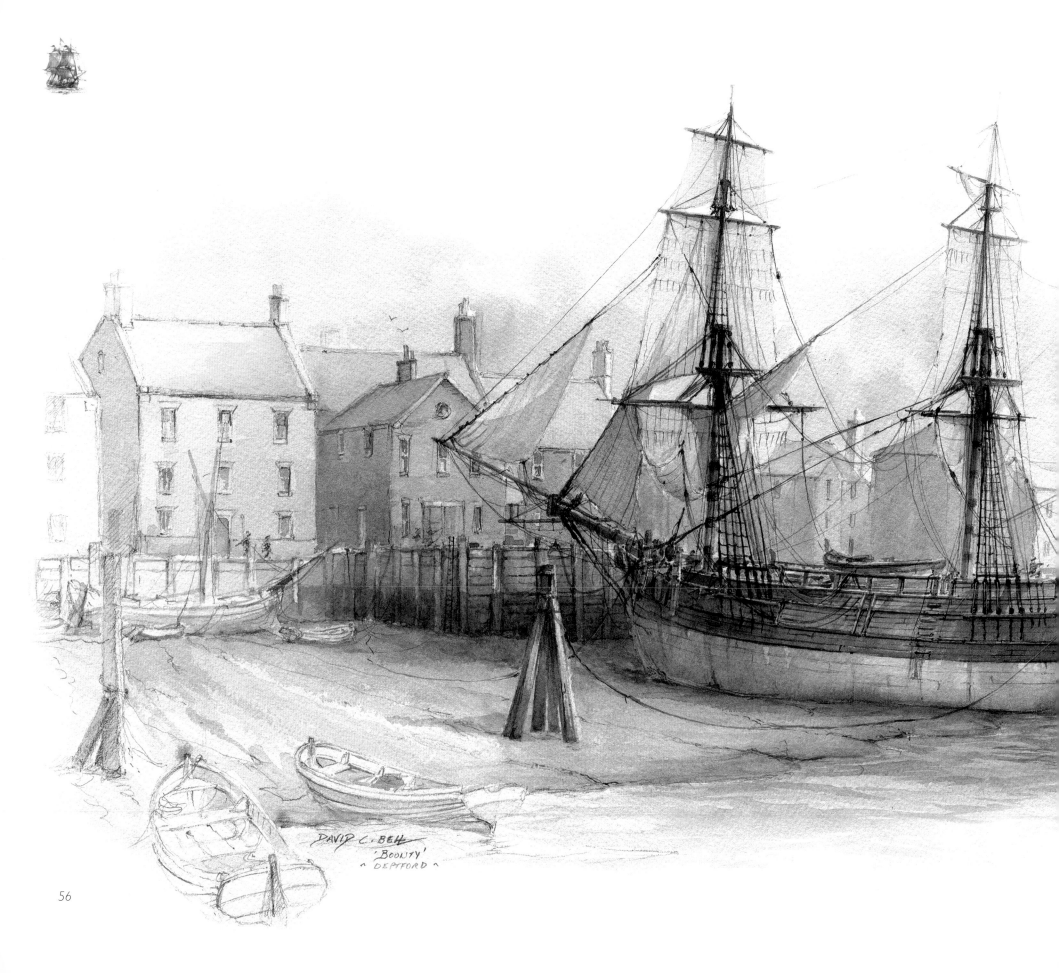

DAVID C. BELL
'BOUNTY'
^ DEPTFORD ^

William Bligh 1754 - 1817

&

The Voyage of H.M.S. Bounty

Bligh was a Cornishman from an ancestral wealth of men who served king and country. Though his mother died when he was only 16, his father Francis Bligh, a Customs officer in Plymouth, educated him well and the navy was where his father saw his future. But Plymouth, itself an established naval port, would still have been a strong influence on him in his early years. He had exceptional qualities in mathematics and sciences and, like Cook before him, was to become a very competent navigator and cartographer, all of which would help establish his career.

In 1770 Bligh joined the navy at the age of sixteen. His first ship was a ten gun sloop H.M.S. *Hunter*, and though technically on board as an able seaman, because of a surfeit of 'allowable' midshipmen on board, this was the start of six years sea-going experience before meeting Cook. Abilities at sea are soon noticed (deficiencies even more so), and Bligh's technical skills were exceptional. 'Strive to Excel' is a great school motto and Bligh strove for praise and promotion and his merits would have been known to the First Sea Lord, at that time the Earl of Sandwich, and give reason for his approval to Cook's third voyage in the *Resolution*. The accounts and events of Cook's death and the aftermath have been given in the previous chapter when Lieutenant Charles Clerke, though unwell, took command, but gave Bligh, the sailing master and fine navigator, the task of navigating a route in the Arctic and ultimately a way home. Though on Clerke's death Gore then took command of the *Discovery* and King took command of *Resolution*.

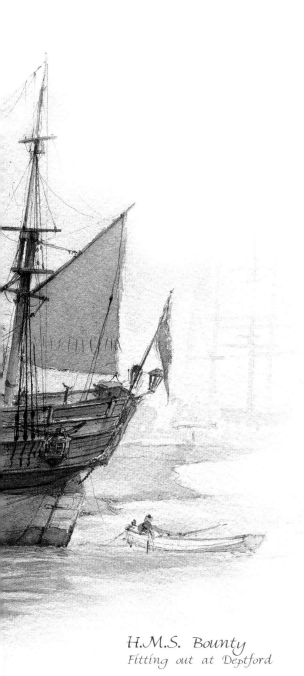

H.M.S. Bounty
Fitting out at Deptford

On returning home to England in 1780 after 4 years and 3 months, the nation was at war with America, who was fighting for independence, and with revolutionary France about to explode, this great voyage, let alone Bligh's sailing feats, were totally eclipsed by these events. Personal achievements were down-graded in the wake of a national problem.

Though disappointed Bligh's career in the navy progressed with his appointment as master in *H.M.S. Belle Poule*, until time and experience gave him promotion to lieutenant (6th) of H.M.S. *Cambridge*. A lull in hostilities came with the Treaty of Amiens in 1783 and many Royal Navy ships, their officers and crew were 'laid up', though in Bligh's case still on half-pay. He had married in 1781 and used his relationship with his wife's uncle, a Duncan Campbell, to gain employment as Captain on his fleet of merchant ships.

It was at this time on one ship the *Britannia* that he employed a 'volunteer' A.B. by the name of Fletcher Christian. Though from a wealthy family and well educated Christian knew of the Campbells and their ships and served in a number of vessels until meeting Bligh and made two voyages under Bligh to the West Indies He obviously had a sound friendship with Bligh and impressed him well, being promoted to second mate on the *Britannia*'s second voyage. He also joined the Royal Navy as an able-bodied seaman.

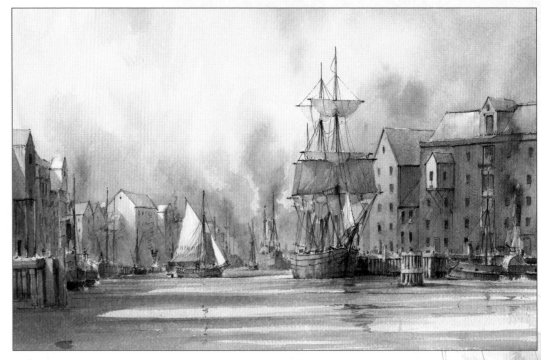

A scene of the River Hull c1880.

The mouth of this small river flows into the Humber and is just behind my viewpoint. The shipping and warehouses go back inland on both sides for a mile or more. The Bethia would have been built in one of the many small drydocks that existed on the riverside a hundred years before this scene, and some still do. At Art College, which was not far from here, I spent many hours recording scenes that still had lots of activity and interest. These days it's only the rise and fall of the tide that moves.

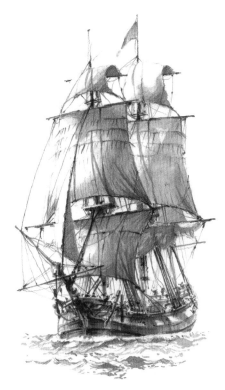

It was that man again, Sir Joseph Banks, now president of the R.S., and with commercial interest in the West Indies who was to determine the next phase of Bligh's life. The botanist Banks knew of the bread-fruit trees, indigenous to Tahiti, from his voyage with Cook on the *Endeavour* in 1769. He had in mind to transport a large number of young bread-fruit trees to the Caribbean to be grown as a staple food for the plantation slaves. He thus approached King George III for a proposed voyage to Tahiti to carry out his plans. Bank's was influential in appointing Bligh, now an experienced captain and navigator, to take command of the *Bethia,* renamed *H.M.S. Bounty* for the voyage. An appropriate name, for the 'reward' from Tahiti would be a cargo of, possibly, considerable wealth and importance. But years later this was all to prove 'fruitless'. For in sacrificing space on board for the bread-fruit trees no marines were taken on board which ultimately led to the ship's mutiny. The R.N. ships always had marines for the ships' and officers' security and the enforcement of discipline. But not in this case. Also Bligh was appointed by the Admiralty as Lieutenant, senior to the other lieutenants, but only just, and not with the clout of a Captain or Commander. Out at sea let alone in the middle of an ocean on the other side of the world, this was, as it turned out to be, a precarious and extremely exploitable position to be in.

The River Hull that flows through the old part of the City centre and the immediate surrounds was at my time at Trinity House Navigation School and at Hull Art College a paradise for painting and drawing and a few of my aged endeavours are reproduced here. Now the River Hull and much of its environs have been 'cleansed' and don't quite have the same appeal to be painted, certainly not to me, as it used to. The *Bounty*'s small at about 189 feet long and 25 foot beam, was, after conversions, to become effectively a 'floating greenhouse'. The plants were to be nurtured by a botanist from Kew, a David Nelson, who had sailed with Cook on his third Pacific voyage.

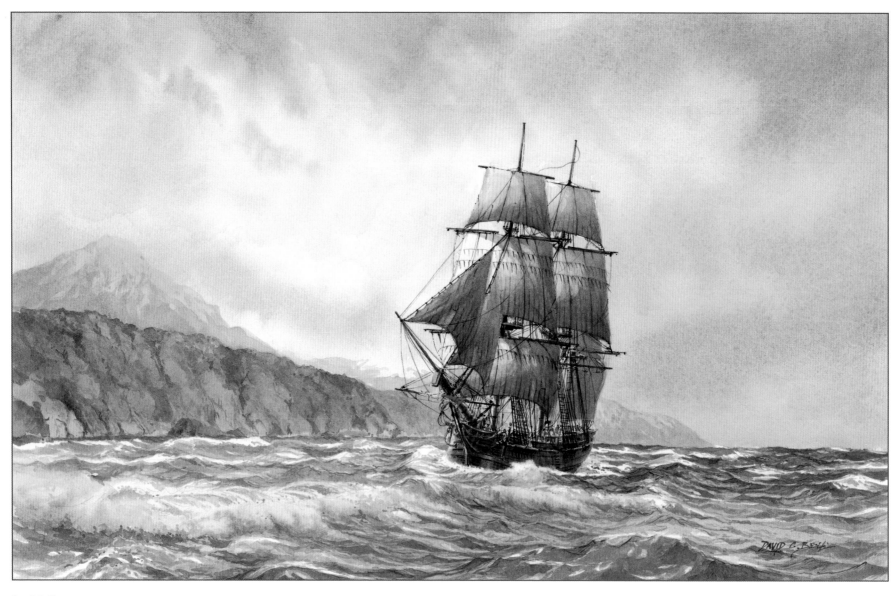

H.M.S. Bounty

Built Hull in 1784 as the Bethia.

Shown here off the Pitcairns, with Christian and his motley crew aboard along with a few Tahitians and Tubuaians. They arrived here in early 1790 and proceeded on the path of self-destruction. When the island was eventually 'discovered', in 1808 by an American whaler and then by Captain Beechey in H.M.S. Blossom, then on another expedition to discover the NW passage, in 1821, it came under the British crown in 1825.

The ship sailed for Tahiti via Cape Horn, but after attempting for nearly a month to round the Horn against the harsh Antarctic weather, Bligh gave up and headed east to the Cape of Good Hope and sailed around the world eastwards, arriving Tahiti on 26th October 1788. Not the best of starts.

To establish the bread-fruit on board Bligh stayed for nearly six months and the sailors, as sailors do, made the most of their time ashore, and in Tahiti they were made most welcome. Though Bligh had years of experience with ships and sailors the appointment as Lieutenant, rather than Commander or Captain, did not have the authority over his men that this would have had. The sacrifice of marines for space needed for the bread-fruit was another factor in the mutiny. Being isolated on the other side of the world, with no back-up from the Royal Navy available was very evident to the crew of the *Bounty*. The strong relationship with the Tahitians, especially the women with the crew, saw the beginnings of insubordination and dissent among the more unruly parts of the crew. It was in Tahiti that half of the 47 crew decided to mutiny - the intentions being to 'start a new life' in the Pacific with the 'relationships' they had made on Tahiti. The leader was the infamous Fletcher Christian.

By all accounts Bligh was by no means a harsh officer. It seems that he was reluctant to use the lash on the outward voyage and not until Tahiti did he have to resort to reprimands, confinement and the lash to maintain his authority. But mutiny it was and three weeks into the return voyage, all but eighteen of the crew seized the ship and cast Bligh and his loyal crew into the 23 foot open boat. With the little water and provisions that they had, death would be slow and certain. Bligh's only chance to survive or perish on a vast ocean was with the sextant he was given and his navigational and sailing abilities. Nelson, the gardener, was invaluable with Bligh in catching fish and the occasional fauna that appeared, that was edible, in sustaining the sailors. They sailed an

amazing 3618 miles to Coupang, Timor (Dutch East Indies) in 41 days. With the loss of only one man, killed whilst ashore on an island looking for food, Bligh's journey was astonishing, and inwardly he must have given praise to his mentor, Cook, for his survival.

Sadly Nelson the botanist died of disease at Coupang. A remarkable voyage equalled only by Shackleton later in 1914.

Bligh was exonerated at a court-martial for losing his ship and his ordeals and survival gave him fame and promotion to Post-Captain - a huge jump from his *Bounty* days. On the other hand the mutineers had fatal consequences of their actions. The *Bounty* along with six Tahitian men and a dozen Tahitian women on board sailed aimlessly across the Pacific and eventually reached the unknown Pitcairn Islands. Here the ship was destroyed by fire - started by a drunken sailor so it is said, and all but one of the crew, a John Adams, were killed by the Tahitians. It is Adams and the Tahitian women who are the forebears of the community there now.

It was later in 1791 that Bligh on his second attempt successfully took bread-fruit to the Caribbean from Tahiti. This time in H.M.S. *Providence* and H.M.S. *Assistant*. Which, incidentally, was captained by Nathaniel Porlock, who was master's mate with Bligh on the *Resolution*. But this time a company of marines were on board, and a young midshipman by the name of Matthew Flinders. Unfortunately the breadfruit didn't take to the Caribbean environment and the locals didn't care for the bland taste either. Bligh returned to England in 1793 and was awarded quite rightly the Royal Society's medal.

February 1793, France now a republic declares war again on England and the start of the French Revolutionary wars. Meanwhile Bligh was given command of H.M.S. *Director* and fought at the Battle of Camperdown in October 1797 in Duncan's defeat of the Dutch. Whilst still in command of *Director* he sailed to St. Helena in the South Atlantic to bring back plants for the irrepressible Joseph Banks, who was still well connected to the Admiralty.

Now in 1800, paid off and on half pay he continued working on boats surveying until being appointed to H.M.S. *Glatton* (54) in 1801. He joined Admiral Sir Hyde Parker with the Baltic fleet with Nelson in second-command. Admiral Sir John Jervis had defeated the Spanish fleet at the Battle of Cape St. Vincent in 1797 and now Spain had become an ally with France. Russia under Czar Paul intended to unite his fleet with the Danes and Swedes against Britain. The Baltic fleet with Parker, Nelson in command, and Bligh, still in the *Glatton* sailed to and anchored off Copenhagen 1801. There, it was Bligh who helped Captain Hardy survey the shallow waters off Copenhagen for Nelson's daring act of attacking the Danish fleet manouevring and anchoring his ships off the Danish fleet which itself was moored in front of the Copenhagen defences.

Bligh in the *Glatton* took the Danish *Daneborg* and as was customary by Nelson was lavishly praised for his bravery. A month later Bligh was appointed to H.M.S. *Irresistible* (74 guns). With the Peace of Amiens in 1802, Bligh found himself on half-pay and the *Irresistible* along with many other ships were laid up in 'ordinary'.

Bligh was made a Fellow of the Royal Society for his distinguished services to navigation, obviously helped by his friend Banks, and another notch on his belt when he took temporary control of the Hydrographic office when Dalrymple became ill in 1804.

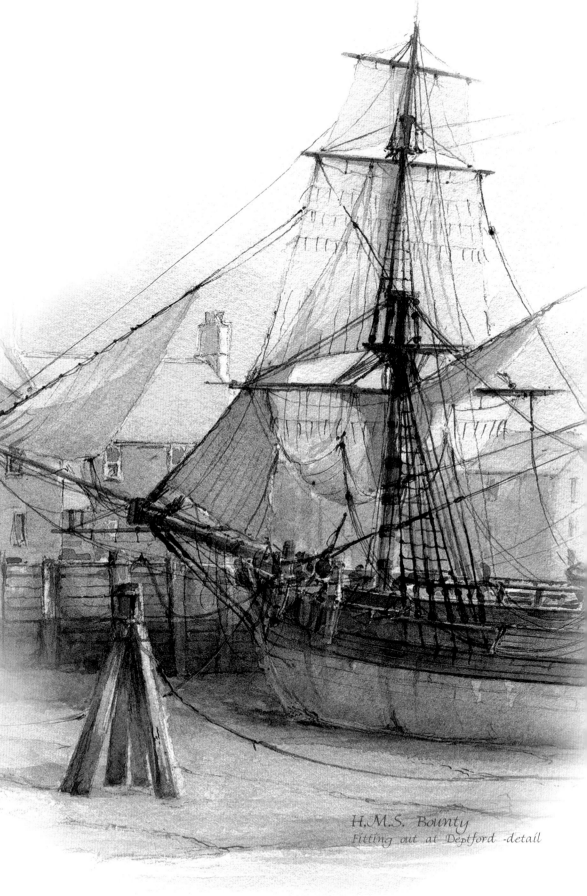

H.M.S. Bounty
Fitting out at Deptford - detail

That year war was looming again with France and Bligh was given command of H.M.S. *Warrior* (74 guns) under the overall command of Admiral Lord Cornwallis. But Bligh's chance of becoming a 'Trafalgar' captain disappeared when he was appointed, as it was traditional for a Naval Officer, to be Governor of New South Wales, Australia. The background here, prior to his arrival, was a complete mess of corruption and anarchy. Hardly surprising with the establishment of a new penal colony there and not having the right man with the authority to run it at hand. Bligh was the chosen man.

His quest for praise and promotion put demands for the highest standards on people about him, which of course would always reflect

on, ultimately, himself. Working relationships had brought him a few problems with his career and continued to do so. He had been tactfully removed from 'home waters' but even when he left England early February 1805 in a merchantman accompanied by H.M.S. *Porpoise* under the command of a Captain Short he was heading for troubled waters. Again for whatever reason, he fell out with Short, whilst at sea, and had him court-martialled on arriving in Australia from a difference of opinion that had warranted Short to fire a shot across the bows of Bligh's ship. An unwise move as the court-martial, under the now Governor Bligh, was successful, and Short found himself on a return passage.

The local 'militia', derived from people posted out to Australia and ex-convicts had created an illegal but lucrative 'rum trade' and the leaders' a Lieutenant Macarthur and a Major Johnston, had rebelled against Bligh's authority and ejected him from Government House but given refuge in H.M.S. *Porpoise*. Now with news of promotion to 'Commodore' he went back to sea as a 'Governor in exile', sailing in Australian waters for over a year, until military reinforcements from England arrived to quell the rebellion. Once again Bligh was court-martialled and again cleared. His time as Governor ended with the appointment of a replacement and he returned home on H.M.S. *Hindustan* to England in October 1810.

His promotion was to Rear-Admiral of the Blue, that year, and finally to Vice-Admiral of the Blue in 1814, and he remained as an Admiralty advisor until his death in 1817 at the age of 64.

As mentioned with Cook the two midshipmen on the *Resolution* were to become eminent sailors and navigators.

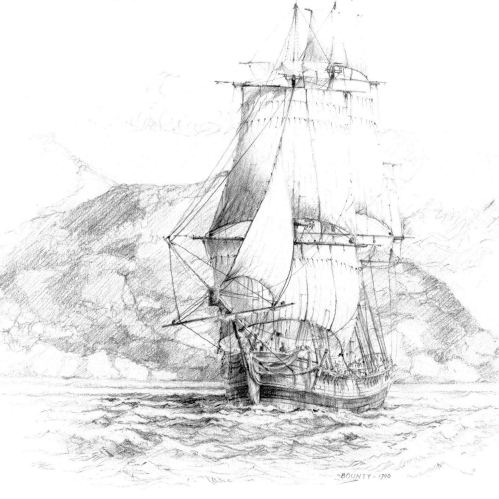

BOUNTY - 1790

H.M.S. Discovery

George Vancouver
& H.M.S. Discovery

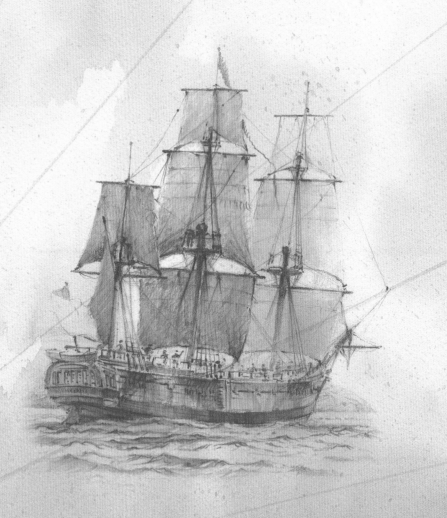

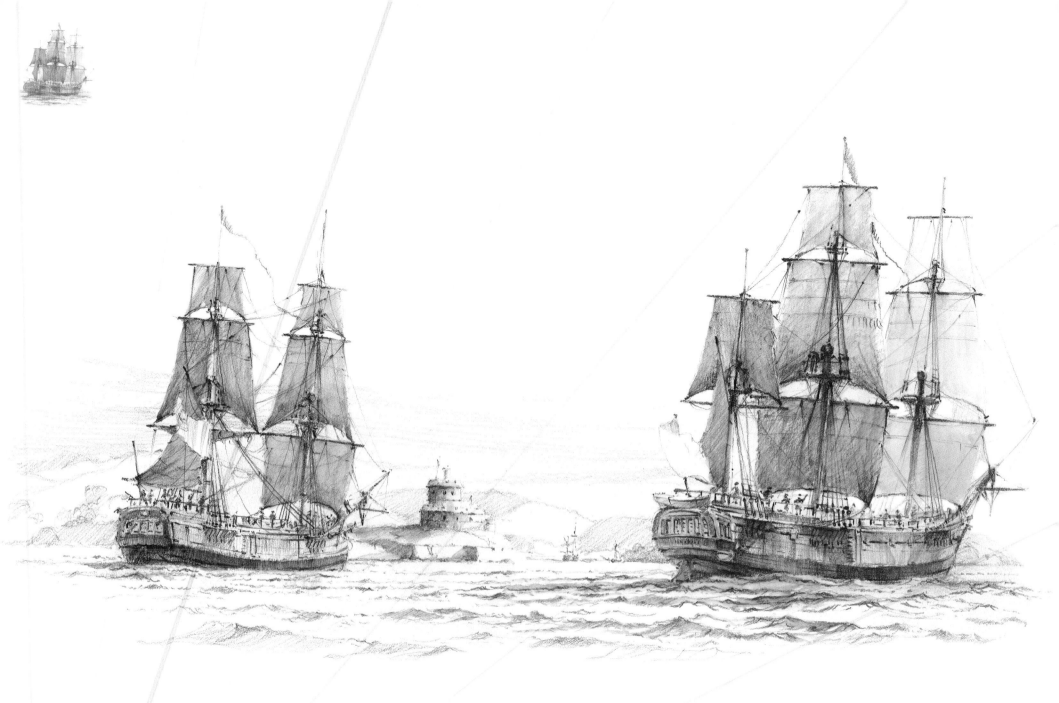

The *Discovery* and *Chatham*
Leaving Falmouth on 1st April 1791

George Vancouver 1757- 1798

&

The Voyage of H.M.S. Discovery

Of Anglo-Dutch descent George Vancouver was born on 22nd June 1757. He was the youngest of six children and was brought up in the maritime town of King's Lynn, Norfolk, then a busy and wealthy eighteenth century port. As I have recently discovered when researching the background of sailors' lives, good and early schooling produced a competence in basics that, student willing, quickly released obvious potential. Wealthy parents also helped.

Vancouver's father, a customs officer, had the necessary connections and influence in the maritime industry that enabled young George, only fourteen, to be included as an 'able-bodied seaman', in reality a midshipman, in the crew of the *Resolution* on Cook's second voyage to the South Seas. The voyage itself is described in more detail in the Cook chapters. When the *Resolution* returned to Spithead in July 1775 after its mammoth second voyage Vancouver was now nearly eighteen, and was sent to Plymouth to join Cook's third and last voyage. This eventful and ultimately tragic voyage, lasted three years, with Cook in command of the *Resolution* searching for the elusive 'north-west passage'. It was these voyages that gave Vancouver the experience, both good and bad, that he would take to his future years in the navy.

He had, on Cook's second voyage, already sailed across the Pacific eastwards to Nootka Island missing the Strait of San Juan de Fuca

(which he was to visit some years later) before travelling up and around the coast of Alaska into the Arctic Ocean. He met Russians and Innuits and crossed the Arctic Circle acquiring a knowledge that would be invaluable to him in later years. From there the ship returned to Hawaii. It was here that Vancouver went ashore with a party to retrieve items stolen from the ship the day before. The events that followed led to the death of Cook. The *Resolution,* now under the command of Charles Clerke, sailed back on the long voyage home to England, arriving in October 1780.

So Vancouver, now 23 years of age already a seasoned and experienced sailor after his exceptionally hard apprenticeship sat and passed his lieutenant's exam in October 1780. Vancouver was appointed to the sloop H.M.S. *Martin,* stationed in the Caribbean, and then transferred to the 74 gun ship H.M.S. *Fame,* part of Admiral Rodney's squadron in the West Indies. From the cold and rigours of the Arctic he now spent nine years in the Caribbean. The French fleet under Admiral Count de Grasse sailed from Martinique to invade Jamaica and was engaged by Rodney and his fleet in the 'Battle of the Saintes', in which the French were defeated and the French flagship the *Ville de Paris* was taken. A defeat which saw the French ideas of a Caribbean conquest extinguished.

Returning to England in 1783 Vancouver served in the *Europa,* before he was, in 1789, appointed second-in-command of a planned expedition to the South Seas, commanded by a Captain Harvey Roberts in the recently built *Discovery*. This voyage was postponed because of the

impending hostilities with Spain about the dispute over land on the west coast of Canada. In the meantime he was posted to the *Courageux* before being paid off and then promoted to the rank of commander in December 1790.

The background to the hostilities with Spain was that John Meares, who was ex-navy, had been trading, mainly in pelts in his ship the *Nootka*. He had sailed into Nootka Sound, part of which he had supposedly bought from the natives, only to be arrested by the resident Spanish and expelled. The Spanish had explored and claimed territories along this coast since 1774 and believed this coast was theirs and considered the British as insurgents. Meares returned to England and complained of his unjust treatment which in turn led to a confrontation between the two countries. The 'navy' was made ready to sail and while preparing the *Discovery* for a scientific voyage as second-in-command, Vancouver was now given immediate command and sent to join the fleet as a fighting sailor. But diplomacy prevailed and an agreement was reached with Spain on the return of property and land under the 'Nootka Convention'.

From the initial disappointments the expedition was now revived and Vancouver with Admiralty orders was sent to 'enforce the agreement' with Spain; to carry out a thorough survey of the Canadian coast now and, yet again, find the non-existent 'north-west passage'. George Vancouver was now to begin his epic voyage.

The *Discovery* was around 350 tons, copper-bottomed, lightly armed but well stocked for a three year voyage. The *Chatham* a smaller two-masted brig was to act as tender for the *Discovery*. The voyage began on 1st April 1791 and, via Tenerife, Cape Town, Cape of Good Hope, Australia and New Zealand Vancouver arrived nine months later in Tahiti.

After a month, the ships set sail for the Sandwich Islands (Hawaii) partly to return Tawrower, a native 'acquired' from a previous voyage to his home. It was thirteen years since the death of Cook but a friendly welcome was given and reciprocated. Here Vancouver had a strong personal relationship with the people of Hawaii, especially King Kamehameha. He endeavoured to improve all aspects of Hawaiian life including agriculture, self-rule and attempted to bring an end to the constant tribal feuding. Surprisingly this relationship and ambivalence with the Hawaiians was said to be remembered more from Vancouver than the memories of Cook.

Vancouver now sailed on to America and California, then called New Albion (now Oregon) and up to the island of Nootka (now Vancouver Island) to follow Admiralty orders to negotiate with the Spanish. In Cook's time this island was thought to be part of the mainland. With such a big channel entrance, now called the Juan de Fuca Straits, it was believed to be possibly the entrance to a N.W. passage. Vancouver now surveyed the coast from his first sighting in Oregon to and into the Straits and like Cook before him named many features after his family and county including Alaska which he originally called 'New Norfolk'. The Straits of Juan de Fuca leads into a huge inlet of water which, as I recall it, is surrounded by rugged, hilly if not mountainous, and tree covered land. Vancouver entered one inlet and founded a settlement called Granville which was burnt down in 1886. The new and impressive town built which was named after the man himself is a spectacular city set in mountains and trees. I first arrived by sea late at night to a memorable scene under what seemed to be an endless canopy of twinkling lights as wide and as high as could be seen.

Nootka Sound was the base harbour and here the ongoing discussions went on between the British and the resident Spanish as to the ownership of Nootka/Vancouver Island. A British supply ship H.M.S. *Daedalus* was already at anchor there, and like the *Discovery* and more so the *Chatham* was in need of repair, to the point where a request to the Admiralty for a replacement ship was needed. In October 1792 however, the three ships left to explore and chart the coast as far south as San Francisco until returning in November. Another spectacular port to arrive at. I have sailed in and out several times in clear weather and in the dreaded 'fog'!

Vancouver returned to Hawaii in early 1793 to a warm reception from the islanders. and then back to the east coast for more surveying work. A tedious operation on a complex and rugged coastline in cold, damp and at times stormy waters. This was probably one of the most arduous surveys ever done. Vancouver's orders also included the small matter of finding the N.W. passage, but he doubted it could be found, and so concentrated on completing a detailed map of the coastline. The ships had been at sea for an amazing three years and with no information from the Admiralty knew little of any international events. The condition of both ships was poor, crew morale low and the long hard work had seriously affected Vancouver's health.

Early in 1794 Vancouver and his ship returned, again, to Hawaii for a refit and repairs before heading back to Alaska. Surveying continued up to Kodiak Island and eventually terminated at what is now Petersburg in Alaska, originally called, appropriately, 'Cape Conclusion'.

What elation all must have felt to to make a final southerly course via Nootka Sound, where they found the matter of the island's sovereignty acceptable, enough at least to head home via South America. An outbreak of scurvy and more repairs forced a stop at Valparaiso, Chile, where the ships restocked for the long haul to St. Helena in the South Atlantic.

A passage through both Atlantic Oceans would have been more than enough, but bizarrely, here at St. Helena, Vancouver was informed that Holland was now at war with Britain so as you would do I suppose he proceeded to capture an unsuspecting Dutch merchant ship and then, astonishingly, set out to capture Cape Town, which was then a Dutch port. What amazing devotion to duty!

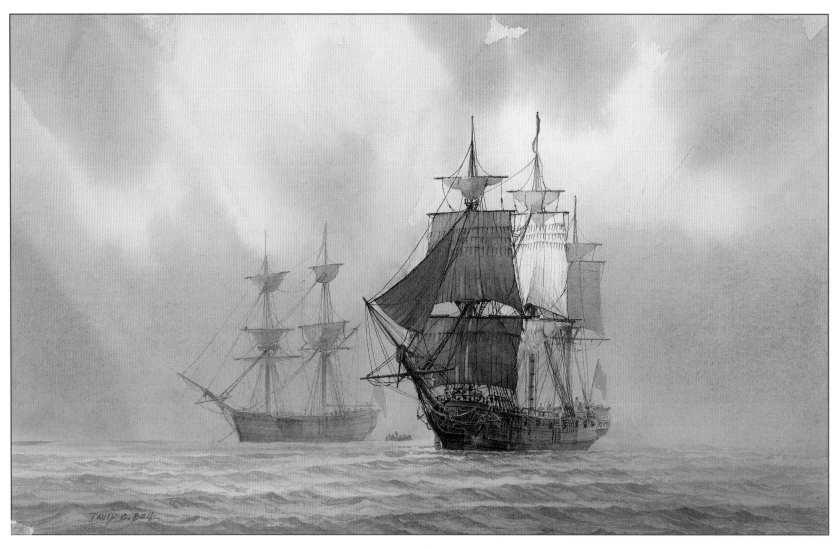

H.M.S. Discovery

Fortunately the naval ship *Arriston* arrived and, being much more suited and seaworthy, was designated for this task so the *Discovery* proceeded, wisely, to England. She made for, and arrived, at the River Shannon on the west coast of Ireland. Vancouver left the ship and made his way to London and the Admiralty to present his papers and reports. After nearly five years away it must have been a sizeable dossier.

He rejoined the *Discovery* at Deptford to complete the paying off and left on the 3rd November 1794 on half-pay. Effectively this marked the end of his naval career. Sadly his arduous life at sea and particularly the last long voyage had affected his health greatly. He died at Petersham in Surrey on 12th May 1798 but not before the completion of his journals documenting this survey and memorable adventure.

The *Discovery* itself, originally built as a merchantman and altered to a ship-rigged sloop for exploration was, after the long voyage, then converted into a 'bomb' vessel and finally 'hulked' as a convict ship.

There is yet another *Discovery* later in the book but here the odyssey leads from one midshipman to another who, like Bligh and Vancouver, followed Cook - one Matthew Flinders and his famous ship the *Investigator*.

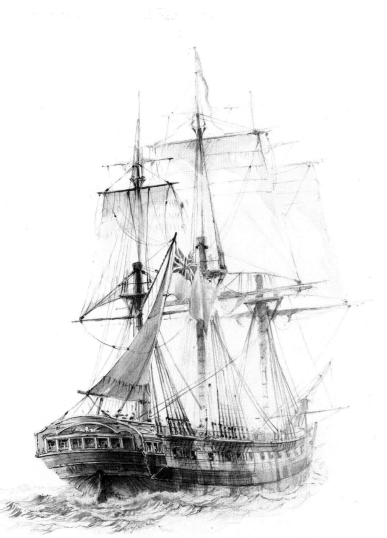

H.M.S. Martin

Vancouver served on this sloop in the Caribbean after qualifying as Lieutenant in 1780.

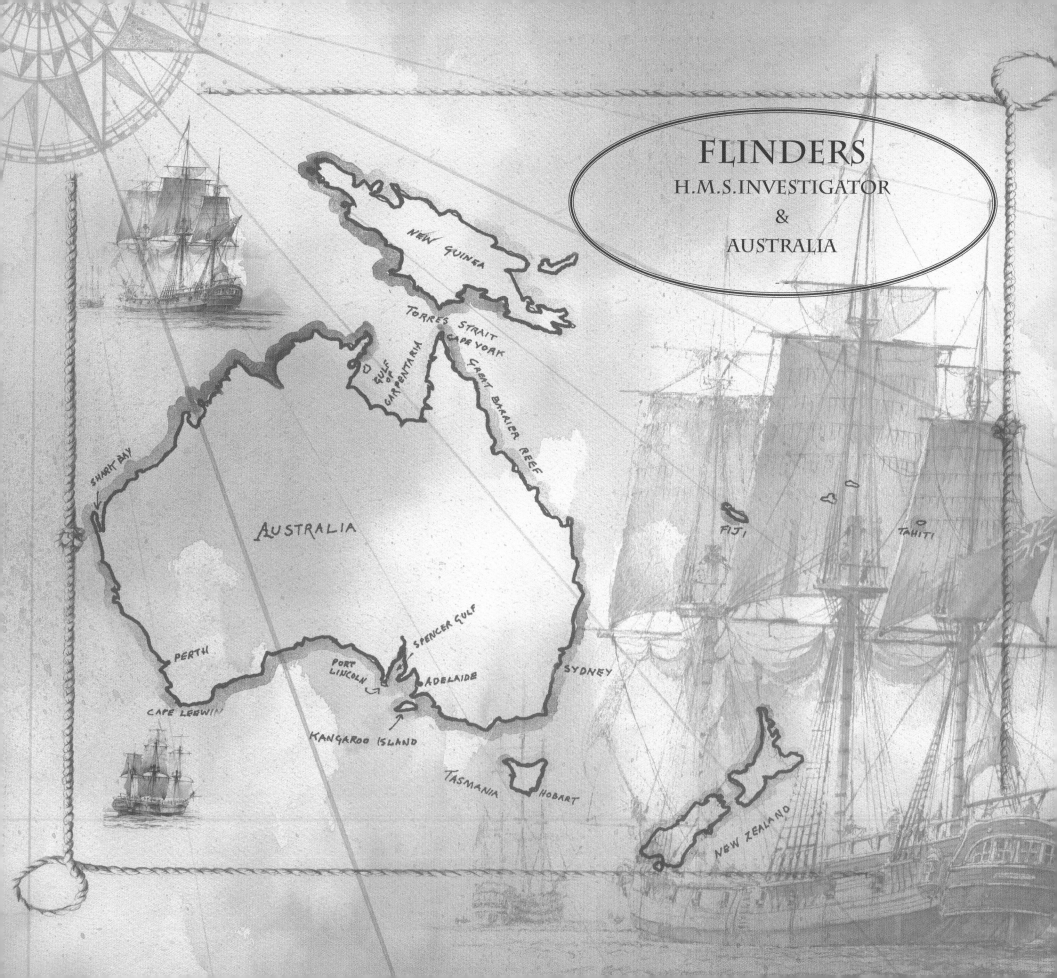

FLINDERS
H.M.S. INVESTIGATOR
&
AUSTRALIA

NEW GUINEA

TORRES STRAIT

CAPE YORK

GULF OF CARPENTARIA

GREAT BARRIER REEF

SHARK BAY

AUSTRALIA

FIJI

TAHITI

PERTH

SPENCER GULF

PORT LINCOLN

ADELAIDE

SYDNEY

CAPE LEEUWIN

KANGAROO ISLAND

TASMANIA

HOBART

NEW ZEALAND

Matthew Flinders

& H.M.S. Investigator

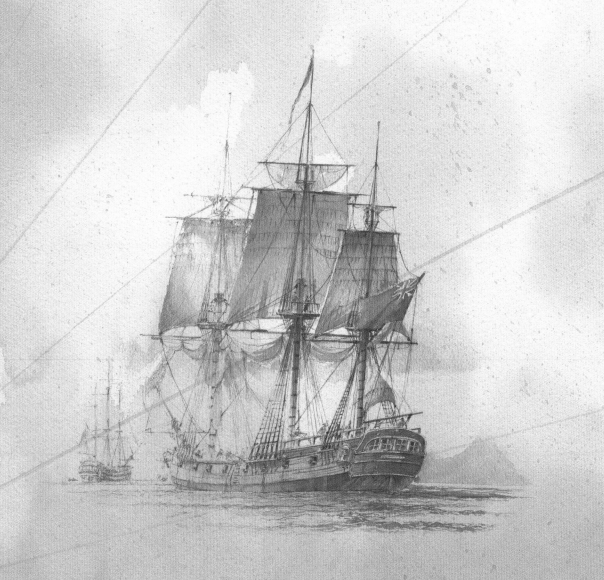

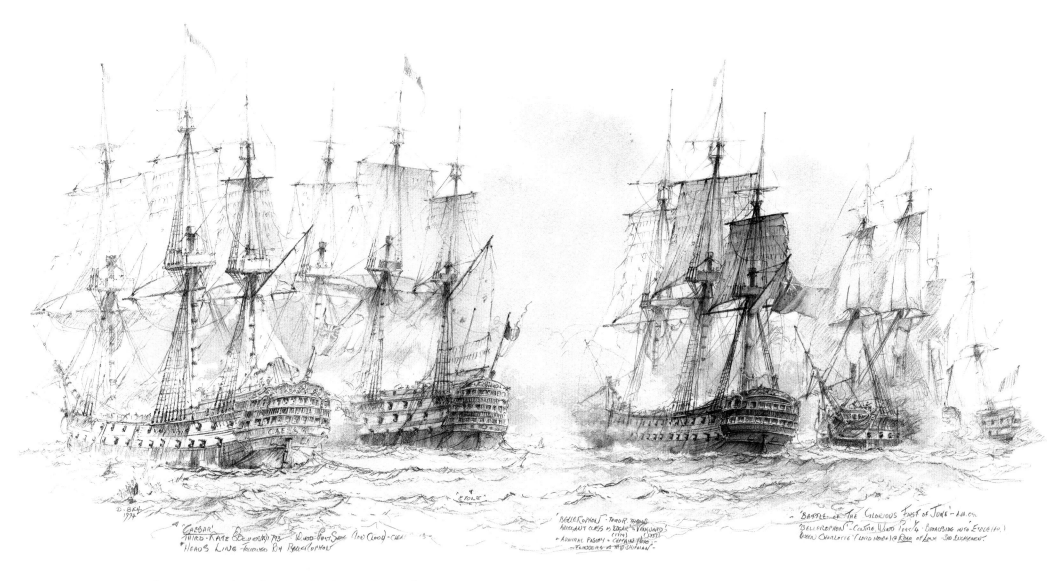

Sketch for the battle of the 'Glorious First of June'

It was with Lord Howe's Channel Fleet that the Bellerophon sailed to intercept a large French convoy from America to Brest, and it was from this port that the French Admiral Villaret de Joyeuse put out to protect the convoy and to engage the British squadron. The ensuing battle, over three days, was to be known as the 'Glorious First of June', the first of the Revolutionary battles at sea. The Bellerophon under Pasley was in the thick of it. Flinders survived this fight, to be his only experience of the like, but Pasley lost a leg to a cannonball and spent the rest of his career ashore. I have only been able to find one drawing of this action and by chance it shows the Bellerophon with Flinders aboard.

H.M.S. Bellerophon

Matthew Flinders 1774-1814
&
The Voyage of H.M.S. Investigator

Many nations contributed to the discovery and charting of Australia. The Dutch made a start with Jansz in the *Duyfken*, 1605, and Hartog in the *Eendracht,* 1616, along with the French explorer Bougainville nearly two centuries later. In between was the enigmatic buccaneer and explorer William Dampier particularly on the Admiralty funded voyage of 1699-1701 in H.M.S. *Roebuck*. The great sailor Cook in the *Endeavour* made his input, followed by the Lincolnshire born mariner Matthew Flinders.

Just south of where I live is the small market town of Donnington where, in 1774, Flinders was born into a family of surgeons and like Vancouver before him, of Dutch descent. Remarkably, close by, are the birthplaces of another two mariners of some repute - George Bass from Aswarby, whose life entwines with Flinders in this chapter, and Sir John Franklin from Spilsby.

It could be argued that, like Cook, Flinders' natural capacity for learning, in particular mathematics, combined with good grammar school education, gave him the basis for his life at sea. But how did he make that step? Like many before him, the connection was simple. To step into the navy then was not via a R.N. recruitment office on the local high street but rather through a well connected person. Fortunately Flinders had a relative, a cousin, who was a governess to the family of an influential Captain Pasley. Impressed by Flinders, independent learning, the Captain nominated him - and this exceptional young man found himself, in no time at all, at fifteen years of age, aboard H.M.S. *Alert*. He stayed on her for seven months before joining Captain Pasley's ship

H.M.S. *Scipio* at Chatham and soon on to the famous 74 gun ship *Bellerophon* as a midshipman. He did not then go to sea. however. With Pasley's help, Flinders was given the opportunity to sail with Captain Bligh as a midshipman in the *Providence* under Admiralty orders, on his second voyage to take breadfruit plants from Tahiti to the West Indies in 1791. He jumped at the chance. The *Providence* sailed, via the Cape of Good Hope, to the Pacific and back via the famous Torres Strait, north of Australia, to Timor and eastwards. Flinders' career was cast. The experience of this voyage was to become the basis for his future endeavours to sail, explore and record.

As a navigator I found this region quite demanding, but outstanding in its beauty and purity. Such ideal tropical weather and a multitude of outstanding sights was breathtaking but always coupled with a cautious attitude when determining the position and movement of a deep drafted ship. On the *Providence* this must have infused in Flinders a great passion to explore and chart. In less than ten years he was to return to these waters and do just that.

On board the *Providence* Bligh and Flinders successfully landed the breadfruit in the West Indies and sailed home. At the same time France declared war on Great Britain, in February 1793. Flinders immediately sought the advice of the now Admiral Pasley who was still in command of the *Bellerophon* at Torbay. Flinders was taken on board as midshipman. At the end of the 16th century and the start of the next, the first

discoveries of the western side of the Australian landmass, were made mainly by the Dutch. The Dutch East India Company invested heavily in the valuable 'spice trade' and made long passages, sometimes eighteen months, with a valuble cargo for the markets of Europe. The passage from the Cape of Good Hope across the Indian Ocean, always going north east, was a slow and fickle crossing. When the Dutch sailors including Brouwer, Eendragt, Dirk Hartog and Abel Tasman and even the Englishman Dampier, fell upon the western shores of Australia - this possibly faster route was taken advantage of. This unknown and uncharted land was now called New Holland.

In1795 during the French Revolutionary Wars the British government sent a new governor, Captain John Hunter to Port Jackson (Sydney), Australia in the *Reliance*. The ship's commander was Henry Waterhouse, who had served on the *Bellerophon* as a ship-mate of Flinders. These two mariners readily accepted Flinders and he jumped at the chance to sail with them for a second voyage to Australia. Of course Cook had charted the east coast of Australia in 1770 but it was Flinders, in time, who was to comprehensively complete the charting of its huge coastline.

It is worth mentioning that on this voyage the ship's surgeon was George Bass, another Lincolnshire man. It was in New South Wales, that Bass on his many explorations discovered the strait between Australia and Tasmania now known as the Bass Strait. These two intrepid mariners, Flinders and Bass, encouraged by the governor Hunter, went on many forays together, along and into this corner of Australia, particularly in command of the small schooner *Norfolk*. Flinders eventually sailed back to England on the *Reliance* arriving Portsmouth in August 1800. He was now qualified, seasoned and mature and it was that man Sir Joseph Banks who was to recognise his abilities and launch him back to Australia on the *Investigator*. Built 1795

by Henry Rudd at Monkswearmouth Shore (Sunderland) and registered as the *Xenophon* of 334 tons, the *Investigator* was purchased from the merchant service and worked on coastal convoy duties. She was a three masted vessel, square sterned and in 1798 was fitted with a new upper-deck and quarter gallery and the lower deck fitted with twenty 32 lb. guns. Alterations to the vessel were completed at Sheerness for the proposed exploration to Australia. Flinders joined her at Sheerness in February 1801 as a newly appointed commander. The ship had 83 crew, including six midshipmen, one was a John Franklin.

I seem to be constantly stating the fact that so many ships were in too poor a condition to sail halfway round the globe but they did just that. The *Investigator* was another case, even at the start of a long voyage she was old and unsound and as following events show was a cause of Flinders' early death.

The ship made Cape Leeuwin on the south-west corner of Australia in December 1801. They sailed along the southern coast surveying and charting, as always, with great accuracy and attention to detail, working from dawn to dusk as close inshore as possible hauling off seaward at night. Across the Great Bight to the Eyre Peninsula Flinders surveyed Port Lincoln, named after my present abode, then Spencer Gulf, and Kangaroo Island before proceeding to winter in Port Jackson where they met the French explorer Baudin in command of the *Le Geographe*. Flinders now put into the magnificent natural harbour of what is now Sydney, in May 1802, to refit and restock the ship but also to plan his next stage of surveying. The plan was to fully chart the Great Barrier Reef, which had been partly done by Cook thirty two years earlier, then up to the Torres Strait, the waterway between Australia and New Guinea, round the Cape of York Peninsula along the coastline of the Gulf of Carpentaria and round to the north-west coasts. The ship had to be in the best condition for the work ahead and it was

to be a three month refit and overhaul before the ship was ready for sea, leaving at the end of July. The *Investigator* and the supply/support brig *Lady Nelson* left port and headed north but, after two months, the tardy *Lady Nelson* was sent back to Port Jackson and Flinders proceeded alone. With great caution Flinders steered north past what is now Brisbane, and started surveying the southern end of the Reef, going north and slightly westward, with the help this time of an improved 'chronometer', to be more accurate in finding longitude. I had the good fortune to be anchored in Sydney Harbour for several weeks and managed to paint some harbour scenes from there. My first and only transit of the Great Barrier Reef was made with a bridge full of the latest navigational equipment and also a pilot who didn't leave till we reached Cape York. Flinders sailed and surveyed in these notorious waters before threading his way out and sailing back up to the Cape York Peninsula and through the Torres Strait, but not before he found a safe passage through the reef - known and used as 'Flinders Passage'. Though little was known of these waters, Flinders had already sailed through the Strait as a midshipman on Bligh's second trip to Tahiti. Now as a Captain and surveyor, he had himself the task of charting a route through the Straits.

Not helped at all by the state of the ship which was now leaking badly from rot, any errors in seamanship, especially in grounding, would have meant a salty end for all. Nevertheless Flinders made a passage round Cape York and into the Gulf of Carpentaria, to beach and careen the hull. There was a notion that this huge gulf might split Australia in two and maybe lead to the Indian Ocean. Of course the Dutch explorer Tasman had been here before, in the seventeenth century and concluded correctly it was a gulf and the swampy coastline was not the most habitable of places. Even today it is sparsely populated.
Once rot took hold of a ship's timbers there was not a lot that could be

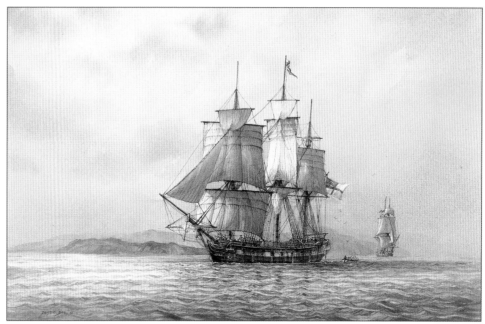

H.M.S. Investigator
Off Kangaroo Island South Australia

When surveying Flinders would keep the ship as close inshore as possible so as not to miss a thing. At night they would haul off to a safe distance and resume at sunrise. With great attention to detail he would also go ashore measuring and making topographical observations. He was great, if not the greatest, at naming any geographical feature of interest. Places all around Australia were named by Flinders using Lincolnshire names - Sleaford, Louth, Revesby, Stamford and many more. Port Lincoln was the first named whilst surveying Spencer Gulf. It would have been an important port had not Adelaide on the other side surpassed its setting in commanding a huge hinterland.

done other than replacement. Even though the ship was in a very bad state of repair, Flinders had corrected many of Cook's errors and he did not intend to be corrected himself by any other surveyor. His nature was to accomplish and succeed and so he continued to do so in his very thorough and careful way.

By the beginning of February 1803 the survey of the gulf was complete and Flinders continued westward around Cape Arnhem, surveying until the state of his ship and his own health deteriorated to the point that he decided to return to Port Jackson. He elected to continue westward, all the time surveying, and hoping to eventually, in an anti-clockwise direction, make Port Jackson. Sadly it was the beginning of the end. The state of his ship was so bad that he first sailed to Kupang, in Timor, where he desperately sought a replacement ship and fresh provisions, but Kupang was not the answer. The crew had little fresh food for months on end and scurvy had now taken hold. Flinders decided on the

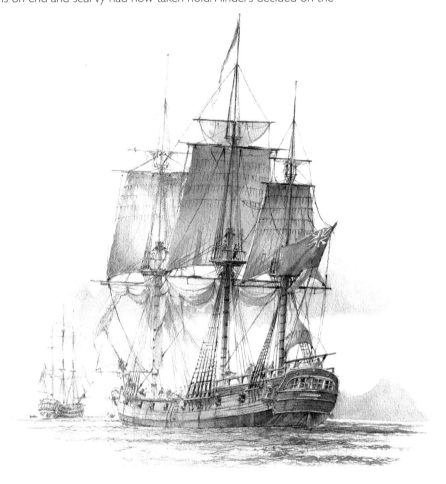

fastest possible passage to Port Jackson, and must have had good sailing conditions as he arrived in June two months later, after a ten and a half month voyage, but not without fatalities and serious illness amongst the crew.

Here the *Investigator* was examined and found unseaworthy. So Flinders decided to return to England to acquire another ship to complete his task. He decided to be a 'passenger' which enabled him to prepare his charts for the Admiralty. Fowler his fellow officer was in command. It was to be unfortunate that Flinders decided to sail north through the reef rather than take the safe south route. He left in H.M.S. *Porpoise* in company with two merchant ships, the *Bridgewater* and the *Cato* on 9th August. Sailing on the outside of the Great Barrier Reef and making for the Torres Strait, disaster struck. When, at night, first the *Porpoise* hit the reef and was wrecked then the *Cato* went aground whilst the *Bridgewater* managed to tack clear. The crews managed to get ashore with some provisions from the ships, but were still in a serious predicament.

Not helped by the fact that the captain of the *Bridgewater* unbelievably gave no assistance and fled the scene, Flinders immediately decided to set off in a ship's cutter to sail back to Port Jackson and get help. He did and successfully arrived a month later. The rescue attempt was slightly involved. Three small ships would pick up the survivors. The *Rolla*, a 432 ton merchantman, would take men if they wished to Canton, China, the schooner *Francis* would take any back to Port Jackson and the third the tiny, less than 30 tons, schooner *Cumberland* would take Flinders and his journals back to England.

The conclusion to this episode does not make good reading. Flinders so

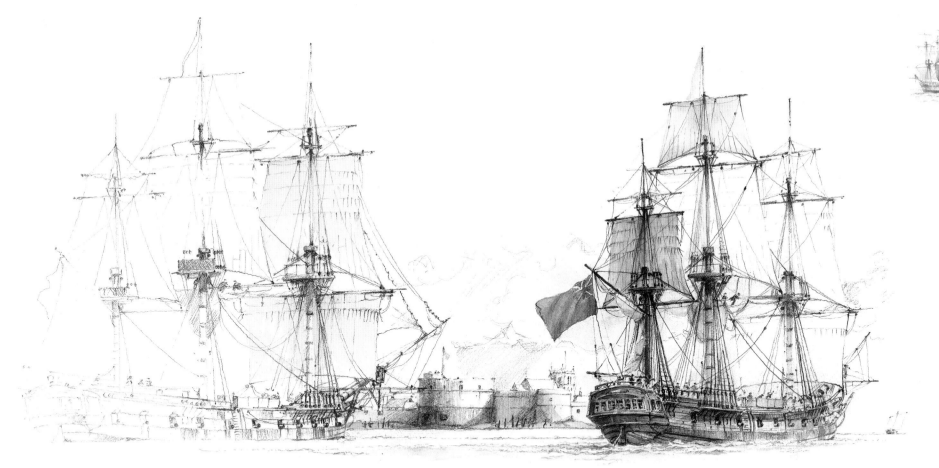

The **Investigator** actually sailed from Spithead after a month at anchor on 18th July 1801. Shown here is a drawing at the entrance to Portsmouth Harbour

- INVESTIGATOR - LEAVING PORTSMOUTH

intent to reach the U.K., again, unwisely, chose a vessel hardly appropriate to sail safely 15000 miles. In keeping with his plan to return home via Timor, the Cape and St. Helena this tiny boat made for Kupang (Dutch Timor) for provisions. Crossing the Indian Ocean with a leaking vessel and necessitating constant pumping, day and night, was so worrying that, with some doubts, he made for Île de France (now Mauritius) in the west Indian Ocean. Though the island was French he thought the 'Peace of Amiens' treaty was still valid. His 'passport' indicated he was 'on a voyage of exploration and not hostile' so he believed he would not be taken prisoner. Sadly, again, this was not so, as Napoleon was at war again with England, and on arriving at Île de France and in possession of a wealth of nautical information he was arrested as a spy.

The governor was a General Decaen, an intelligent military man and

ferocious patriot of his country. The Frenchman had landed at Port Louis, Île de France, after an unsuccessful attempt to land in India at Pondicherry, and had, with new orders, reverted to take charge of this tiny island. He had been in command for only four months when the woeful Flinders arrived. Apart from sinking it was the worst possible move.

His enforced stay was not a happy one. In fact he became despondent and his health deteriorated over the time there. Even so with the remnants of scurvy, depression and failing eyesight Flinders wrote his journals, reports and prepared his treasured charts.

Whilst imprisoned Flinders kept up correspondence with the Admiralty,

mainly about his release but also other matters. When Flinders charted the Gulf of Carpentaria he rightly ascertained that Australia was one landmass. The Dutch however had claimed the western half of this land in the seventeenth century, and had called it 'New Holland'. Cook, however on his travels had claimed the eastern side for England and named it 'New South Wales'. This division was pointed out by Flinders to the Admiralty and he suggested the name Australia for the whole landmass which they duly took up.

Freedom for Flinders came when the British Navy arrived on the scene and a blockade was enforced and, after a staggering six and a half years in captivity, Flinders was given his liberty and left Île de France on 13th June 1810. On his return to England in October, after an incredible nine years three months away, he was made Post-Captain and given command of a coastguard ship at the entrance to the Thames in H.M.S. *Ramillies*.

Though still very ill he continued to write and record all he had done but sadly he died at the age of 40, in July 1814, only just in time to see his memoirs in print.

His superiority at communicating maritime knowledge is recognised by sailors and historians for its accuracy. He is renowned for his surveying, charting, and all the accompanying information on tides and weather. I first learnt about 'Flinders Bars' on a ship's binnacle and its role of counteracting the effect of a ship's magnetism whilst I was a new cadet at sea many years ago, and having at least followed a little of his meanderings at sea I can now appreciate the quality of this man as an explorer and accomplished navigator.

Ironically the *Investigator* remained in Sydney as a store ship until 1805. When repaired it returned to England under a Captain William Kent after a five month voyage, arriving Liverpool in October 1806, four years before Flinders. Then, in 1810 she was re-rigged as a brig and sold back to the merchant service and re-registered as the *Xenophon*. Oddly she reappeared in Australia in 1851, then registered in Melbourne and there she was finally broken up in 1872.

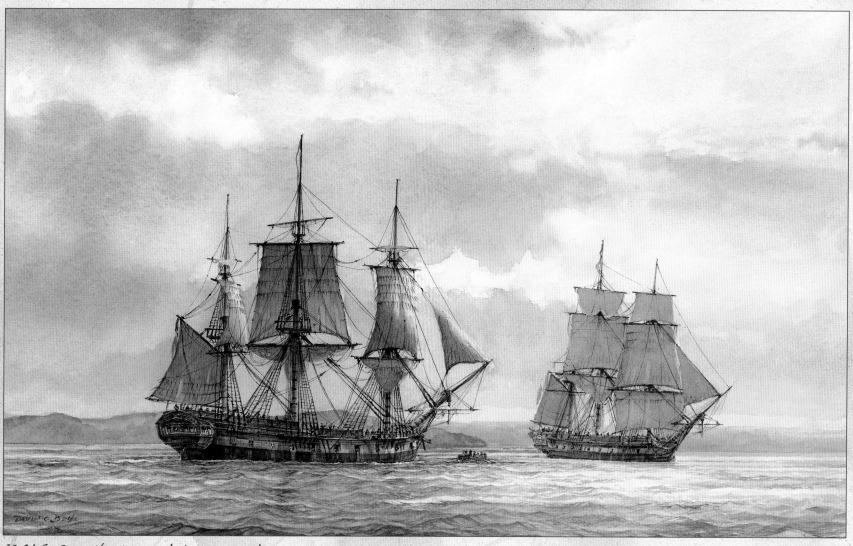

H.M.S. Investigator and La Geographe

At the same time as the British expedition the French also had a voyage of exploration under way.
Commanded by the experienced Captain Baudin, the French corvette La Geographe had arrived at Western Australia in June 1801 and eventually travelled eastwards to encounter Flinders and the Investigator off what is now Kangaroo Island, near Adelaide, naming it Encounter Bay. The ships of Flinders and Baudin suffered greatly during their adventures, especially in human life. Ironically both men ended up on the Ie de France on the return voyages, Flinders as a prisoner from December 1803 to June 1810 whereas Baudin died there in September 1803.

H.M.S. Victory

Horatio Nelson
& His Ships

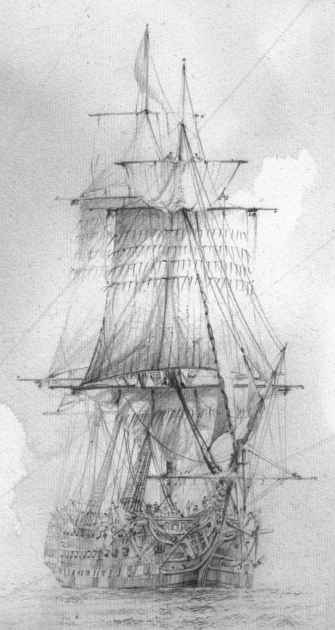

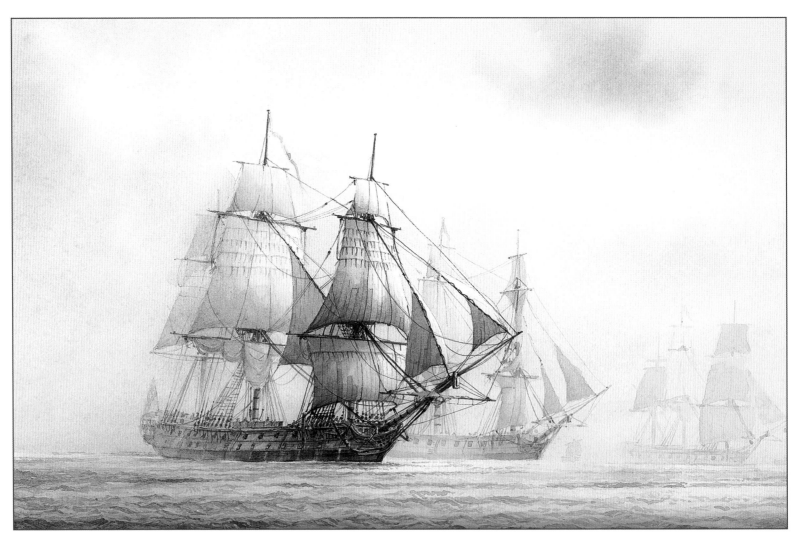

H.M.S. Valiant 74 guns Built Chatham 1759

Horatio Nelson 1758 - 1805
&
His Ships

From Vancouver I move on to probably the most famous, well documented and known chapter of England's maritime history - that of Nelson's period. Unless in hibernation during 2005 no one can have avoided seeing some reminder of this great man's life, so I have no intention of repeating much of his biography. I will, however, briefly trace his life through the numerous paintings and drawings I have completed over many years depicting Nelson's Navy.

Earlier, I touched on my reasons for choosing maritime themes for my subjects. In no area am I more inspired and compelled to paint than that spanning Nelson's era. Probably even more than the first sight and tour of H.M.S. *Victory* at Portsmouth dockyard, my first visit to the National Maritime Museum was a great influence on me as a young man in the sixties. I've returned many times since to see the Trafalgar artefacts and the superb paintings by Cooke, Chambers and the like, and anyone, with even the smallest interest in ships and the sea would be educated, moved and humbled by the lives of all who served at sea during this period. Of all these lives the most significant and interesting is Nelson. Nelson's life must be the most well researched and chronicled of any mariner's, and I do not intend to be too dialectic in my handling of this chapter. Rather the content will serve to augment or explain the drawings and paintings and in doing so will build a picture of his life.

The difficulty with Nelson and his ships is which is more noteworthy or rather pertinent to the book? It would take a fairly hefty tome and some considerable time to portray this complex character, and what more could be said about him? So I gladly take the easier option in this chapter and put the emphasis on retrieving and reproducing a few of my paintings and sketches of the numerous ships of this period.

As an island nation, Britain needed a powerful maritime force and this evolved and developed as a navy of many and varied sailing ships of war. My first painting of these is the *Valiant*. This watercolour shows the newly launched ship, a third rate of 74 guns, under sail, but going nowhere, in a calm sea and misty weather. Built at Chatham in 1757- 59, it was actually a copy of the French 'Invincible' class, during a time when British ship design was under the 'French' influence, during the Seven Years War with France. It is interesting to note that, as the vessel was being created on the stocks at Chatham, England's future naval hero was born to Edmund Nelson, rector of Burnham Thorpe and his wife Catherine. Close to the North Norfolk coast, almost within sight of the sea, the location of his birth was to shape his life.

So, destined for a life at sea, Nelson was without doubt driven by ambition but was equally assisted by a great deal of luck and family influence, mainly in the form of his uncle, Captain Suckling. It was under this man's patronage that Nelson started his naval career at the age of twelve, joining the 64 gun ship *Raisonnable*, ironically one of many captured French ships. His time on this vessel was short lived and both Nelson and his uncle were transferred to the *Triumph*, at the time a guardship on the Medway.

Suckling could see no advantage for his nephew in being stationary and so had him transferred to a merchant ship, on passages to the West Indies, for the next year. Driven by his innate ambition, Nelson, so soon, became coxswain for the ship's boat aged only fourteen. Subsequently under Captain Lutwidge, Nelson joined the *Carcass*, a strengthened bomb vessel which, along with the *Racehorse,* set out to explore a possible Arctic route eastwards, to the Pacific, an expedition instigated by the Royal Society. It was on this trip that Nelson first demonstrated his bravery and perhaps stupidity when the slightly built lad took on a polar bear in hand to claw combat, fortunately to be saved by a sailor who fired a warning shot.

Nelson's story would have ended there, had not fate played its part. The onset of an Arctic winter brought with it ice that would have imprisoned the *Carcass* for many months. However good fortune provided a way out and a safe passage back to England. In 1773 Suckling's influence once more sent Nelson into another adventure. He was off to India on the 20 gun frigate *Seahorse* under Captain Farmer. It was here Nelson saw his first action, capturing an armed ship of the Ruler of Mysore, at that time Britain's enemy. He survived this but eighteen months later returned to England having succumbed to the dreaded malaria.

The small watercolour reproduced on page 89 is of the *Lowestoffe*, a 32 gun frigate on which Nelson sailed as a Second Lieutenant, an appointment again influenced by his uncle.

By the time of his Uncle Suckling's death, Nelson had developed his own strengths as an officer of character and ability so that he could withstand this setback and loss of influence. Now he had qualities that set him apart from his fellow officers. A short command of the *Little Lucy* provided the opportunity for Nelson to again demonstrate his courage when he boarded and took an American vessel in difficult conditions. His qualities were recognised and he was rewarded with a transfer to *H.M.S. Bristol* in the Caribbean, the flagship of Sir Peter Parker. Nelson had come of age. He was nineteen years old and promoted to First Lieutenant, this time on his own merit.

The 'man-of-war' spent little of its time fighting, but had many other uses, with commerce, communications, supporting duties and as seen in later chapters, exploration. But now with a short stint on the *Badger,* a 16 gun brig, at the end of 1778, as commanding officer patrolling the Caribbean, Nelson's big breakthrough came. He was promoted to the twenty eight gun frigate *Hinchinbroke* as Captain and joined her at Port Royal, Jamaica, in September 1779.

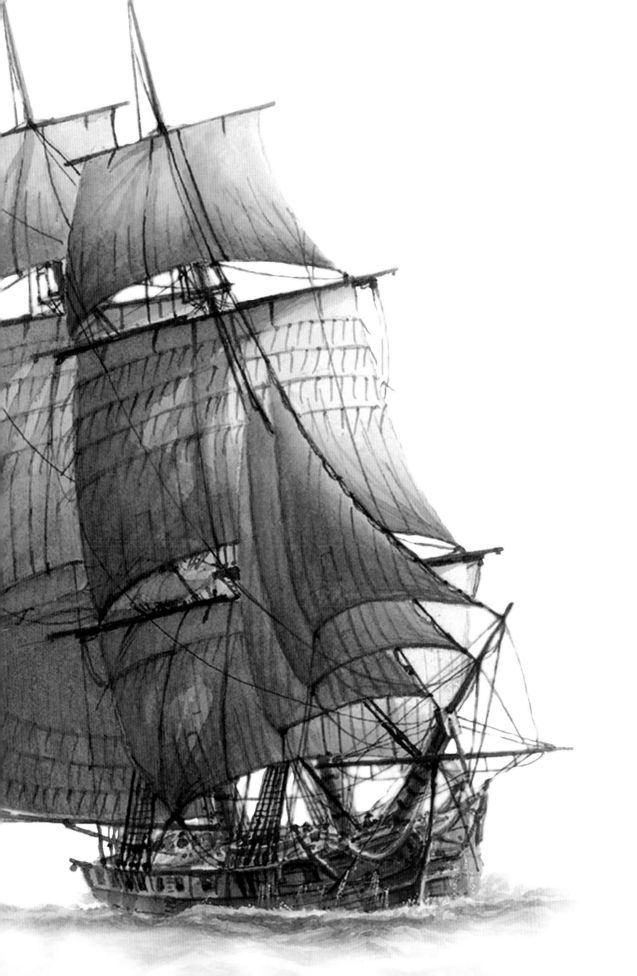

H.M.S. *Racoon* *Caribbean duty*

He was a mere twenty one year old and the start of his illustrious career was well under way. He was to serve on a succession of ships, many of which are well known to many people simply because Nelson was their captain. This is really where my interest in ships of this period begins, Nelson being the thread holding this particular odyssey chapter together.

As a Merchant Navy navigator I spent a good deal of time trading in the Caribbean, and Nicaragua was one place I remember well. Even in these modern times these countries are not the most hospitable of destinations. Neither were they for Nelson, for in these waters on board the *Hinchinbroke,* after leading an ill-fated exploit up the San Juan river, Nelson, already unwell, was transferred to the *Janus,* a 4th rate, where he fell victim to yellow fever and became seriously ill. Diseases ravaged both the troops on duty ashore and the sailor's aboard a harbour destined ship in these waters.

Slightly improved he was returned to England in December 1789, and when fully recovered took over his next command aboard the 28 gun *Albemarle.* This was largely an uneventful time but an opportunity to join Hood's squadron back in the Caribbean gave Nelson the chance for action during a sea-land action in The Bahamas. This conflict, however, allowed Nelson, again, no distinction. After four years he paid off at Portsmouth in June 1793. The Treaty of Versailles ended the war of American Independence and ensured peace and a long time ashore for many ship's officers, including Nelson. During this time on dry land he toyed with the idea of entering Parliament and pursuing a career in politics. He totally failed to gain a seat however, and having been assisted to obtain a command he was appointed to the frigate *Boreas* in March 1784.

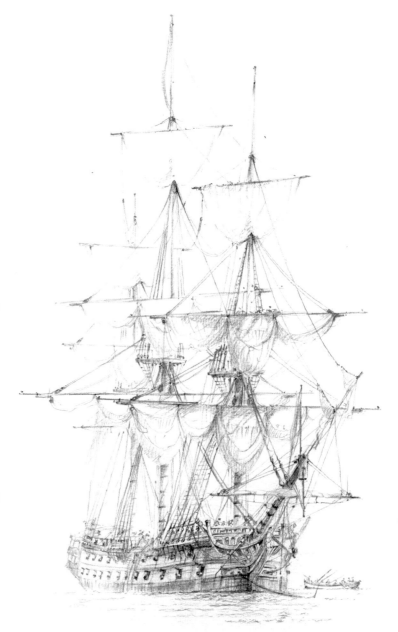

H.M.S. Lowestoffe

A mid eighteenth century warship, designed by Sir Thomas Slade, built at Deptford Dockyard and launched as a 32 gun 5th Rate frigate in July 1761. When built would have had a 'lateen' mizzen yard, being replaced later with the more practical 'gaff' yard and boom as illustrated.

The ship was undergoing a 'large repair' at Deptford when, having qualified as an officer on 9th April, Nelson was appointed Second Lieutenant to the ship the following day.

It was in this ship under Captain Locker that Nelson was given a brief, just several months, period of time to command a small prize, a schooner, to operate as a tender to the Lowestoffe. His first command.

The ship, on convoy duty in 1801, ran aground in The Bahamas off the island Little Inague north of Hispaniola, and was wrecked.

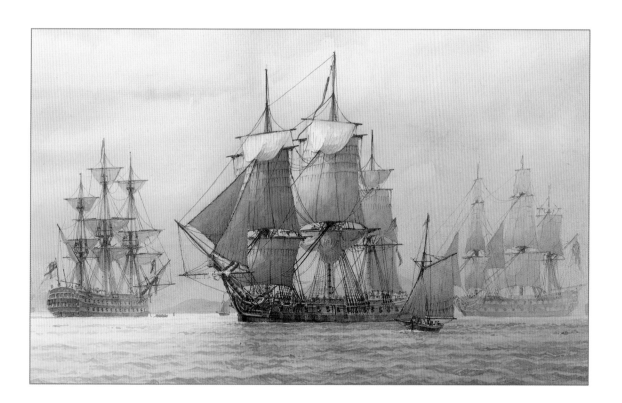

Buckler's Hard

The maritime museum at Buckler's Hard has been a most interesting and helpful place for me, certainly in my understanding of early shipbuilding and maritime affairs and I thought it relevant to include a brief history of this gem of a place.

The River Beaulieu is a short and quite picturesque river from its mouth on the Solent north to the town of Beaulieu some twelve miles upstream. Buckler's Hard is still a small hamlet, basically preserved as it would have been in its shipbuilding heyday in the late eighteenth century, half way up on the west bank. From the first naval ship *Surprise* built here in 1745 to the last in 1814 this small private shipyard built many vessels, some merchant, but mostly naval contracted ships. After the French navy routed the English in the Battle of Beachy Head in 1690, the government orders to build further naval ships gave more work than the Royal dockyards could cope with. This gave the opportunity for smaller private yards to take on the contracts. The

proximity to Portsmouth and even Plymouth dockyards, and with the availability of timber from the surrounding forests gave the Beaulieu river an advantage and opportunity to develop its assets. The first naval vessel built on the River Beaulieu was, possibly at Bailey's Yard further up river, the 48 gun *Salisbury*, almost 700 tons, in 1698. It was in actual fact Duke John of Montagu who owned the Manor of Beaulieu who proposed the building of a port on the river to enable his plans of importing sugar from the West Indies. Buckler's Hard was chosen for its suitable natural 'hard' shoreline onto the river that was adapted, that is sloped, for the building of ships, and the river had enough depth of water for launching fairly big vessels of several hundred tons. The year

'AGAMEMNON'

D.G.BELL

now 1724, and Montagu Town, as it was proposed, was begun. A quay was built, new houses erected and a wide, some eighty foot, street was shaped and sloped down to the river. As it happened the fine proposals didn't really materialise and by 1731 only a few houses had been built. The 'sugar venture' had failed and the development of a new town collapsed. Not until 1739 and the war with Spain, then France, did the return of the shipwrights to the Beaulieu River renew the fortunes Buckler's Hard.

By the middle of the eighteenth century there was an upsurge in naval building and the River Beaulieu flourished again. When a naval vessel was ordered from a private yard a Navy Board 'overseer' was sent to do exactly that - oversee the ship being built and ensure the contract was fulfilled. Normally in those times he became resident during that period. The amazingly wide street between the two rows of cottages was now ideal for the storage and easy retrieval of timber, which was then available from the locally estate owned oak and elm forests. After serving the long apprenticeship as a shipwright at Deptford Dockyard Henry Adams was the man appointed in 1744 as overseer and expected to reside on the site for two years. As it turned out Adams never returned to Deptford to work but lived and worked at Buckler's Hard till his death in 1805. The name Adams is now synonymous with this place as much as his fame as a shipbuilder.

As the naval overseer he saw the launch of the first naval vessel the 24 gun *Surprise* in 1745 by the resident shipbuilder James Watt. Probably due to his marriage to a local girl, Adams gave up his government duties and took over the role of 'contractor' as a builder of ships at Buckler's

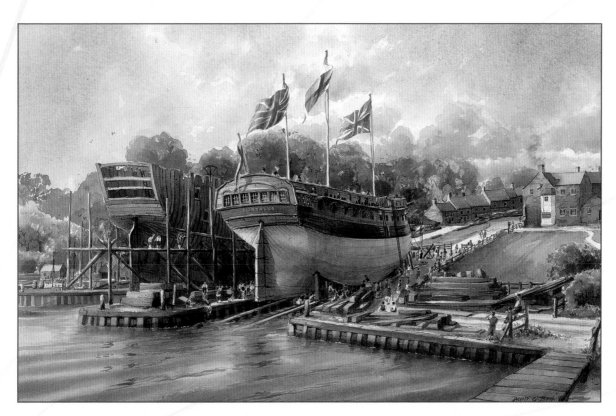

'Launch Day' H.M.S. Euryalus 8th. June 1803

Hard. The previous two builders had failed in their contracts, but Adams, a reliable and knowledegable man, with the encouragement from the Beaulieu estate took over in completing the launch of the 44 gun *Woolwich* and his first naval contract the 24 gun sloop *Mermaid* (500 tons) also launched in 1749. From this time to the start of the Seven Years War with France in 1756, the shipbuilding industry became precarious throughout private yards all over the country, but Adams survived the slump. It is strange that no naval ships were launched at Buckler's Hard between the *Hayling* of 1760 until the *Greyhound* in 1773 and the Adams yard still remaining solvent. His renewed business interests with ship-builders back in Deptford which built and launched many ships of the line and his interests in dealing with local timber and associated ironwork industry was to keep him with an income.

At last in 1774, Adams built and launched his first 'ship of the line' the 64 gun *Vigilant* at Bucklers Hard. Henry Adams was now a wealthy and established businessman in the world of shipbuilding and with the outbreak of war in 1776 shipbuilding took another upsurge. He now built the most famous ship at Buckler's Hard, the 64 gun *Agamemnon*, launched 10th April 1781. During its life the ship had noted commanders including two and a half years under Nelson and had a long and active service. The *Indefatigable* was another 64 gun, 3rd.rate, built later and launched in 1784, and was to have a noted commander in Admiral Sir John Pellew.

It was when Adams was given a contract to build his first, and longed for, 74 gun ship, the *Illustrious,* launched July 1789, the biggest rated ship to be built at Buckler's Hard, that he was to reach his shipbuilding zenith and at seventy seven years of age began to consider his future and take a back seat. Two of his sons, Balthazar and Edward, trained as shipwrights, took over the general running of the business and continued to build merchant and naval ships including the 74 gun *Spencer* and the 74 gun *Swiftsure* launched 1804. The *Swiftsure* is seen depicted with a watercolour on the stocks at Buckler's Hard almost completed and ready for launching.

The war with France from 1793 continued to 1802 until the short lived Peace of Amiens but in 1803 the Napoleonic Wars started, culminating in 1815, at the Battle of Waterloo.

The vessel I've featured here with several watercolours, commissioned some years back, show the building and launching of the 32 gun frigate *Euryalus* in 1803 and making way on its first commission after fitting out at Portsmouth dockyard. Like the *Agamemnon* and *Swiftsure,* the frigate *Euryalus,* all built at this shipyard, took part in the Battle of Trafalgar in 1805. There are several watercolours of these ships shown here, all contrived from the superb range of models on display at the museum. The *Swiftsure* model is quite exceptional, a finely made and finished work of art by the Japanese Ship Modelling Society and presented to the museum in 1998.

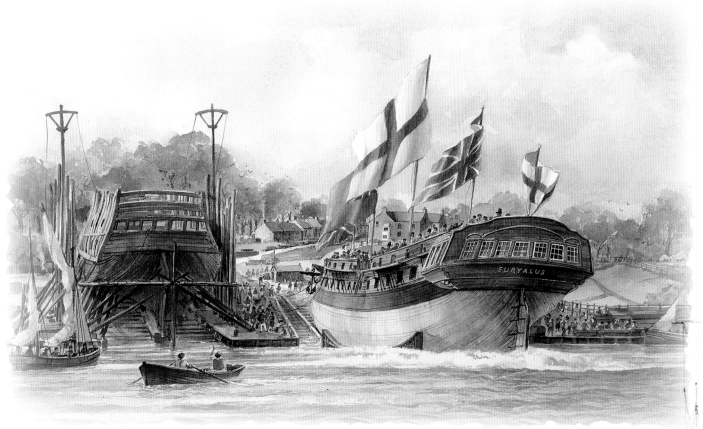

'The Launching'
Euryalus 36 gun Frigate 6th June 1803 Buckler's Hard

The 74 gun *Swiftsure* was built and launched in 1804, but the changes in government, the wartime economy and industrial changes actually saw the Adamses making a loss on this ship. The shipbuilding era was about to go into serious decline. By 1811, due to varied circumstances such as a lack of local timber, the long period of time building and the inflation that goes with it, and a lack of wider interests to support the, profitless at times, shipbuilding saw the Adamses' partnership end.

Shipbuilding itself continued at Buckler's Hard - Balthazar Adams died in 1821, but Edward precariously continued in building small vessels until 1838. The relative peace in England from 1815 to 1854 saw a decline in orders, but now the Industrial Revolution and its effect on shipbuilding practice saw nearly all the small merchant yards capitulate to the town and city yards. Buckler's Hard ceased to take any prominence in the Industrial Revolution and by 1845 the shipyard gave way to pastureland. Edward Adams, at eighty two, the last contact died in 1849.

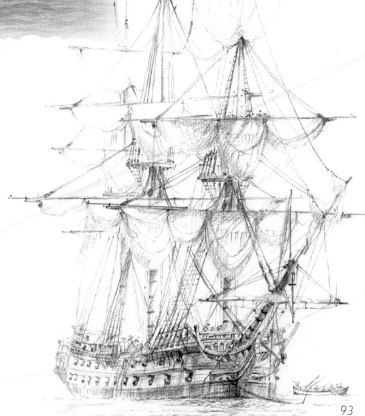

H.M.S. Agamemnon

The *Agamemnon* was laid down in 1777 at Buckler's Hard the yard of the famous shipwright Henry Adams and launched on 10th April 1781. Built to the Ardent class design the *Agamemnon* was a 3rd rate of 64 guns. Her most famous captain was Nelson himself who commanded the ship from January 1793 to June 1796, and was said to be 'Nelson's favourite'. Active service was considerable. Newly commissioned she was with Admiral Kempenfelt in the *Victory* at the Battle of Ushant 1781, and soon after, in early 1782, joined Admiral Rodney's squadron enroute to the West Indies, then joining up with Admiral Hood's fleet at Antigua. Here the opposition was the large French fleet under Admiral de Grasse based at Martinique. The two fleets eventually met near Dominica in April that year in what was to become known as the Battle of the Saintes. The French flagship *Ville de Paris*, 110 guns, and de Grasse himself were captured.

Peace followed and the *Agamemnon* returned to Chatham dockyard in June 1783 until 1791. With the outbreak of the French Revolutionary War in 1793 the ship was commissioned with Nelson as the new commander. Into the Mediterranean with Lord Howe's fleet, but under the control of Admiral Hood, started blockading French ports and undertook diplomatic missions. The *Agamemnon* also saw constant action with French frigates. In January 1794 the active *Agamemnon* was involved in the lengthy siege and capture of Corsica and during the landing at Calvi Nelson was injured from a gun-shot splinter to his right eye. The restricted vision resulted in his famous eye-patch.

When Nelson left in June and joined the 74 gun *Captain,* the now ageing *Agamemnon* was in much need of repair and returned once again to Chatham, in September 1796 and was eventually re-commissioned in 1797.

The mutiny of the channel fleet at Spithead in April 1797 was probably the only black mark in her illustrious career. At Copenhagen in 1801, with Admiral Parker's fleet, the *Agamemnon* under Captain Fancourt was present at the siege but due to grounding on a shoal contributed little to the contest.

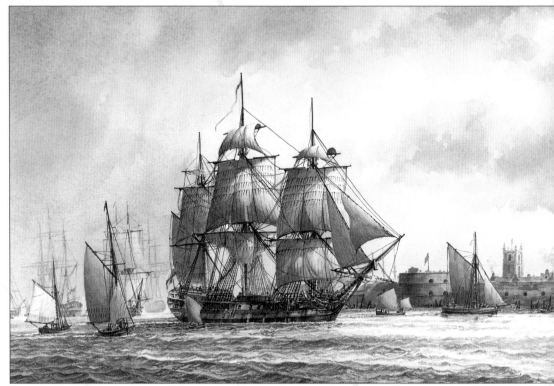

H.M.S. Agamemnon
Portsmouth 1781
*Nelson's first ship was the **Raisonnable**, one of the Slade designed 64 gun Ardent class, and built at Chatham 1765-68. When he joined at 12 years of age he would have known little of the complexities of fighting ships. But 22 years later in January 1793 he boarded another 64 gun ship the **Agamemnon** as her new commander.*

*A 3rd rate could have 64 or 74 guns, the **Agamemnon**, a 64 gun ship, was known as 'Nelson's Favourite', probably because she was fast and sailed well. He had her under his command for three and a half years. A very early watercolour shown here sailing out of Portsmouth Harbour.*

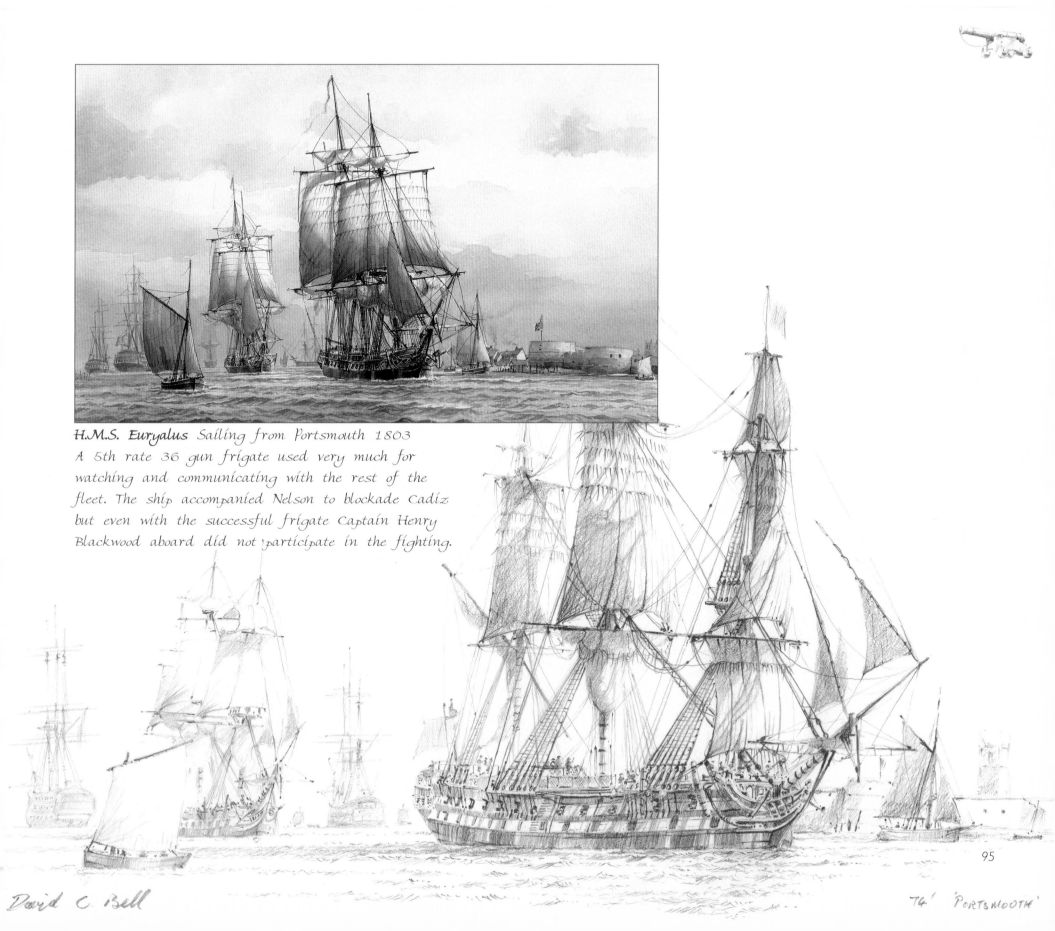

H.M.S. Euryalus *Sailing from Portsmouth 1803*
A 5th rate 36 gun frigate used very much for watching and communicating with the rest of the fleet. The ship accompanied Nelson to blockade Cadiz but even with the successful frigate Captain Henry Blackwood aboard did not participate in the fighting.

David C. Bell

74' 'PORTSMOUTH'

The Peace of Amiens in 1802 saw many ships paid off and laid up in 'ordinary', futures uncertain. The start of the Napoleonic Wars a year later now saw these ships recommissioned and the *Agamemnon* joined Cornwallis with the Channel Fleet in 1804. Involved in Admiral Calder's indecisive action off Finisterre with a French squadron under Villeneuve in the July of that year. After a long hard blockading duty of French ports the ship was refitted at Portsmouth and back on duty, this time with Collingwood's squadron on blockade duty off Cadiz. The next major engagement was Trafalgar itself. The ship was in Nelson's weather division halfway along the line behind the 100 gun *Britannia*. Under a brave Captain Berry the outgunned veteran engaged French and Spanish ships including the great *Santisima Trinidad* of 136 guns before

the famous victory was certain. Even then the *Agamemnon* was to take the severely damaged seventy-four *Colossus* in tow, now under storm conditions, to safety fifty-five miles away in Gibraltar harbour - a six day ordeal.

Endless action again in the West Indies under Admiral Duckworth before returning on convoy duty to England and Chatham for a refit in December 1806.

The final chapter was the voyage to South America, a politically created situation, which saw the ship in and out of ports in an increasingly poor state of seaworthiness. In 1809, seeking refuge in the Rio de Plata the ship grounded off Montevideo harbour and was lost.

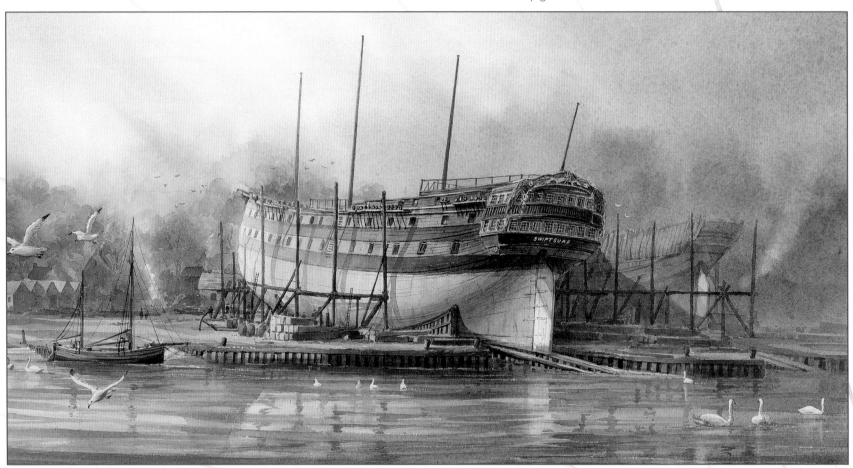

'Daybreak at the Hard' H.M.S. Swiftsure 74 guns on the stocks Buckler's Hard 1804

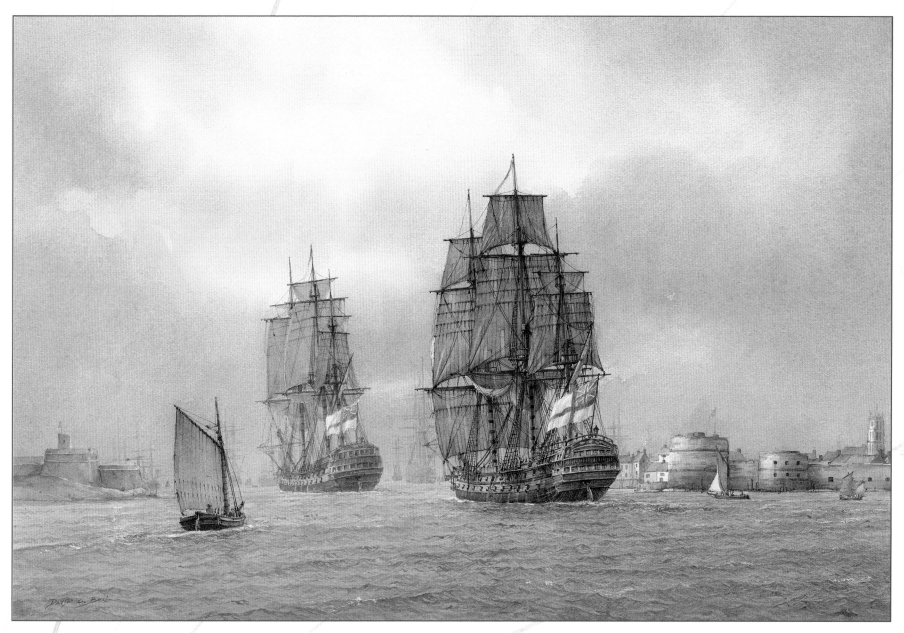

H.M.S. Agamemnon Portsmouth

As mentioned the Flag-Captain of the **Vanguard**, when Nelson joined her in March 1798, was Captain Berry. After the Battle of the Nile, Berry was injured and on his passage back to England was captured, but eventually released and back in London was knighted for his gallantry. He was a close friend of Nelson and was appointed to the **Agamemnon** in October 1805, just in time to be in Nelson's column.

War was declared on Britain by France in February 1793 then Spain and Holland joined the coalition. Nelson was appointed to the *Agamemnon*, 64, at Chatham in February of that year. This was his first 'ship of the line,' aboard which he saw his first but brief action with the French frigate *Melpomene*, 44.

Napoleon Bonaparte who was to become a long time adversary, had retaken Toulon, on the French Mediterranean coast, from Britain and her allies. It was here whilst in Naples delivering dispatches, Nelson first set eyes on Emma, the wife of Sir William Hamilton. The meeting was brief as Nelson was soon in pursuit of French prey and he and Emma would not meet again for another five years.

Nelson's task in the Mediterranean was to provide a more central base for Hood and his ships. He was to make raids on the coast, taking Bastia in Corsica, at the time held by the young Bonaparte. Ironically, it was on land, overseeing the bombardment that Nelson received a stone splinter to his forehead that was to impair his sight, and resulted in him wearing the famous eyepatch to shield his eye from strong sunlight.

It was whilst in command of the *Agamemnon* that Nelson, now under Admiral Hotham's squadron, engaged a French fleet leaving Toulon. The French ship *Ca Ira*, 84 guns, fouled a fellow ship, losing the fore and main topmasts and was so greatly impaired and lagging behind, that Nelson managed to harass the ship until her surrender was almost inevitable. However the remaining French fleet returned to the *Ca Ira*'s rescue and relief. The event that ensued is known as the 'Battle of the Gulf of Genoa', 14th March 1795. The following morning whilst the *Ca Ira* was on tow by the *Centaur*, 74, well astern of the French fleet Hotham's fleet took up the attack once more. Though the French ships turned back again in support, the *Ca Ira* and the now crippled *Centaur* were captured.

H.M.S. Victory (detail)

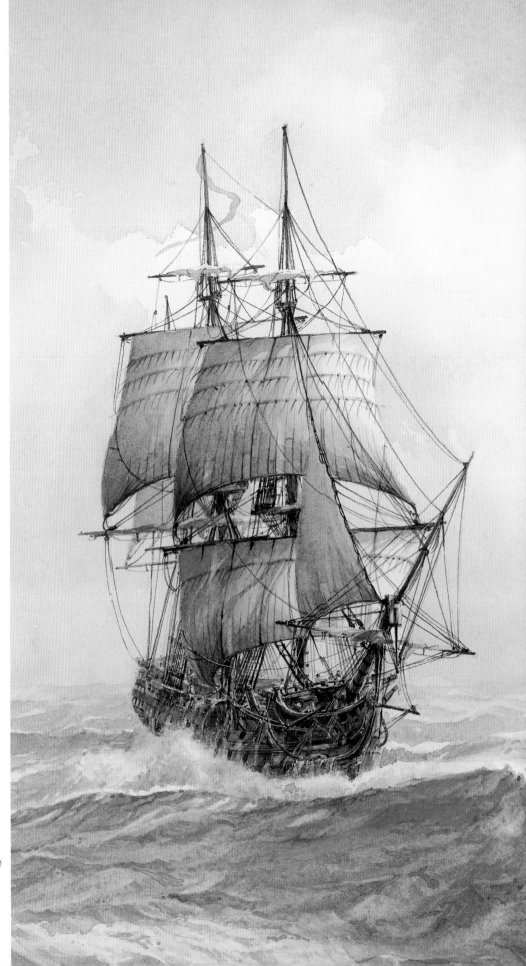

Now under Sir John Jervis, Nelson had proved to be an exceptional officer and was transferred after three years on the *Agamemnon*, which returned home for much needed repairs, to the *Captain,* 74 guns. His abilities, if not actual achievements, aboard the *Agamemnon* earned him promotion and he was formally given the rank of commodore in June 1796. He now transferred his broad red pennant to the *Captain*, and was given a 'Captain' for general command of his ship.

Blockading duties and moving troops to Elba, all to thwart the French, now occupying northern Italy, came to an abrupt end when the British withdrew from Corsica and the Mediterranean. Nelson sailed to Gibraltar and with new orders boarded the frigate *La Minerve*, originally a French frigate, captured in 1795. At the time she was under command of Captain Cockburn, as commodore. They sailed to Elba to evacuate British troops. This short voyage was full of incident with action against Spanish warships.

'Captain' 74

San Josef (112)

ORION (74)

Battle of Cape St. Vincent 14th February 1797 about 4 p.m.
Nelson now in command of the 74 gun ship 'Captain'. part of Jervis's fleet of 15 ships on blockade duty.
The Spanish ships - 27 returning to Cadiz for supplies prior to sailing north to join the
Dutch ships to confront the British. the fleets met 20 miles off Cape St. Vincent.
Jervis in command on the 'Victory' & Admiral Cordova in the 130 gun 'Santísima Trinidad'.
The sketch shows Nelson in the 'Captain' (far right) coming alongside the San Nicolas (80)
boarding and taking her & then boarding & taking the San Josef which had collided with the San Nicolas.
The 'Orion' (74) follows the 'Captain' into the action.

After this eventful passage he left the Mediterranean on board the *Captain* to rejoin the fleet near Cape St. Vincent off the South-west corner of Portugal. Ten miles off Spain's Atlantic coast Admiral Jervis and his fleet were waiting for the Spanish ships. In ships and firepower the Spanish fleet under Admiral Cordoba had a considerable advantage. The opposing fleets formed a 'line of battle' and on the morning of the 15th February 1797, the Battle of Cape St. Vincent began. The watercolour shows Nelson in the *Captain* centre stage in the battle scene.

It was in this battle that Nelson in the *Captain*, 74, engaged alone the Spanish first rates *Santissima Trinidad*, 130, *San Jose*, 112, *San Salvador del Mundo*, 112, and *San Nicholas*, 112 guns. The balance of defeat for Nelson was ridiculous but the *Captain* survived until the *Culloden*, 74, arrived on the scene to relieve the situation, followed by the *Blenheim* and *Prince George*. By mid-afternoon the *San Nicholas*, under heavy fire, turned away and fouled the *San Josef*. This gave Nelson the opportunity to close and board the *San Nicholas*. Without hesitation and with amazing bravery Nelson himself boarded the enemy ship and rapidly took her surrender. The adjacent *San Josef*, still firing, was then boarded by Nelson and his sailors from the decks of the *San Nicholas*, and also surrendered. Nelson transferred from the battered *Captain* to the *Irresistible* and returned to Lisbon. He resumed command of the *Captain* after repairs, and now, promoted to Rear-Admiral of the Blue, joined another 74 gun ship, the *Theseus* in May 1797, and continued blockading duty with Jervis's fleet off Cadiz. It was this action at Cape St. Vincent that catapulted Nelson's career into the history books.

It was after this confrontation with the Spanish, and on the relentless blockade duty that Jervis' with Nelson, decided to take the offensive and planned an attack on Santa Cruz in the Canary Isles, and capture a reported 'treasure' ship. Initially, they decided against an attack on Santa Cruz due to the great possibility the winds would be unfavourable, resulting in military force having to be landed to overcome the defensive forts. At the time no troops were available, or willing. However the news that the frigates *Minerve* and *Lively* had attacked and cut away a French frigate in broad daylight, encouraged Jervis to allow Nelson to make an attack. With eight ships and an extra two hundred marines, Nelson was ordered to attack Santa Cruz, destroy enemy ships and capture the reported 'treasure' ship and return forthwith. Briefly, a first attempt to land troops and simultaneously sail into Santa Cruz harbour was fouled by the predictably adverse weather. Nelson, still determined to succeed, attacked again, on the 24th, leading the assault himself. It was on landing that Nelson was hit by a musket ball, shattering his right elbow and was quickly returned to his flagship, the 74 gun *Theseus*. His arm was immediately amputated near the shoulder, and he yet again survived to fight another day.

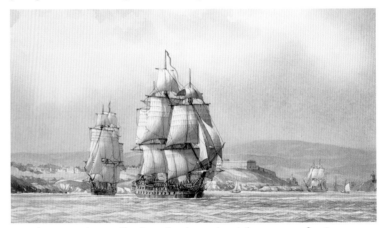

*Again another Slade designed ship, one of the formidable 'Arrogant' class, the **Vanguard** was a 74 gun, 3rd rate, built at Deptford and launched 1787.*

Nelson joined her at Spithead in March 1798, initially going on convoy duty with Admiral St. Vincent's fleet, but went on to the Mediterranean to find and ascertain the movements and intentions of the French fleet.

The Battle of the Nile was three months later.

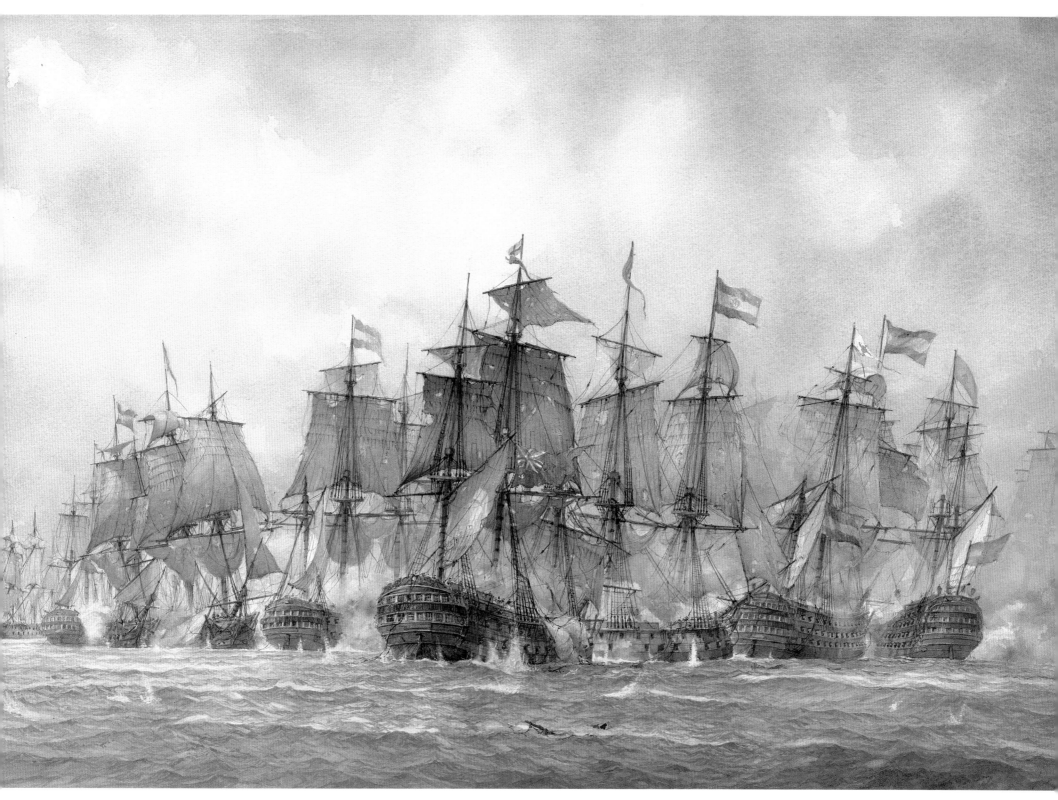

Battle of Cape St. Vincent
15th February 1797

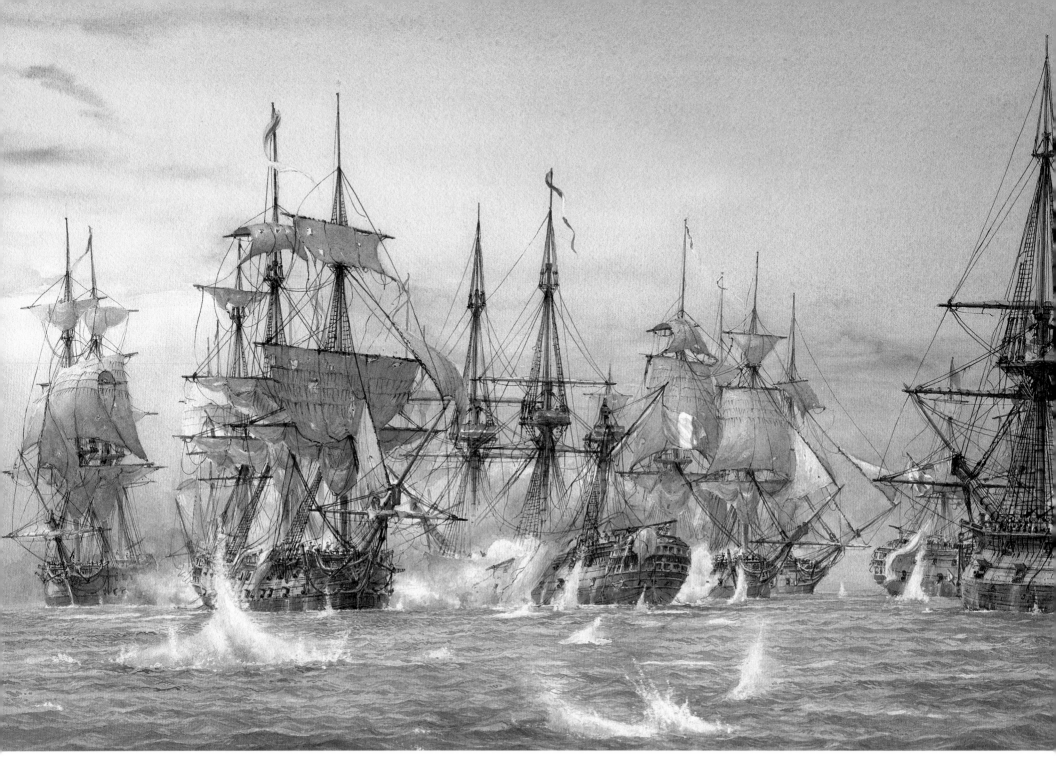

Battle of the Nile 1st August 1798

This was the spot where Admiral Brueys anchored his fleet at the uncharted Aboukir Bay
some 15 miles east of Alexandria. The **Theseus** under Captain Miller is seen anchoring alongside
the French **Spartiate** with the **Goliath** just astern. Nelson is in the **Vanguard** behind the **Aquilon** which
is anchored in the foreground on the right.

The fate of the remaining landing force was dire. A Captain Troubridge, from the *Culloden*, 74, with few men fought his way to the centre of the town, only to be surrounded by a much greater force and was doomed to defeat. However, by declaring boldly that the town would be put to the torch unless allowed to return safely, Troubridge and his men were remarkably allowed to do so and retrieved the day from a complete disaster to a failed mission. Nelson, in great pain and despondent at his failure, had thought that he would have led the assault and that it would be a complete success and 'crowned our efforts'. In reality his rash impetuosity to lead and defeat a superior enemy, ready and waiting, was fuelled by self-esteem, not by stealth, reason or a practical force, but by his desire for glory and success. At this minor place of confrontation he only just escaped with his life. He returned to England September 1797 on the *Seahorse* to recover his health.

His wound now healed, Nelson was recalled by Jervis in March 1798 and was able to command another 74 gun ship and rejoin Jervis off Cadiz - this time in the *Vanguard* and another episode began.

With a squadron of ten ships, Nelson was given priority in the duty of reconnaissance of the French fleet in the Mediterranean starting with Toulon. The French 'Directory' still wanted to invade England and Bonaparte was in command of the army to do so. But the channel and the indomitable British Navy was to divert Bonaparte's military efforts elsewhere - namely Egypt, the east and beyond with his '*Armèe d' Orient*'.

Now in the *Vanguard*, 74, bad weather and the slight mishap of losing a topmast put Nelson into the refuge of San Petra Bay, Sardinia, with the company of the *Alexander* and *Orion*. On leaving he had news from Captain Hardy in the frigate *Mutine* that his squadron, in his absence, was going west, en route to Gibralter, not what Nelson wanted or would have done.

- NILE -

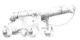

Nevertheless Nelson was eventually reinforced with more ships including his close friend Troubridge in the *Culloden*. Nelson had enough fire power to tackle Admiral Brueys and the French fleet - if only he knew where they were and what their intentions were. In a huge expanse of water with very slow communications it was a very difficult exercise, to say the least, to collect any hard facts. On local intelligence acquired from intercepted ships Nelson and his Captains agreed that the French must be heading for Egypt and a path to the East.

Bruey, the French fleet and the army arrived at Alexandria in July. The army disembarked and marched on Cairo, entering the city in triumph by the 15th July. Meanwhile Bruey, unsure of access into Alexandria, tentatively anchored in Aboukir Bay some fifteen miles to the east of Alexandria, close to the shores of Aboukir Island. Nelson and his fleet had actually arrived in the vicinity of Alexandria several days before the French but the restless Nelson headed north in pursuit towards Turkey then all the way back to Sicily in a fruitless search before his watchful frigates gave news of the French fleet. It was at the beginning of August that the *Zealous* sighted the enemy masts in Aboukir Bay and Nelson prepared to make an immediate attack.

The French had anchored fore and aft, tight into the shore, close to shoals, forming a formidable line of battle, but being so static and with an adverse wind the rear ships became merely onlookers if they were not engaged. Late in the afternoon Nelson went straight in, leading his column of 74s intending to attack the van and then the centre of the French line. It was Captain Foley in the *Goliath* at the van of the British ships who, in a bold move, dared to go to landward of the leading French ship the *Guerriere*. He had assumed there would be just enough water to attack this less prepared side of the French, and he was right. At the appropriate time they anchored, using the bow anchor with a line bent on and led aft, overboard, through a stern gunport and made

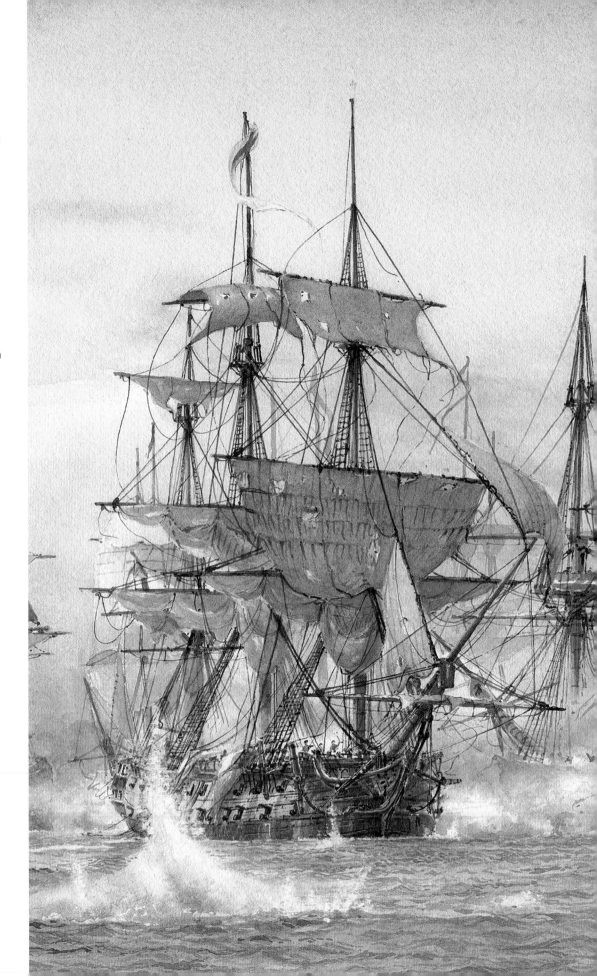

fast. This gave the ship a slight improvement in the arc of fire when hauled on by either line. The French ships also had this arrangement to increase their own arc of fire. The *Zealous, Audacious, Theseus* and *Orion* followed. Now with five ships on the weaker French port side, Nelson and the rest of his ships selected an enemy ship to engage and anchor alongside. The battle commenced with Nelson having a decisive advantage. The barrage of fire from both sides resulted in heavy damage and many casualties, Nelson himself taking a splinter in the forehead but bravely maintaining command. It was a resounding victory.

Unfortunately, I've not sailed this far east in the Mediterranean and was undecided to tackle such a subject. An event so late in the day might prove problematic to depict but the two hundredth anniversary of one of Nelson's victories was encouragement enough and I've retrieved preparatory drawings and a quite complex painting to be included here. In the painting the British ships initially headed by the *Goliath* form the main subject, the *Theseus* in the foreground which had anchored once to engage

the *Spartiate* but then moved and re-anchored close to the *Aquilon* further up the line. The French ships are all facing to the left, first the *Guerriere* then the *Conquerant* and then half into the picture is the *Spartiate* with Nelson's *Vanguard* in the background and coming up to anchor alongside her starboard side, less than a hundred metres away.

I should mention two things of interest here. Firstly, Captain Darby and his ship the *Bellerophon* on his turn in the line anchored next to and engaged the French flagship the *L'Orient*, a huge three-decker with 124 guns. A brave, but very one-sided duel developed with the smaller British ship totally overwhelmed, outgunned and slowly battered to pieces. However she replied with her own broadsides which resulted in fires breaking out on board both ships, one in particular on the Frenchman looked likely to spread onto the almost touching *Bellerophon* and so she cut her cables to drift away for survival as much as safety.

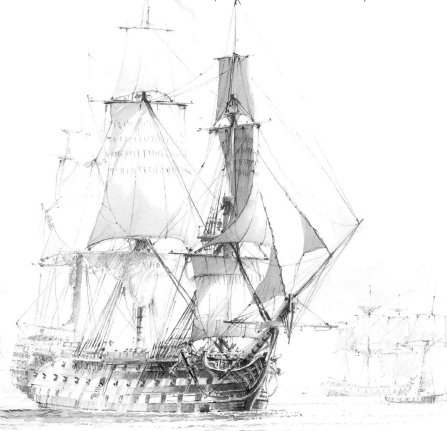

Study of 'Ships of the Line' H.M.S. Victory in centre.

Two 74s now entered the battle. The *Swiftsure* replaced the *Bellerophon* and the *Alexander* came round the *L'Orient's* bows and anchored on her port quarter - both pounding out broadsides into the Frenchman. The hot iron sinking into the ship's timbers caused a fire aft on the *L'Orient* and spread rapidly, so much so the ship's crew decided to escape overboard and all went quiet awaiting the inevitable explosion. Quite an explosion it was as the remains of this ship are still being found today far from the spot. But, to my second point of interest, a Captain Hallowell of the *Swiftsure* picked up some wreckage, part of the *L'Orient's* mainmast, and had a coffin made for Nelson (for future use) from this wood and presented to him. Whether he ended up in it I don't know.

The loss of eleven of thirteen French ships and most of their Admirals was a decisive victory. The British Navy was now in control of the Mediterranean seas and a blockade of Egypt put Bonapartes'*Armèe d' Orient*' into a solitary position.

to formulate yet another coalition of 'armed neutrality' and impede the British fleet's ongoing intention to blockade the French fleet.

The strictures of trade in the Baltic created by this coalition, and the signing of the 'Treaty of Armed Neutrality' in December 1800, initiated the mobilisation of the British fleet. Lord St. Vincent, at the Admiralty, organised and sent a fleet to the Baltic. Their efforts were intended to allow British merchantmen free trade and movement and, hopefully, force Denmark to withdraw from the Alliance This was to be under the command of the cautious Admiral Parker, the fleet sailed for Revel in the Baltic (now Tallinn, Estonia), to intercept the Russian navy. They sailed first to Copenhagen where they were to suppress the Danish fleet anchored in front of the city walls.

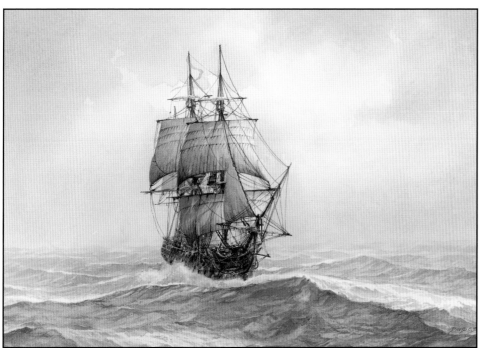

H.M.S. Victory at Sea

I have no record of any paintings of this next conflict to show but to briefly keep things in order what happened next was the continuing conflict in Europe in 1800. This partly stems from the 'Seven Years War' back in 1756 when France and Britain fought over colonial possessions, especially over young America and faraway India.
An alliance was formed between Prussia, the Holy Roman State of Hanover and Britain against an alliance between Austria, Russia, Sweden and France. The 'Peace of Paris', in 1763, ended the war, but resumed again when King Louis XVI was executed at the start of the French Revolution, and resulted in France declaring war on Britain in 1793. This time a coalition between Austria, Prussia, Spain, Portugal and the Netherlands was formed against the rising supremacy of France.

The French continued to gain victories on land and when they defeated the Austrians in 1800, the nations of Russia, Sweden and Denmark were

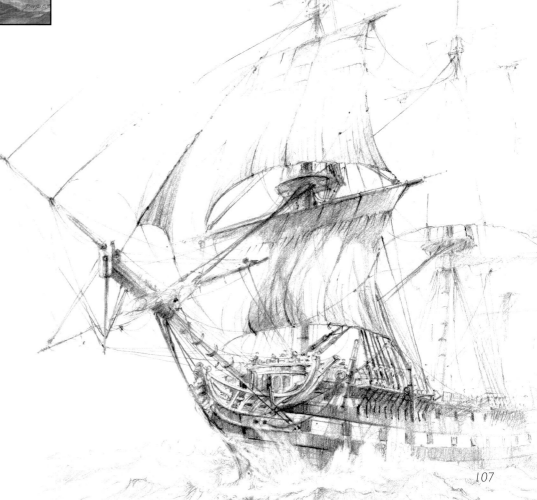

107

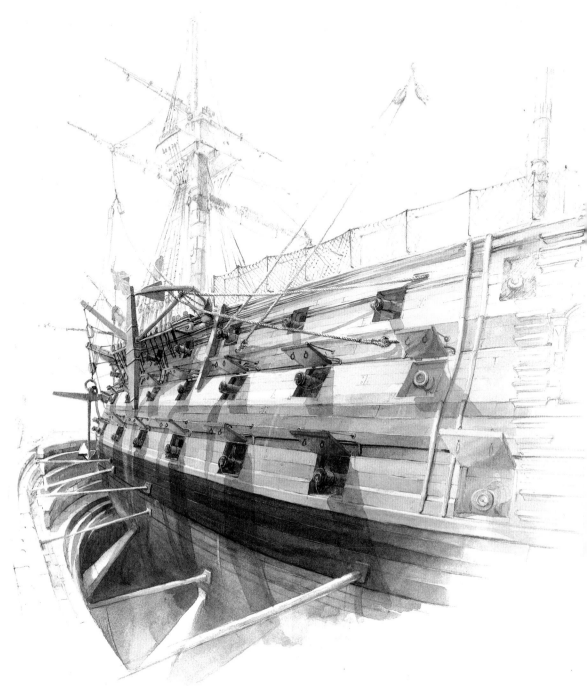

Promoted Vice-Admiral of the Blue, Nelson was appointed to the *St. George*, 98 guns, as second in command of the fleet, and had his reliable friend Captain Hardy aboard. From the outset Sir Hyde Parker had made it clear that he had little respect or liking of Nelson and not until the approach to the Skagerrak did they meet and talk of tactics. Their fleet had to subdue the Danes at Copenhagen before moving on to ships in Sweden and Russia. It was in this battle that Nelson was to turn a 'blind eye' to Parker's ambiguous order to 'discontinue action' when Nelson's squadron was at a precarious stage against the Danish ships.

The British fleet anchored in the Kattegat, to the north of the Swedish port of Helsingborg. Opposite this port, in Denmark, is Helsingor, at the narrowest point between Denmark and Sweden. This strait which opens into a waterway known as 'The Sound,' leads into the Baltic Sea and has Copenhagen, on one of the many islands of Denmark, to the east, and is a strategic point for anyone entering it. A spectacular landscape makes an interesting transit to sail through when making for Baltic ports. Even now I find it hard to visualise a fleet of ships with sail-less masts at anchor here as a line of defence for a city. But in the Kattegat the British fleet waited for the enemy to show for what Parker wanted - a duel at sea. However Nelson, as second in command, gave his suggestions for an assault on Copenhagen and a two pronged attack was devised to destroy the fleet moored off the city walls. Prior to this attack, in Nelson's view, his ship drew too much water for the shoals off Copenhagen and so transferred his flag to the *Elephant*, 74, under

This could be called a 'study in patience' as it was quite an ambitious undertaking but clearly shows the complex structure and dimensions of this ship. I was with a colleague at the time who was on board sculpting a new Nelson relief from a huge piece of original 'Trafalgar granite', to soon mark the new spot where Nelson died.

Drawing from life is an essential and fundamental part of the process to competently render any image on paper. The **Victory** is a great subject for this. Docked here at Portsmouth in 1780 the **Victory** was refitted, painted and re-coppered along with a 'large repair' which was almost a rebuild. Finally docked for preservation in 1922.

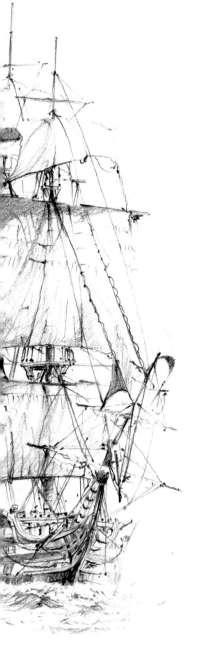

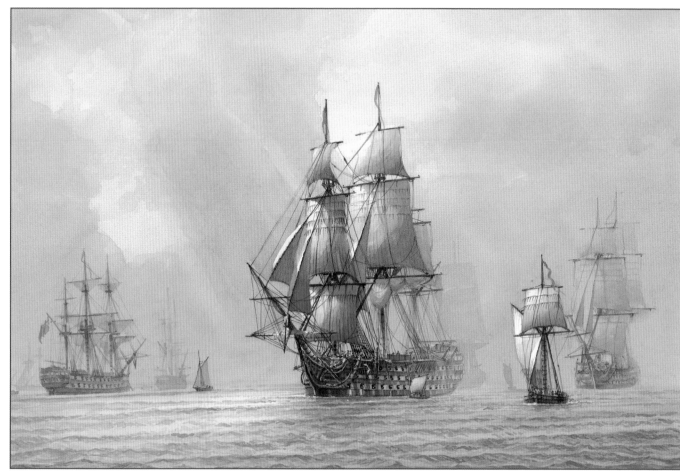

H.M.S. Victory *Getting under sail in the green-tinged waters of Spithead. At Trafalgar Nelson was Commander-in-Chief Mediterranean and like Collingwood a Vice-Admiral, his weather column consisted of 12 ships of the line, and Collingwood's 15 ships.*

Captain Foley, though hardly fifteen inches separated their draughts. Nelson's old flagship the *Agamemnon* was unfortunately grounded on approaching the shoals and never got into the battle.

In the conflict that followed Nelson seemed to get the upper hand in the exchanges and the anchored Danish battery of ships, in a static 'line of battle', succumbed to the superior fire-power of the British that led, shall we say, to a truce in favour of the British. On 4th April Nelson transferred back to the *St. George*, and with the news of the death of

Tsar Paul of Russia, and the resulting negotiations with the Swedes concluded, the Baltic campaign effectively ended and the fleet returned to England. An armistice followed with the 'free movement of trade', and in May 1801 the 'man' was rewarded once again. This time he was given the title of Viscount Nelson of the Nile and Burnham Thorpe.

Nelson's pursuit of the French and the events prior to Trafalgar are interesting. The French Admiral Villeneuve was always ahead of Nelson in time. He arrived in Martinique some three weeks before Nelson

even arrived in Barbados. An encounter with the French fleet at Martinique would have been possible but for the misinformation from his commander at St. Lucia on Nelson's arrival in the West Indies. It was this wrong news that made him sail south to Trinidad rather than north to the French held Martinique. On learning that Nelson had arrived in the vicinity, Villeneuve tactfully sailed back to Europe, heading to Ferrol, northern Spain.

Chance information received by the Admiralty enabled Admiral Barham to issue orders to Cornwallis for his five ships to join with the ten ships of Admiral Calders (at the time on blockade duty off Ferrol) to 'find and engage the French'. He was redeployed to intercept the French and did so, late in the day, on 22nd July, but darkness brought an end to this confused and indecisive action. Both admirals failed to make any more clear engagements. Calder's priority was to preserve his crippled fleet whilst Villeneuve just sailed in to Ferrol. Nelson's superior, Cornwallis, ordered the returning *Victory* and *Superb* (74) back to Portsmouth for some leave and much needed rest for Nelson.

Villeneuve and his fleet, under orders from Napoleon, managed to leave Ferrol to go to Cadiz, there to join forces with the Spanish and seize Gibraltar. The logistics of maintaining a fleet of ships was then, as now, an enormous task to achieve and maintain. Thus the impending invasion of England was suffering, with the French fleet effectively incarcerated at Cadiz. But elsewhere, the Russians and Austrians now formed a coalition with Britain against France forcing Napoleon to turn his attention east to deal with that threat.

Victory at Spithead 14th September 1805
The keel of this ship was laid down on 23rd July 1759 at Chatham Dockyard and was launched six years later on 7th May 1765. Launched during a time of peace the ship was laid up and moored off the dockyard until 1778 and the start of the conflict with France and the U.S.A.

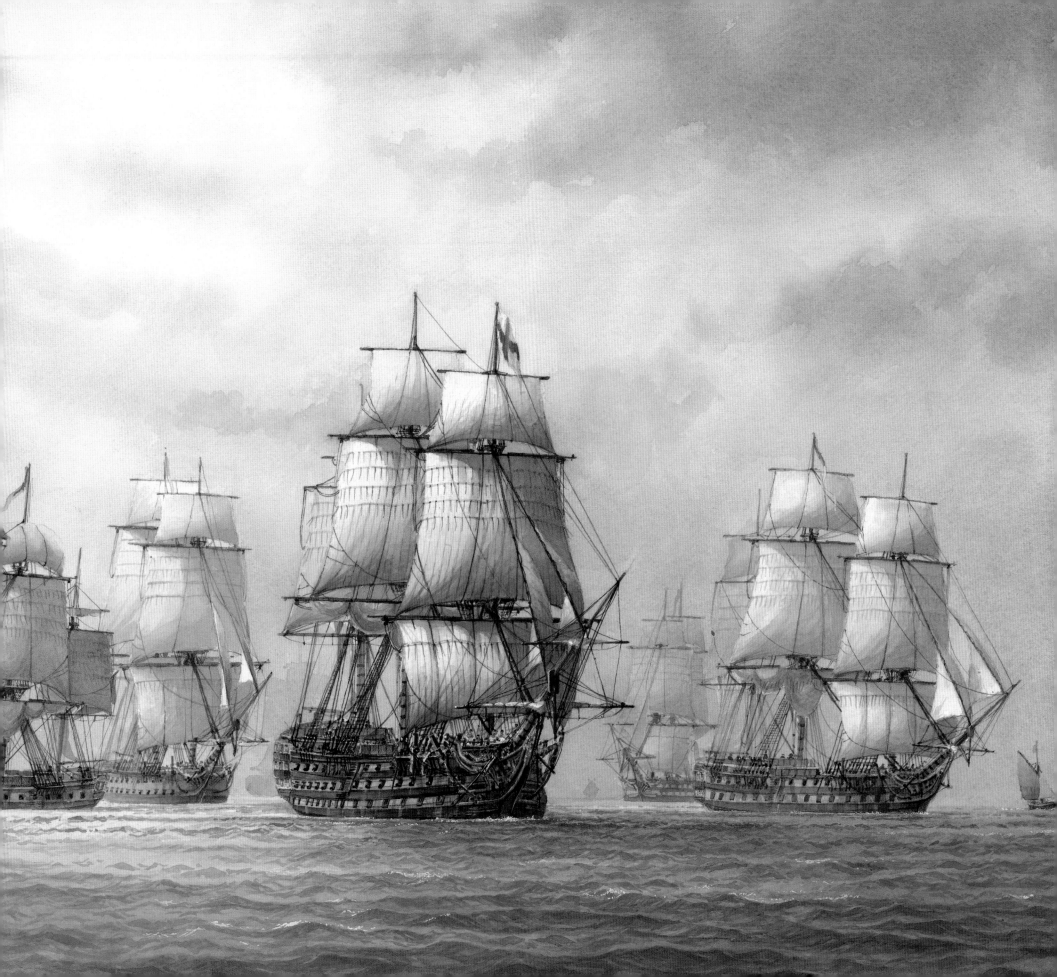

Captain Blackwood of the frigate *Euryalus* brought news of these events to Nelson who immediately went to Portsmouth and re-joined the *Victory* at anchor leaving on the 14th September 1805. They took three days just to sail along the coast to Plymouth, where they were joined by the 74s *Thunderer* and *Ajax*. By the 28th Nelson was off Cadiz and had now at last caught up with Villeneuve. At this point the French invasion of England was postponed, if not cancelled - Villeneuve and his fleet were under orders to sail into the Mediterranean and land troops at Naples to defend Bonaparte's 'soft underbelly' against the British threat.

During the coming battle Nelson had believed Admiral Decres to be in overall command, rather than Villeneuve, who was himself unsure of his future as an admiral and certainly wrong in the belief that the British blockading fleet was seriously weakened. However Villeneuve chose his moment, and early on the 19th October left Cadiz. Albeit with light but favourable winds it took till the following afternoon before an assortment of thirty-three ships, Spanish and French, slowly cleared Cadiz and, getting their act together, sailed west to get some leeway, before heading south to the Straits of Gibraltar.

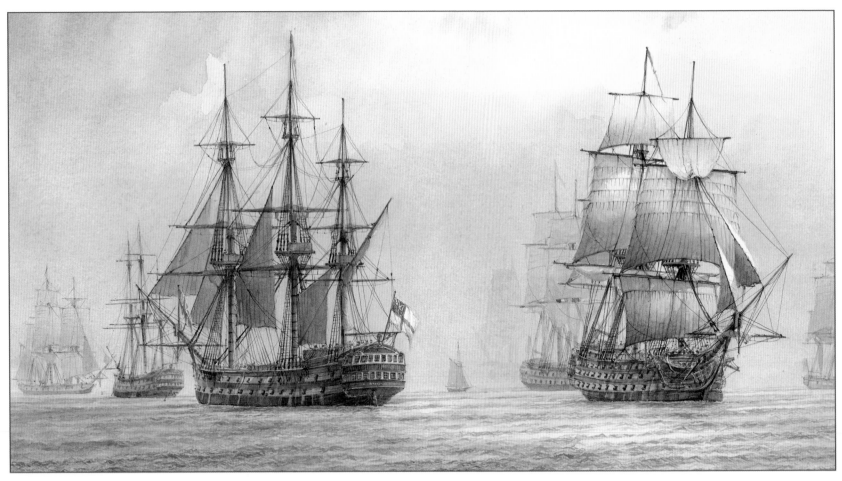

H.M.S. Temeraire
Built Chatham 1798 98 guns
Her only glory was at Trafalgar and in Turner's painting The Fighting Temeraire.

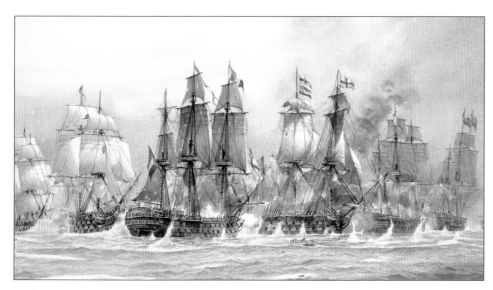

This very early painting, that probably should be illustrated with a complete blanket of acrid brown smoke, depicts the **Victory** 'breaking the line' around 12.20 p.m., approximately. The **Victory**, taking centre stage, with the **Bucentaure** on her port side and the French 74 **Redoubtable**, seen almost stern on, to starboard, about to run alongside. This ship was commanded by the diminutive Captain Jacques Lucas. A courageous and extremely able sailor who though severely wounded that day survived the battle and was taken prisoner, returning to France in 1806. His captured ship was lost in the gale after the battle, but it was the Emperor Napoleon who said of him 'had all my officers acted as you did, the battle would have been a different story'. Perhaps.

Intending to make for the Straits through the coming night, Villeneuve realised his haphazard fleet would more than likely make contact with the enemy fleet and by the morning had signalled to his ships to prepare for battle. The morning of the 21st saw both adversaries in sight of one another - Nelson had only one intention - to bring the reluctant enemy to battle. His plan was to attack the enemy line from windward in two, possibly three columns - effectively cutting it up into three parts and thus concentrating his ships' firepower on a 'smaller' isolated enemy. Villeneuve was wise enough to guess Nelson's tactics, but a heavy swell with very light winds gave him little chance of manoeuvring the ships to his advantage. It was in fact the lee column led by Collingwood in the 100 gun *Royal Sovereign* that started the Battle of Trafalgar. His ship must have had better sailing qualities in those conditions and pulled ahead of the *Belleisle* to engage the French-Spanish line. Facing an enemy line of ships head on means you would incur several broadsides and suffer the appalling consequences. (Both Collingwood and then Nelson engaged with this action.) However if your ship survived it could equally return a broadside to devastating effect. Crossing the 'T' was not the best manoeuvre for either side, but rarely in any engagement in those days did a ship of the line sink even after many a cannonball struck.

The anxious Nelson, eager to be in the thick of it, ordered the slightly faster *Temeraire*, second in line, to keep astern of the *Victory*, and then crossed the 'T', though, from all accounts, it was by no means at right-angles. She took the first enemy fire from the Spanish ship *Santissima Trinidad*, then the French *Neptune*, *Redoubtable* and the *Bucentaure*. It was at this early stage that the few British ships engaged were in a dangerous position and most vulnerable to being overwhelmed. Not until the following ships had slowly moved into the fray and engaged an enemy ship did the battle turn to British favour. The pace was slow and the risk of crippling damage was real for the *Victory* but Nelson's aim of getting in to close quarters with the enemy meant accepting this tactic.

Trafalgar 21st October 1805
*Another early watercolour of this battle and a subject I would tackle quite differently now. Slightly unusual in having a broadside view of the **Victory** and showing nothing immediately on her portside, but which is about to lock spars with the French 74 **Redoubtable**.*
There is probably far too much 'artistic licence' in this scene, which gives too much clarity and neatness.

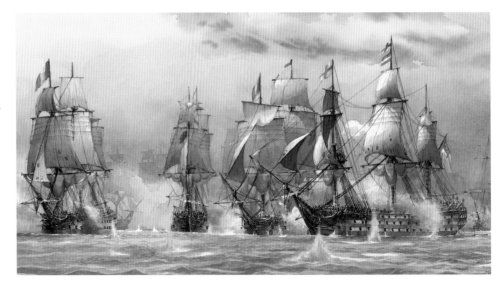

His reliance on the seamanship, gunnery and the seasoned salts aboard his ships would, he reckoned, eventually win the day. Then across the 'T' the Victory had the chance of unleashing her devastating broadsides on either side, raking the *Bucentaure*, Villeneuve's flagship, with a broadside of cannonballs from stern to stem rendering the French flagship crippled and vulnerable. The mass of lumbering ships, French, Spanish and British now came together in a furious exchange of shot, grenades and musketballs; duels were fought out at closequarters until ensigns were lowered in defeat, all in a sea of smoke, noise and confusion. Once the opposing ships came together it simply became a free-for-all in selecting, or just by chance, an enemy ship and out-gunning it into submission. Two against one was desirable.

Emerging through the smoke the *Victory* now runs onto the *Redoubtable* which was the one ship that could match the *Victory* with its now heavily damaged rigging. The *Redoubtable* a 74 gun ship was under the command of Captain Lucas. He would manoeuvre for close combat, get attached with grappling irons and then board and overcome his opponent through armed physical force of man against man. To help matters his 'tops' were full of trained marksmen. Of course this was the intention of most Captains on both sides, but the action was Captain Lucas's speciality.

The 98 gun *Temeraire*, under Captain Eliab Harvey, seen immediately behind *Victory* in the painting, was about to come onto the scene. Only minutes behind the *Victory* and approaching the line, she took broadsides from the French *Neptune*, returned fire herself and turning to port came up alongside the *Redoubtable*, now sandwiched between two powerful three-deckers. The casualties and carnage on Lucas's ship below decks can hardly be

imagined but his marines in the tops were there to clear the enemy's decks and to make way for their own boarding parties. A hail of grenades and musketballs kept the British sailors looking for cover and the *Victory's* decks clear. That is except for Nelson and Captain Hardy. Then one marine from many marksmen in the *Redoubtable's* mizzentop, who would have been abeam and probably no more than 60 feet away from Nelson put a musketball, aimed I would suspect, or possibly at random, we don't know, above the easy target of his medals, fatally, into Nelson's chest and down into his spine. He was done for in his moment of glory, barely minutes into the first duel. Neither ship succeeded in boarding and it was damage from the the incessant fire power of both ships, muzzle to muzzle that neutralised each other, almost suspending

firing. As exchanges became infrequent, the French made the final effort to board the *Victory* by using a lowered yard as a bridge. Hard to imagine it being done in all that mayhem but with the *Temeraire* now alongside and pounding the Frenchman, all this was abandoned, and Lucas struck her colours to the *Victory*.

The French 74 *Fougeux* under the heroic Captain Baudin went from the fury of one action, already badly mauled by the *Royal Sovereign*, to drift through the smoke and collide with the *Temeraire* only to be met with more shattering broadsides. Still putting up a fight until cannons, their crews, Captain and officers had suffered many casualties the *Fougeux* was boarded and taken. The *Fighting Temeraire* was now in the history books.

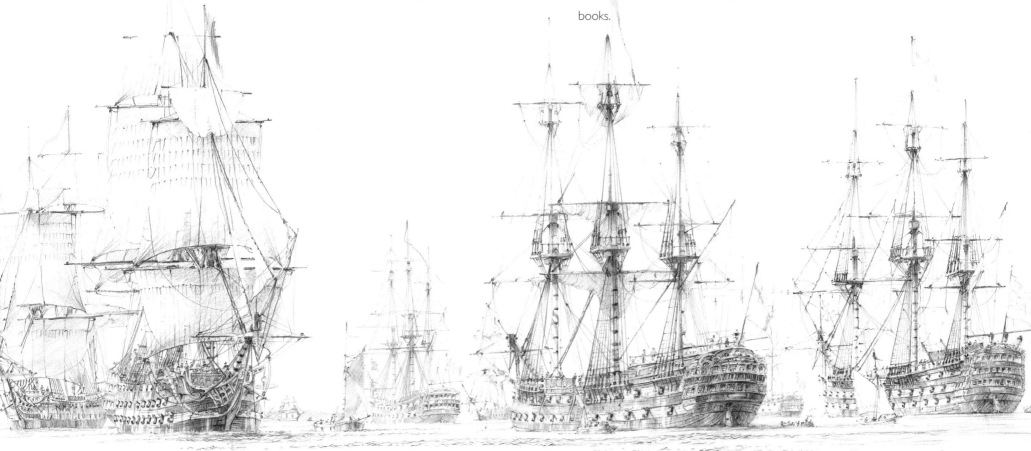

Pencil study, again, of 'Ships of the Line' at Spithead

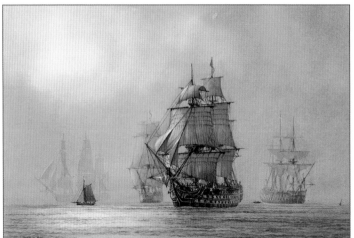

H.M.S. Temeraire

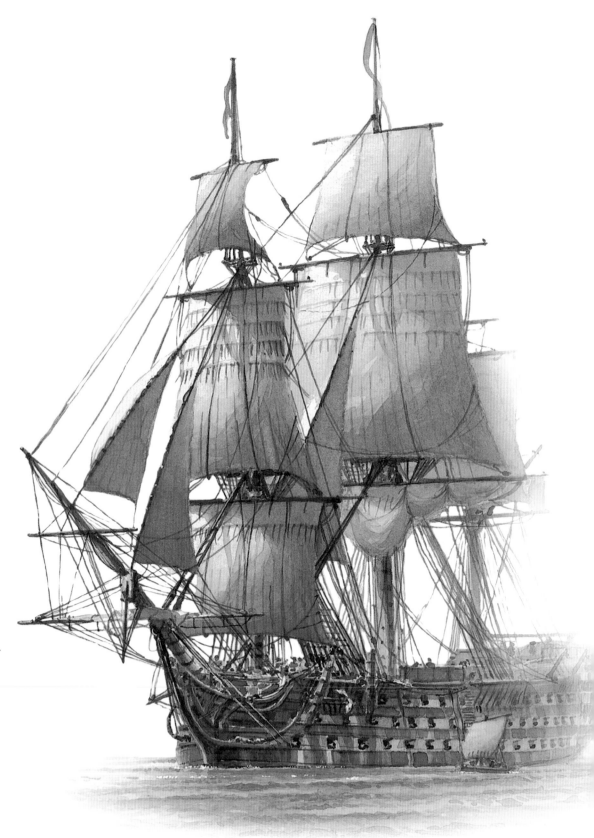

The shattered *Victory* wallowed away, inactive, lamenting the dead Nelson. But the casualties were considered light, though in the end the *Victory* had the highest fatalities on the British side.

Sadly though, both the *Redoubtable* and *Fougeux* were wrecked the following day, with even greater loss of life than in the battle itself.

The triumph of Trafalgar was complete in itself with eighteen of the enemy ships, from a total of thirty three, taken or destroyed. Even after the battle itself three other enemy ships were coming out of Cadiz to assist the fleeing ships, and were themselves driven ashore and wrecked. Also Admiral Dumanoir's van of some four ships, decided to head north to the safety of Ferrol but unfortunately met Captain Sir Richard Strachan and his squadron and were all taken as prizes.

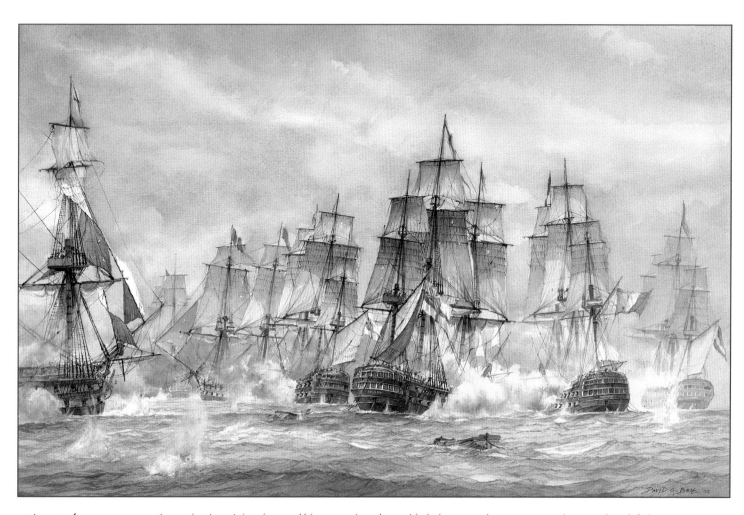

The **Colossus** was the sixth ship in Collingwood's lee division and was to have the highest casualty rate, over 200 men, of the British fleet.

Commanded by Captain James Morris the ship engaged the French **Swiftsure** and then the **Argonaute**, both 74s, in a ferocious duel. The watercolour shows the **Colossus** in the centre, stern on, engaging the French **Argonaute** to starboard; the **Bellerophon** ahead is engaging the French **Aigle** and Spanish **Bahama**. Coming up astern is the British 74 gun **Revenge**.

The ship suffered severe damage but survived, and was taken in tow by the **Agamemnon** back to Gibraltar before the impending storm.

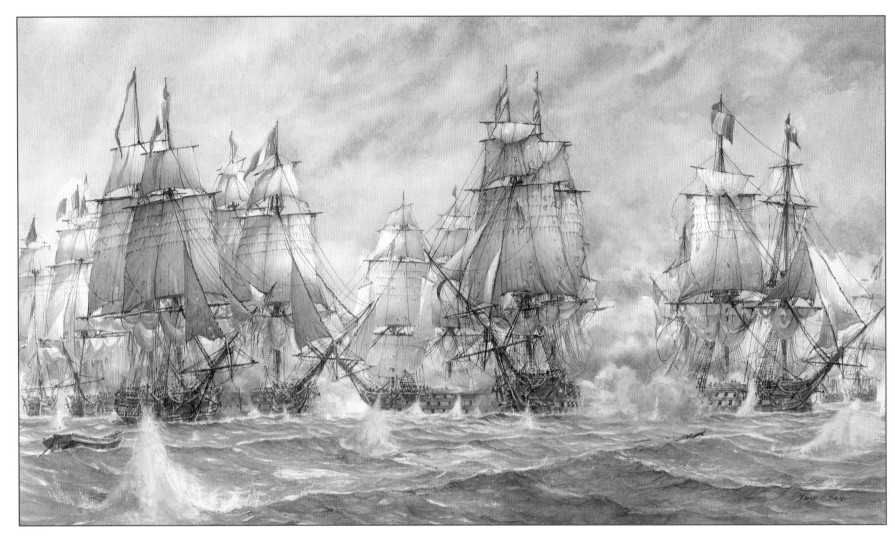

Battle of Trafalgar 21st October 1805

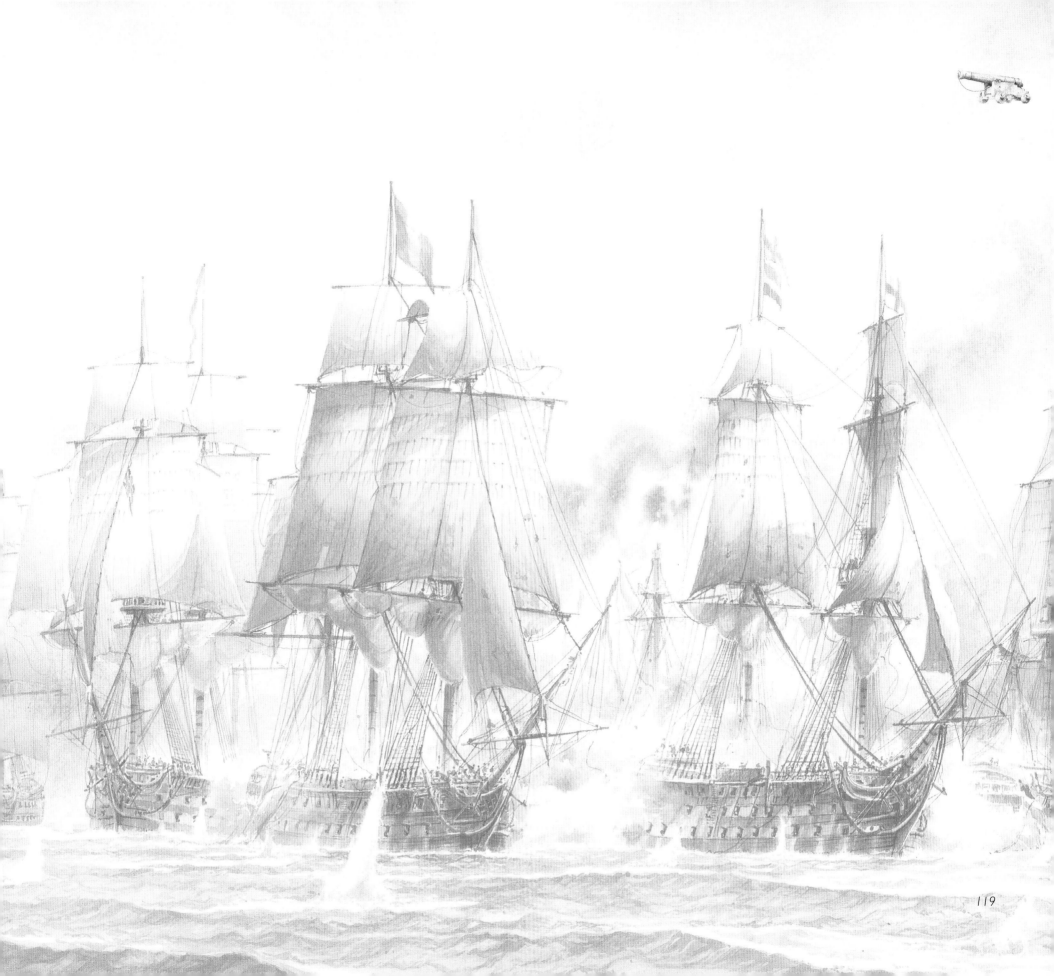

So some twenty five ships were taken or destroyed during or after the battle and the storm that followed was itself a major contributor to the final outcome. Nelson would have anchored with all prizes and weathered the storm and then sought refuge at Gibraltar. But Collingwood, then in command, saw otherwise and made immediately for Gibraltar with the prizes in tow, but over the next few days lost nearly all the captured ships, though not the French *Algeciras* (74) which was retaken and reached the safety of Cadiz.

The enemy van at Trafalgar was commanded by Admiral Dumanoir le Pelley in the *Formidable*, 80 guns. It can be said that it was the serious irresponsibility of Dumanoir's indecision, if not reluctance in the van, not to come about and join the action at the very onset of the battle that weakened Villeneuve's ability to turn the battle into his favour. Had he done so it would not have been such a decisive defeat of the combined fleet. Though the outcome would still have been an English victory at that time, without such huge losses a regroupment of the French fleet would have been possible. The management and execution of Villeneuve's fleet was poor from the onset. Collectively the fleets were 'combined' but the reality was quite different. Spain, at the time an ally of France, had no intention of invading England, but that was Napoleon's obsessive quest. The reluctance, or lack of will and reason to wage war with the British navy was demonstrated by the inaction of the enemy 'van' of the combined fleets. In saying that, Villeneuve, his Captains and crews showed as much heroism and bravery as the English.

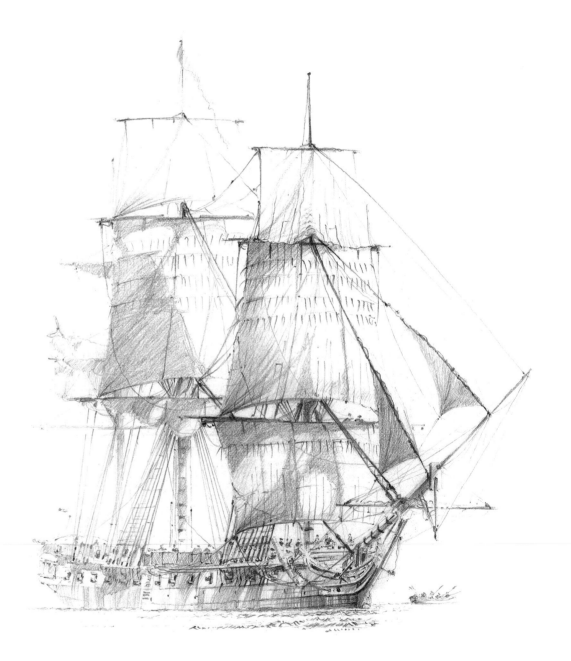

The final two columns, lee and weather, of Nelson and Collingwood, comprising twenty seven ships of the line, attacked in succession the French and Spanish centre of twenty three ships and defeated all but five. The superior sailing and seamanship of the British ships and the mastery of their gun crews in the prevalent conditions was the undisputed factor in their victory. It is strange that the great sea battles fought between nations in these times had little effect on the war on land. Nelson did not destroy the French navy at Trafalgar. After this sea battle the great loss of French and Spanish ships did not deter Napoleon's war in Europe and beyond. The French had a large fleet at Brest and Toulon and continued to build ships, but Napoleon was never to gain control of the sea.

He instead pursued his dream of conquering Europe by land until his demise at Waterloo.

Nelson's final words 'I have done my duty' form an appropriate end to this colourful part of the odyssey on the man and his ships. The coincidence of his death at the time of his finest success made him into the enigma of immortal hero to historians, great sailors and British people alike.

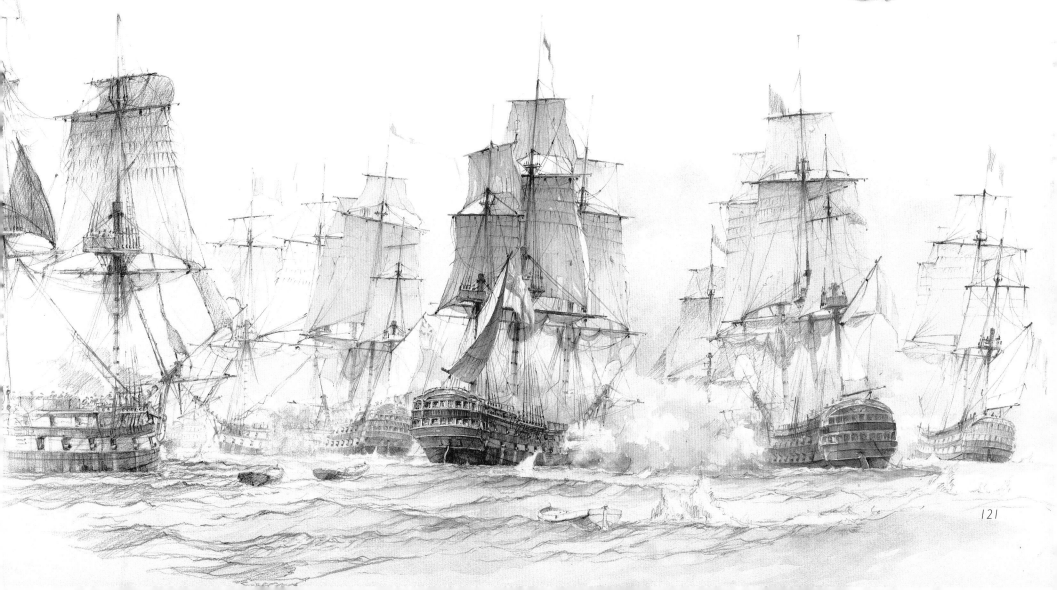

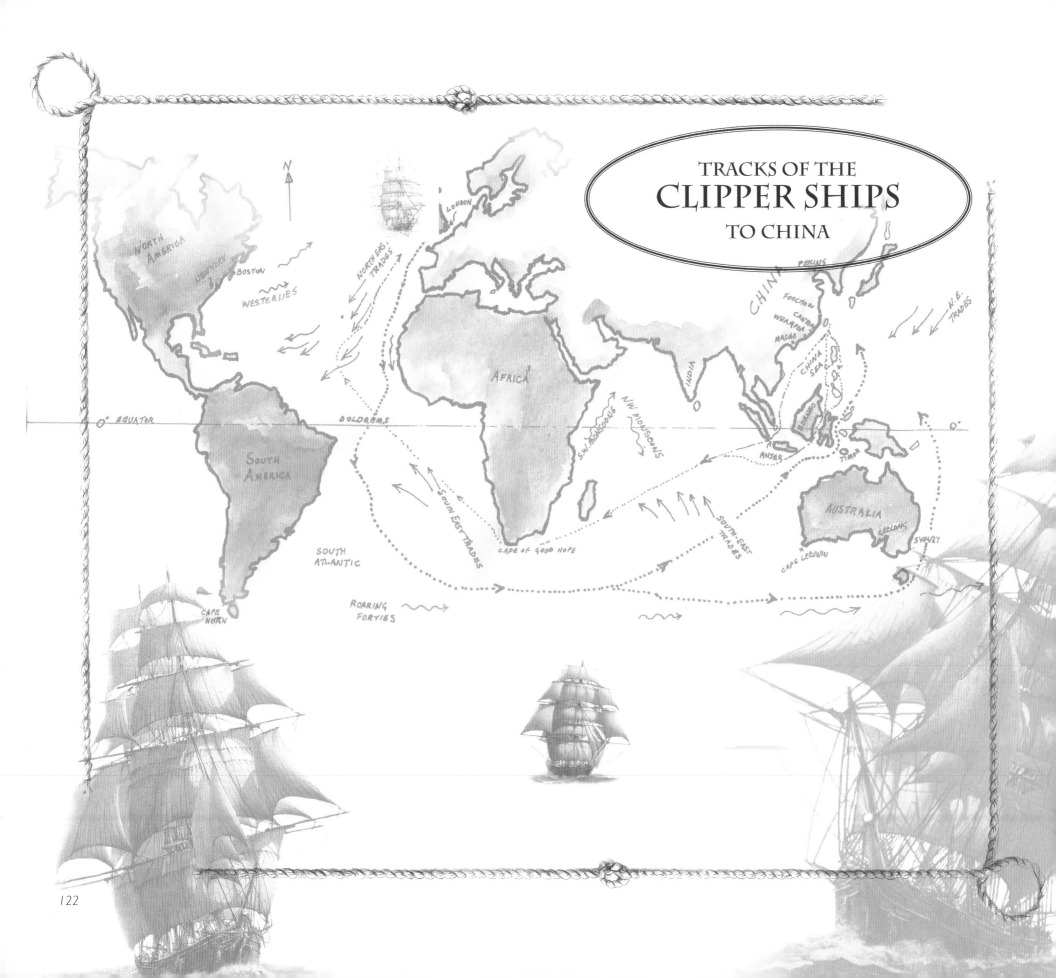

TRACKS OF THE
CLIPPER SHIPS
TO CHINA

NORTH
AMERICA

NEW YORK
BOSTON
WESTERLIES

NORTH EAST
TRADES

N

LONDON

CHINA

PEKING

FOOCHOW
CANTON
WHAMPOA
MACAO

N.E.
TRADES

0° EQUATOR

DOLDRUMS

AFRICA

INDIA

SOUTH
AMERICA

SOUTH EAST TRADES

S.W. MONSOONS

N/W MONSOONS

CHINA
SEA

BORNEO

ANJER

TIMOR

AUSTRALIA

GEELONG

SYDNEY

SOUTH
ATLANTIC

CAPE OF GOOD HOPE

SOUTH-EAST
TRADES

CAPE LEEUWIN

CAPE
HORN

ROARING
FORTIES

122

The Clipper Ships

Cutty Sark - Thermopylae - Taeping - Torrens - Samuel Plimsoll - James Baines

H.M.S. Beagle - Sovereign of the Seas - City of Adelaide - True Briton - Ariel

The Clipper Ships

From watchkeeping and stargazing in the sixties and seventies I took quite a dramatic change of course, in fact not only just changing tack I came right about and headed back to land. I looked at my own aptitudes and abilities and from a life at sea, pondered, and opted for the arts, and eventually fine art.

After I left the sea, survived art college and started painting seriously I had the opportunity to go to the Falkland Islands and paint a series of commissions for the military, which I did and as difficult and exacting as it was I enjoyed nearly all of it. I went in 1984 exactly two years after the war, and on landing was immediately struck by the lack of verdure or any interesting landscape features. A fairly bleak, treeless range of tussock and scree covered hills, much like the duller parts of Scotland. When Darwin and Fitzroy on the *Beagle* arrived in March 1833 his observations were on similar lines to mine and probably most visitors since. It's at this point I can add more to the tapestry by introducing the *Beagle* and bridging the gap between the 'naval' era and moving on to 'trade and discovery'.

From over a hundred of the 'Cherokee' class 10 gun brig sloop H.M.S.*Beagle* was one of five chosen for survey duties built between 1817-1832. Not considered as a great sea-boat, this class of ship undertook many different duties. The *Beagle* was built and launched at Woolwich in 1820, laid up in ordinary and five years later was chosen for survey service, its first commander being Pringle Stokes, and the inhospitable southern peninsular of South America beckoned.

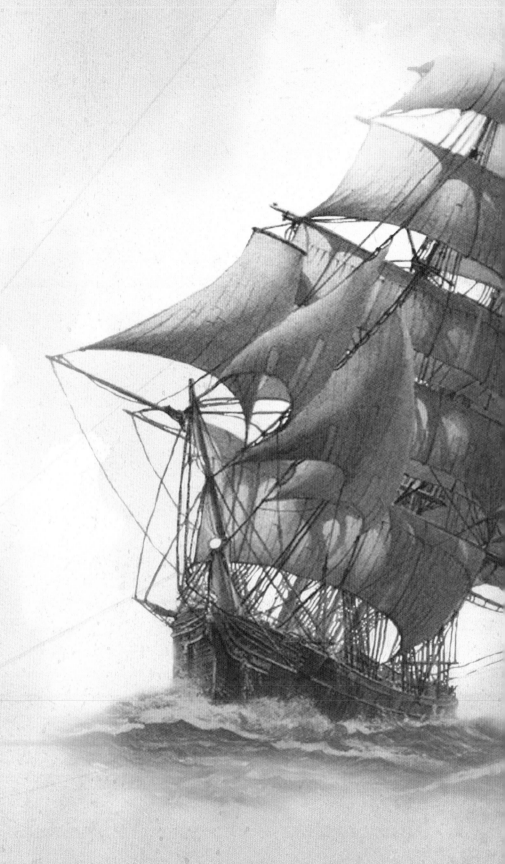

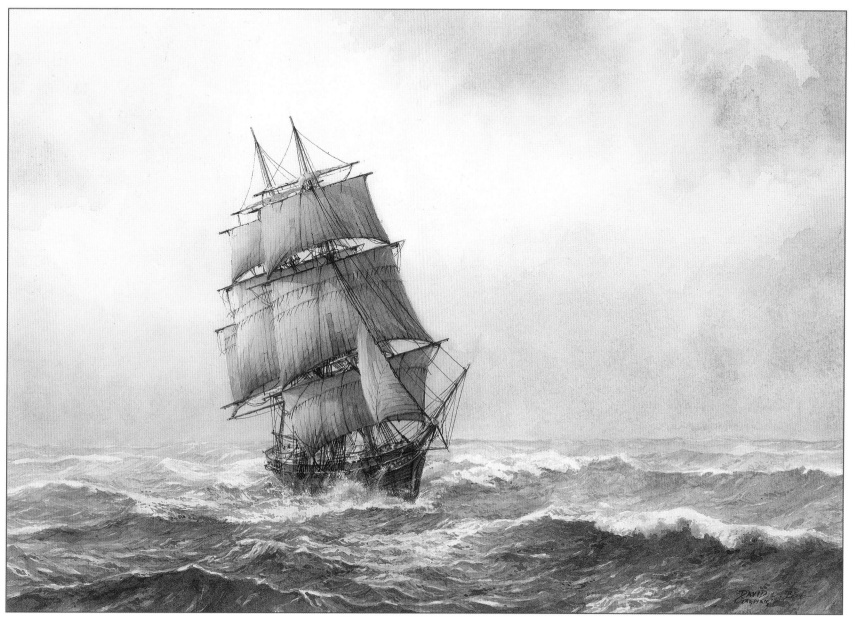

Sovereign of the Seas

One of Donald McKay's first big clippers, this fine ship, launched at his Boston yard in 1852, took 103 days on its maiden voyage from New York to San Francisco. Shown here in heavy seas and shortened sail, the ship was tested at the very outset on a passage that included Cape Horn. Under the German flag and new name the ship foundered in the Malacca Strait and was wrecked in 1859.

There is a little vagueness as to the authenticity of the *Beagle's* exact design and build. The first refit of the *Beagle* for survey duty was major and transforming. Fore and main masts repositioned and a third added as a mizzen mast, to make her 'barque rigged'. Bits and pieces added and altered and on her second voyage, this time at Plymouth Dockyard, under the supervision of her next master Commander Robert Fitzroy, was extensively refitted and altered again. Nothing was quite what it seemed and I found working to these plans quite difficult and drew many possibilities before opting, right or wrong, for what is shown. The earliest is the *Beagle* leaving Plymouth on the third and most famous voyage with Darwin on board. Of course this amazing five year voyage with the competent Fitzroy as master and navy hydrographer and the young Darwin, made the name *Beagle* rise to historical fame. But the travels of this tiny ship including the third voyage and the survey of Australian waters under Captain John Lort Stokes have made her famous in maritime history.

From what I can gather of Darwin and the Falklands he wasn't too impressed with the scenic wonders, or lack of, and Fitzroy spent only a month surveying this odd set of islands before going back to the mainland and Montevideo. A small asset in the form of a sealing schooner was procured by Fitzroy in the Falklands naming it *Adventure*.

126

-- H.M.S. BEAGLE -- PORT LOUIS FALKLAND ISLANDS MARCH 23RD. 1833

1831 THIRD COMMISSION UNDER COMMANDER ROBERT FITZROY - Charles Darwin as naturalist.
FROM T. DEL FUEGO ARRIVED FALKLANDS 1ST. MARCH FOR SURVEYING & REPAIRS. LEFT 6TH APRIL FOR ARGENTINA.

This assisted in survey work of the islands whilst the *Beagle* returned to the mainland, and back to the Falklands, clewing up there and back to the mainland coast before rounding the Horn and sailing up the western seaboard via Valparaiso to the Galapagos Islands.

From there the *Beagle* travelled across thePacific, eventually to the Bay of Islands in New Zealand. A beautiful and historic landscape, even when it's raining, and I've included a contrived drawing of the ship seeking an anchorage. Unlike most visitors today Darwin, as with the Falklands, wasn't impressed with what he saw in New Zealand leaving without much reluctance to the similar latitudes of Sydney, Australia. As it is throughout the book my own connections with the ships and here with the *Beagle's* voyages, are simply the places it visited. The visits to Montevideo, the Falklands and the Bay of Islands, New Zealand and Eastern Australia were all on the *Beagle's* second voyage from 1831 to 1836. My visits to all these places were over a much bigger time span and though I eagerly put brush to paper in those places I have, unfortunately, a fairly sparse folio of work left to reproduce here. Except perhaps the Falklands, and as I spent a fascinating five weeks painting all over the islands at the request of the military its influences on my work should be at least mentioned here.

The *Beagle* arrived in the Falklands from Tierra del Fuego in March 1833. As previously said, after a few weeks surveying they departed for the Argentinian coast and on to Chile.

Captain Fitzroy would not have seen in those times what was so starkly apparent on my visit in 1984 which was the amount of shipwrecks. Some were just a few remaining weatherworn timbers or rivetless bilge plates left mud-bound and decaying, but many quite substantial and recognisable, the *Lady Elizabeth* being the most notable.

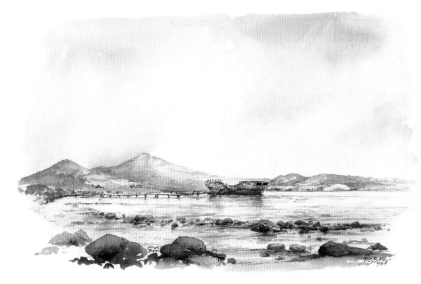

Jhelum at Port Stanley, Falklands 1984
A sketch of the remains of this small sailing ship on a very cold morning at the western end of Stanley harbour. Built by Joseph Steel and Son of Liverpool 1849, the Jhelum has been in residence here since 1870 another victim of the Horn weather.

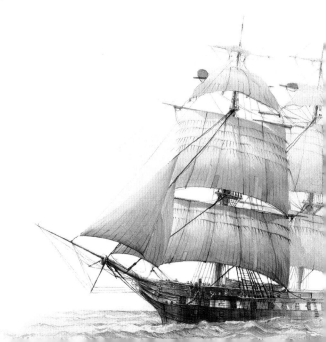

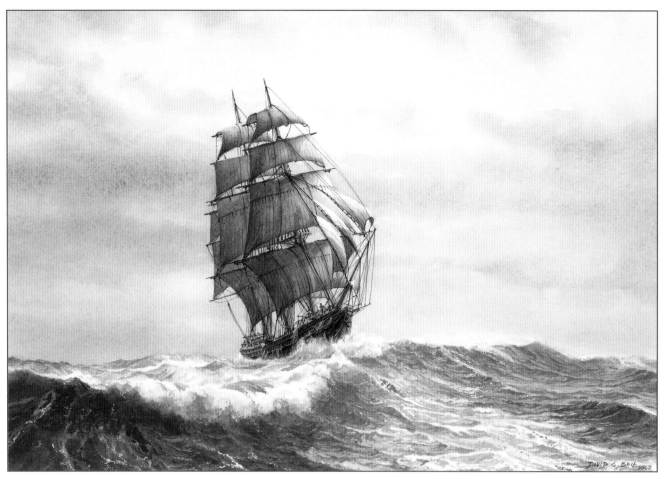

City of Adelaide

At the Scottish Maritime Museum known as the **Carrick**

It was built by John Pile & Son of Sunderland and launched in May 1864 as the **City of Adelaide** for Devitt & Moore's passenger run to Australia. The ship can be rightly described as a 'small clipper' at only 791 tons. Like the **Cutty Sark** she was a composite built ship. The reason it still exists is probably because it was planked in teak like the later locally built **Torrens**, and had an unusual but attractive half-rounded poop, the top sheer of which was painted white and extended well forward as an accessible passenger deck. This lovely little ship's career was quite varied - a training ship, a store ship, a hospital ship, a naval hulk, and, as the Naval gunnery training ship **H.M.S. Carrick** on the Clyde. After spending a year, for some reason, on the Clyde sea-bed she was raised and brought round to Irvine harbour, now the National Maritime Museum of Scotland, and hauled up on a slipway for what can only be described as an uncertain future. Certainly the hull and decks can be repaired to look as new but masting and rigging would be out of the question. I felt strongly that I should in some way contribute to her restoration and produced a painting of her to help in funding the restoration and as the painting shows is in full sail with single topsails, before being replaced with doubles. There is still plenty of interest in securing her future, mainly from Sunderland and Adelaide but a great amount of foresight and energy will be required rendering it an immense task.

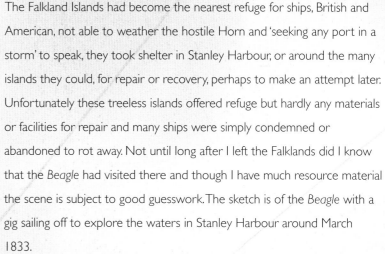

I once drydocked in Sunderland in the sixties, when the shipbuilding industry was, like the Merchant Navy, in rapid decline. The history and feel of a maritime town was still in the air, but the shipyards were soon to become 'real estate'. Not until sometime later after visiting the Carrick at Irvine in Scotland did I realise it was actually built in Sunderland and I strongly believe, the maritime minded people of this town would and should have it, to be preserved here, in any condition.

The Falkland Islands had become the nearest refuge for ships, British and American, not able to weather the hostile Horn and 'seeking any port in a storm' to speak, they took shelter in Stanley Harbour, or around the many islands they could, for repair or recovery, perhaps to make an attempt later. Unfortunately these treeless islands offered refuge but hardly any materials or facilities for repair and many ships were simply condemned or abandoned to rot away. Not until long after I left the Falklands did I know that the *Beagle* had visited there and though I have much resource material the scene is subject to good guesswork. The sketch is of the *Beagle* with a gig sailing off to explore the waters in Stanley Harbour around March 1833.

When I could I managed to observe and sketch some of these static relics. The harbour front at Stanley had then a row of large wooden sailing ships moored alongside the quay and used as storage 'sheds'. Some of the masts could be found around and about adapted for various uses but the upper decks on all of them had been covered in corrugated steel making a vernacular and durable warehouse, simply a storage hulk, which, apart from sustaining its life also complemented the town's local roofing style. Being the first in line and at the quieter end of the port, the easiest ship to sketch was the *Jhelum*, a ship built in Liverpool in 1849 which, via the Horn, came to rest here in 1870. Fortunately I could get clear views to paint from the lee of a sheltered bank along the water's edge about a metre high, which was a feature of the Falklands wherever you went. The tide, in these latitudes hardly a metre in range, interfered very little to the time you took but the constantly incessant bad weather made up for it.

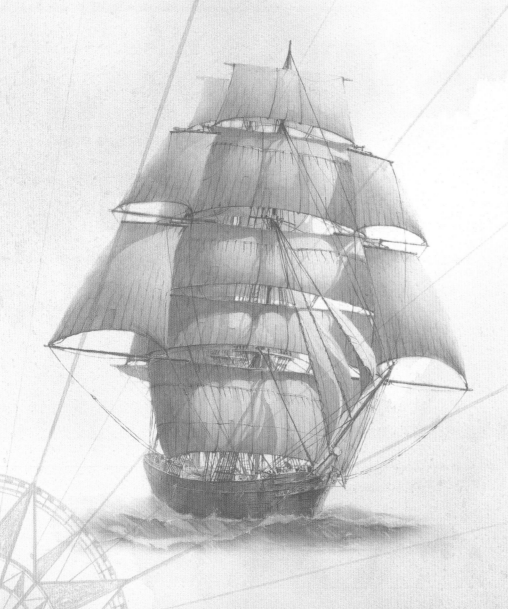

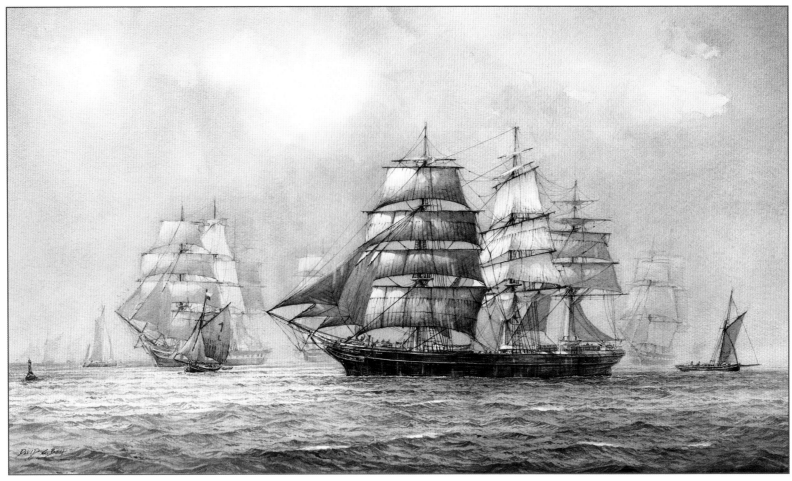

TORRENS

The other and perhaps most famous ship built in these parts is the composite ship Torrens (1875). This type of ship would have been built of teak or oak, either American white oak or English oak, or even rock-elm. With the **Torrens**, the planking and bulwarks were in teak - four and a half inches thick, on average, laid on iron frames. Built at the big shipyard of James Laing of Sunderland, she was 1276 tons and 222 feet long, a big, handsomely proportioned, classic sailing ship. With a sharper bow than normal for a passenger ship, she was, by all accounts, a superbly balanced and sparred vessel and had the ability to sail exceptionally well in light airs. A distinctive feature was the long poop, eighty foot, from stern to mid mizzen and main-mast, a comfortable deck for the passengers to stroll along. A great record of passages was made by Captain H. Angel from London to Adelaide from 1875 to 1890, and another six years under a Captain Cope, and finally Captain Falkland Angel, son of the Captain H. Angel. Sailing for many years exclusively for the passenger trade to Australia, this was the ship that the sailor and later famous author Joseph Conrad served in as Chief Officer for two years, less two weeks, from 1892-93.

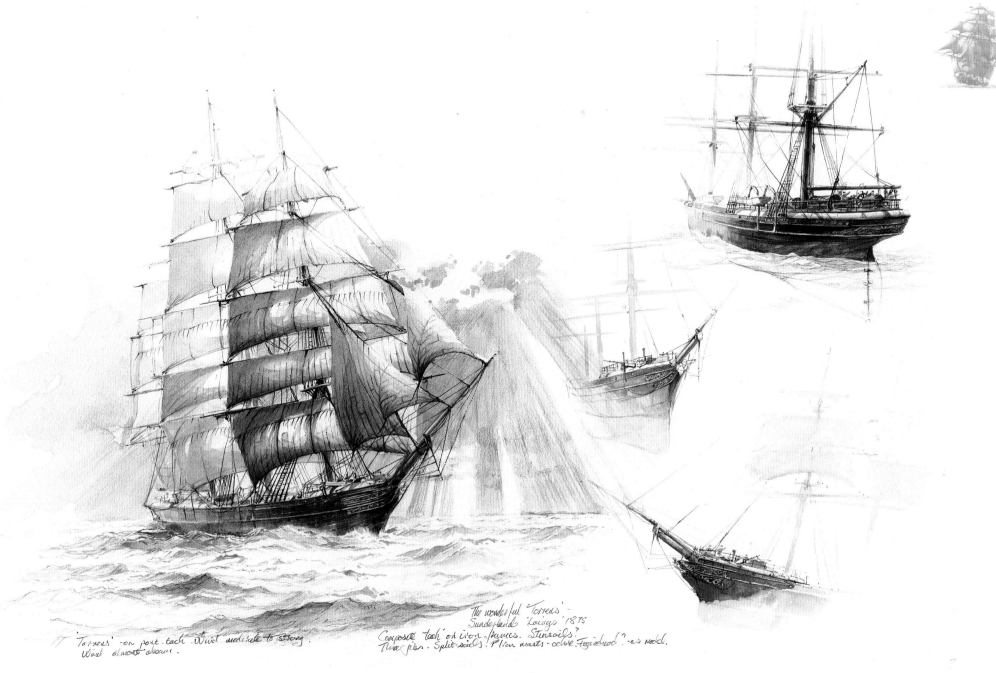

The wonderful 'Torrens'
Sunderland 'Laings' 1875
Composite 'teak' on iron frames. Stunsails?
Three jibs. Split-sails. P'iron masts - octive. Figurehead? - as model.

'Torrens' - on port tack. Wind moderate to strong.
Wind almost abeam.

Leaving the **Torrens** in 1893 and some time later Conrad wrote of the ship with eloquent attachment, and agreed loudly with Basil Lubbock that she was indeed 'The Wonderful Torrens'! Conrad spoke with great pride of her and many years later on knowing her fate he writes of her - 'that her fine spirit has returned to dwell in the regions of the great winds, the inspirers and the companions of her swift, renowned, sea-tossed life which I too, have been permitted to share for a little while'.

Well worn, and with ageing iron and wood and in need of constant repair, the ship was sold to Italian interests and finally, after being twice put ashore, and though refloated, was taken to the breakers at Genoa in 1910.
The drawings are from the superb model in the museum at Sunderland.

131

Taeping, the Chinese name for 'calm sea', was given to this famous tea-clipper when it was launched from Robert Steel's yard at Greenock, on the Clyde in 1863. The 1860's saw the peak of the 'tea-races' and the great contest it became was for the all important premium awarded to the first clipper home. The Taeping was one of many clippers built that year to attain this coveted title. Her first two years were almost disastrous. The ship went out to China, under the command of Captain McKinnon and due to the notorious weather in the China Seas and the resulting damage didn't arrive back in London till early 1865. Repaired and restored she was back to Foochow, China, by mid-year for another cargo, returning in 102 days, the fastest time for the season, and was at last showing her true form. Not yet tested against the top clippers the chance came the following year, 1866, in one of the great classic tea races.

At the mouth of the Min river was gathered a line up of first-class, top pedigree clippers. All their holds and any vacant spaces, packed with the season's tea chests; rigging and spars in perfect condition and masters, all different in temperament and guile, planning the route home. This was the start of a great tea-race, not the one illustrated but worth mentioning.

The favourite was one of Steel's three clippers at anchor, the Ariel. She had been loaded first and sailed first. Commanded by the experienced Captain Keay, the Ariel, launched at Greenock only the year before for Shaw, Maxton & Co., was a perfect clipper, composite built with teak planking.

The Taeping and Serica followed within hours, and then the Fiery Cross a smaller clipper by 160 tons, and thus a smaller draught, was able to be towed ahead and off to a flying start. The Taitsing the following day. The ships all sailed south through the China Seas, occasionally in sight of one another, until entering the Indian Ocean via the Sunda Straits. Still within a few days of each other the Fiery Cross took the lead followed by the Ariel, Taeping and Serica. By the Cape they all rounded within hours of one another while the Serica and Taitsing began to lag behind. They all crossed the equator on the same day and now the Taeping began to draw away. Through the Doldrums and up to the Isles of Scilly, the Ariel now took the lead followed closely by the Fiery Cross and Taeping. By the time they reached Beachy Head, all ships still under a mass of canvas it was closer than ever and the Ariel now off the Downs called for a pilot desperately trying to keep the lead. Only a mile astern the Taeping then arrived for a pilot and both ships took on tugs for the final leg to London. As it happens the Taeping's tug was the faster of the two and arrived at the docks first, though both clippers had to wait for a rising tide to enter. The Taeping entered London Docks first and the Ariel at the East India Docks minutes later. After 100 days of the finest seamanship they shared the premium. The Serica also arrived and docked on the same tide - quite a remarkable feat as they had all left on the same tide from the Min river. The passages from the Far East should have had an agreed finishing line as the most unpredictable and often difficult section was the Channel approaches and the pilot/tug/tide/dock episodes.

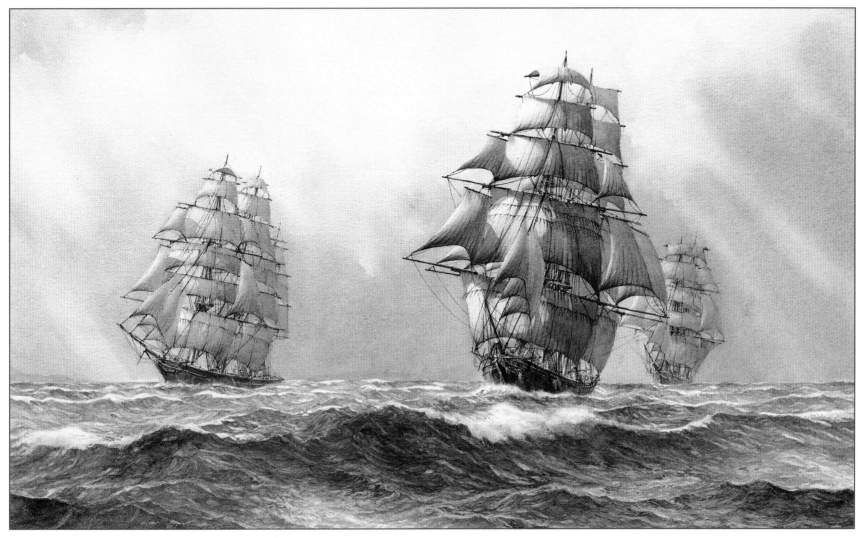

China Seas - Taeping, Serica and Ariel

The tea-race of 1866 was, perhaps, the most exciting. This painting depicts another, that of 1868 when loading at Foochow, a port midway between Hong Kong and Shanghai, the **Ariel, Sir Lancelot, Taeping, Spindrift, Lahloo, Serica** and **Fiery Cross** were all at the Pagoda anchorage. But the **Ariel, Taeping** and **Sir Lancelot** left Foochow first, on the same tide, and immediately raced away, the **Ariel** ahead, with all sails set. A week later the **Ariel** was now in company with the **Taeping, Spindrift,** another clipper the **Undine** and the **Lahloo** not far behind. All rounded the Cape safely and still in close company raced north to the equator, the **Spindrift** crossing first. They all headed for the Western Approaches, the **Ariel** arriving off the Scillies first but then the wind dropped to a calm and only the **Spindrift** and **Sir Lancelot** managed to make way. However, the **Ariel** did arrive at the docks first followed by the **Spindrift** and **Sir Lancelot.** The **Taeping** and **Lahloo,** not at their best in such light conditions, brought up the rear. The **Spindrift** took all honours, narrowly beating the **Ariel** on time.

It is here I leave the fighting navy and move to the fascinating world of merchant sailing ships. The *Beagle* for me bridged these worlds. The end of the war at sea after Trafalgar (though the conflict continued on land for another ten years), resulted in a safer place for the seafarer and the trade routes to the Far East. Pax Britannica was to last for another century. Now exploration, investigation, charting, and surveying continued, as with the *Beagle*, and an explosion of trade began. Passages to colonies and the 'new' world which had such trading potential developed into a regular undertaking. So we leave the fighting navy but stay in these southern waters.

I had seen some great sights of sailing ships whilst at sea but here in the Falklands I first saw, apart from static preserved and adapted ships, the actual, and fairly recent, remains,of many notable sailing ships. So here I realised at first hand new and exciting horizons and started on the first of many portraits of great sailing ships. But why all the wrecks? In three words: the 'Californian gold rush'.

Thermopylae

Anchored in Sydney Harbour 1871, awaiting a cargo of wool. I was once anchored at this spot for nearly six weeks, awaiting engine repairs. The landscape is from life but the vessels are derived from models and plans.

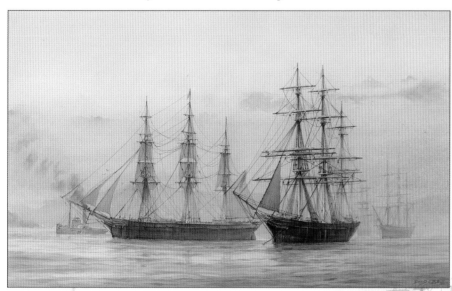

The trade from the American eastern sea board to Californian goldmines in the 1840s, was easier and safer by sea and the demand for sailing ships to achieve this created the development and rapid building of bigger, safer and faster ships. The extremely fast schooners built in Virginia and particularly the 'Baltimore Clippers' were excellent for short trade routes such as from the West Indies to ports on the east coast of America, and 'privateering', especially during the American - British wars. This 'clipper' design influenced the slightly bigger but still fore and aft built schooners for fishing and fast but shorter trade routes. Now this influence became evident for the next bigger designs now needed for these new trading opportunities. Whether the term 'clipper' is an American colloquialism for 'the finest of its kind', or to 'clip' the time off a passage or simply move at a faster pace, the sharp-bowed 'clipper ship' was launched.

The American shipyards, initially with Griffith of Portsmouth, Virginia, started to build these remarkable vessels. The short and wide ship gave way to the long, sharp hulls - a shape designed for speed. The most famous of the American shipbuilders working from his yard at East Boston and a name synonymous with the clippers, was Donald McKay. His ships ring with great names such as *Staghound* (1850), the great *Flying Cloud* and *Flying Fish*. He went on to build over forty of these first class ships until the end of the clipper era.

Now, back in home waters and half way through the nineteenth century this building explosion for the Far East trade in part made such an impact on the British government it brought about the repeal of the Navigation Acts (1849).

This now allowed free trade from British ports to its colonies to any nation's ships. So in effect this commercial modernisation of trade initiated the immediate development of British ships from the much slower East Indiaman to eventually the faster competitor in the British clipper. Like the gold in California the opium and tea trades from India and China to Europe and America, all demanded fast passages to make bigger profits and created the need to build these fast sailing ships. The American designs now seen in London docks gave the architects a taste of reality.

So after Trafalgar, 1805, and the Napoleonic Wars and with less navy ships coming off the stocks, but still with a shortage of oak, it seemed entirely natural to introduce iron as a substitute for the bits and pieces that strengthen the oak framing. This and the freedom to trade, worldwide, on reasonably safe routes allowed the merchantman to evolve. From the distinctive ship of war, especially the universally adopted all round 'frigate', and with the British architects' vast naval experience they modified this type to a sleek, flush-decked fully rigged merchant ship. Packet ships, West Indiamen and now the British East Indiaman evolved on frigate lines.

The biggest merchantmen at the beginning of the 19th century were these East Indiamen. Big, some 1500 tons, though typically 1200 tons and fine ships with their painted hulls to look like navy frigates and even the occasional two-deckers. A little slow and heavy, they were not built for speed - a round trip from England to China took all of one year.

Already the steamship was becoming a major competitor, establishing in 1838 a trans atlantic service. Speed to transport cargo and passengers was the answer for the sailing ship and so the next design and forerunner to the clippers were the 'Blackwall Frigates'. So called because they were built at the Blackwall Yard of Green & Wigram on the Thames. So this next step was the 'all wood' passenger built ships, the 'frigate-built' or 'Blackwallers', descendants from the East Indiamen themselves. The noted shipping 'magnate' of that time was the exceptional businessman Robert Wigram (1743 -1830), who went on to own and run a large fleet of East Indiamen, and on retirement in 1819 sold his shipping empire to his two sons and the businessman and entrepreneur George Green (1767-1849). The Wigram Green company had three ships named *True Briton*. The first of 1790, built Deptford, a successful ship but lost in the China Seas in 1809. The second was built at the Blackwall Yard and launched in 1835, and half the size of the first

at 640 tons. The third and finest was again built at the Blackwall Yard in 1861 of 1046 tons. So the first painting that falls in line here has to be the *True Briton* depicted leaving Wapping Docks on the Thames. Lubbock describes her as the 'finest and last thing in Blackwall frigates'.

With the American influence literally sailing up the Thames it quickly followed that from the East Indiaman to the Blackwaller or 'Blackwall Frigate' the next step was the jump to clipper ships. Shipbuilding and naval architecture was established as a progressive science, the Dutch, French and English all leaders in this practice - in fact going back to 1790 the 'Society for the Improvement of Naval Architecture ' was founded. But the development of the sailing ship was rapid in the forty years between 1820 and 1860. The sailing conditions from the U.K. to China and then Australia influenced the design of British ships. The yards produced smaller ships, around 200 feet in length, but just as fast as the Americans, and, as the Civil War raged in America, the yards of Laing (Sunderland), Hall (Aberdeen), Steel's (Greenock), and more, built and launched the first of our great clippers and the start of the 'Tea Races'.

The ship-builder Donald McKay of Boston U.S.A., originally from Nova Scotia, always worked with wood. In his prestigious career his great wooden argosies were unrivalled. Now, in Victorian Britain, with the Industrial Revolution under way, iron and, later, steel, was being introduced during the transition from sail to steam. The British shipbuilders competed against the mighty wooden ships of McKay with 'composite' built ships. This clever inventive design of iron frames with wood planking gave the strength needed throughout for the increased size of hull and the tall masts which held an immense spread of canvas. One such design the *Taeping* was a classic 'composite' ship. Though not exactly where the 'fast sailing ships' all started, this

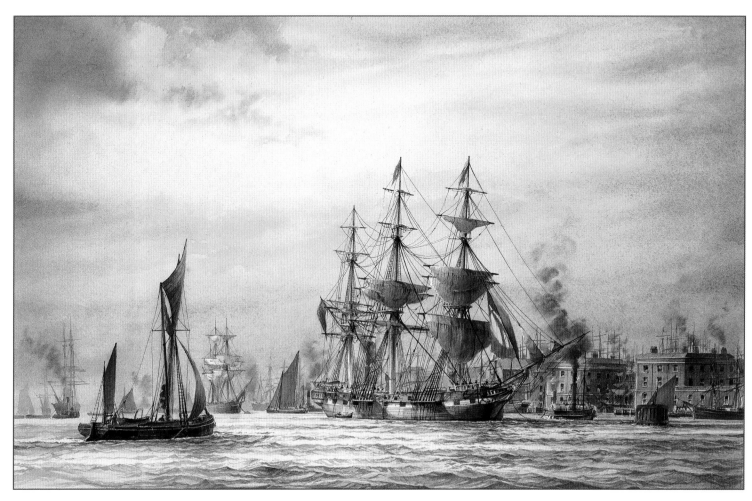

True Briton 1861
Off Wapping Docks c1863

Voyages under sail to New Zealand and Australia started in 1785 and continued until the late 1940s ending with the passages of the four-masted barques **Pamir** and **Passat** carrying their cargoes of grain. Still under the command of Captain Woodget, and under British ownership, the **Cutty Sark**'s last passage from Brisbane, Australia, back to the U.K. with over 5000 bales of wool, was in 1895. With an explosion in migration to the Antipodes in the mid to late nineteenth century, the 'emigrant' ship with seven and possibly eight hundred passengers, and a full cargo set sail and completed endless passages to Australia through thousands of miles of, often inhospitable, oceans to arrive with luck, endeavour and skill at an equally inhospitable and untamed land.

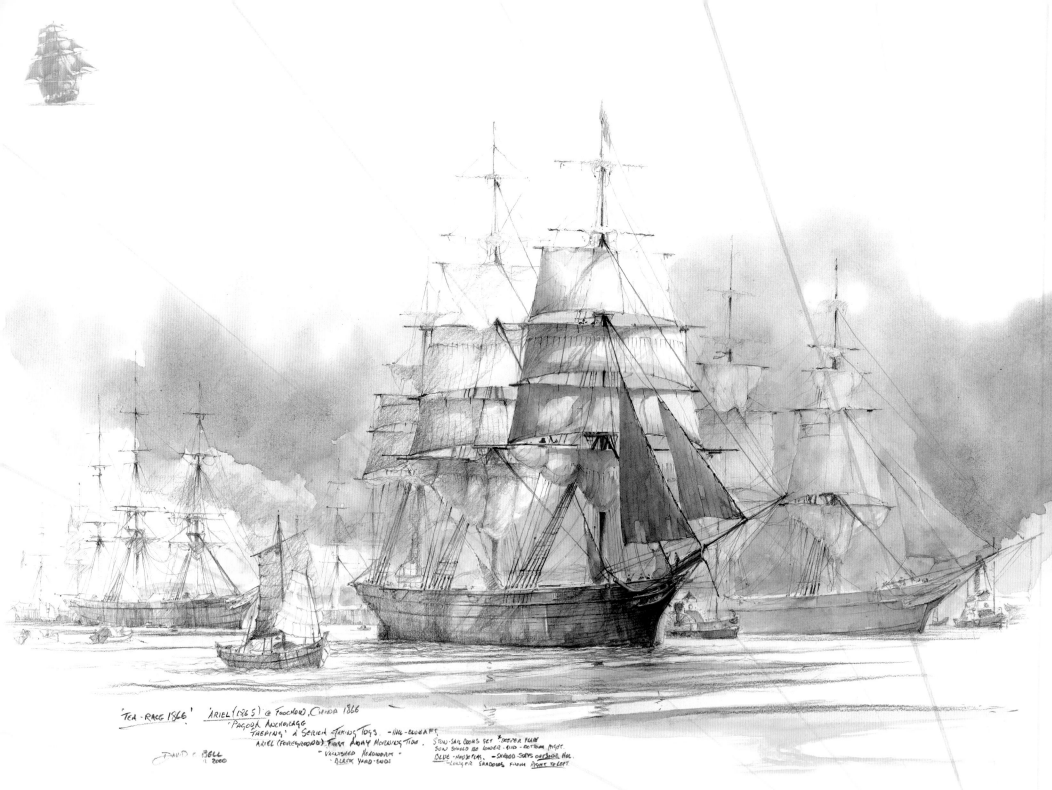

'TEA-RACE 1866' 'ARIEL (1865) @ FOOCHOW, CHINA 1866
'PAGODA ANCHORAGE
TAEPING' & SERICA TAKING TUGS - ING-ON DRAFT
ARIEL (FOREGROUND) FIRST AWAY MORNING TIDE.

STUN-SAIL BOOMS SET DEEPER FEAR
SUN SHOULD BE LOWER - AND - BOTTOM RIGHT.

DAVID C BELL
2000

'VARNISHED HEADWORK'
'BLACK YARD-ENDS'

BLUE - HOUSEFLAG, - SHROUD-STAYS OUTSIDE HUL.
LONGER SHADOWS FROM RIGHT TO LEFT.

138

This is the nearest I get to a 'thumb-nail' sketch. A possible sketch never, as yet, taken to the next stage. Loosely, it shows the Pagoda anchorage at Foochow, China, and the large fleet of clippers that are about to make sail with the first of the season's tea. The ship in the foreground is the newly built *Ariel* (1865). The others could be any of the following - *Taeping*, *Serica*, *Lahloo*, *Black Prince* and *Taitsing*. It became the classic tea-race of 1866 described earlier.

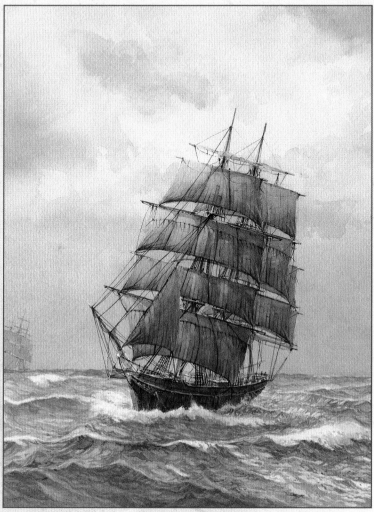

Samuel Plimsoll 1873
An iron built ship of 1444 tons she was launched in 1873 as an emigrant ship by Hood of Aberdeen for the White Star Line. From her first voyage continued to make many passages to the Australian ports throughout her life, usually returning with a wool cargo.

development did lead to the Scottish shipbuilders and the great clipper ships built there.

Slightly contradictory, an exception and mentioned in some maritime books, is the clipper/schooner *Scottish Maid*, 142 tons, built 1839. Feasibly as the forerunner to British built 'clipper' ships and having used a model of this for a painting subject or as an extra, you can see the similarity although in miniature. The beak-head, rails and bits and pieces are now all part of the continuous hull form. This fine vessel was built by Alexander Hall of Aberdeen and became known as the 'Aberdeen bow'. This type of ship sailed from Leith to London as a fast packet service known as the 'Leith clippers'. The term 'clipper' is now used as a general term for any fast ship or designed to sail at a fast speed. This fine tapered stem and the long sharp bow and its degree of fineness determined the 'clipper' class category. This painting, one of the first I ever tackled many years ago, and still have, shows its graceful shape with a little artistic licence.

These ships are all so well documented they are a subject in themselves, even each type and shipping company, and will be a future task to tackle.

James and William Hall of Aberdeen initiated 'tank-testing' for hull forms and design. In fact I believe, the 'Denny Ship Model Experiment Tank,' at Dumbarton, built later in 1883, is open to the public, and still testing. This leads of course to the great clipper ships launched from the yards of the Clyde and Aberdeen, in particular the preserved *Cutty Sark* (1869) and the *Thermopylae* (1868), two of the many classic clippers I've tackled over the years.

On leaving nautical school I joined my first ship, with just a little

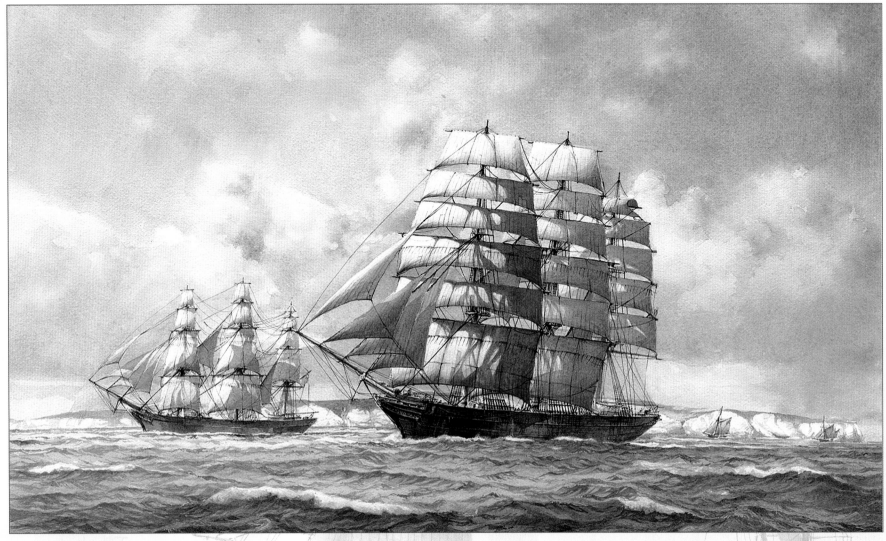

The **Thermopylae** once again, this time in the English Channel. Seen at her best in a moderate breeze, here on the starboard tack, with fore and main royals already set. The topsails and the topgallants are both split into upper and lower halves to make sail handling easier.

I mentioned earlier the sad demise of the **James Baines** in Liverpool Docks in 1858. When wool was brought down to the docks for loading, it was then, alongside, mechanically tightly compressed into a bale. It was literally, 'screwed' into the hold as secure and compact as possible. The tighter the better, because not only were more bales able to be loaded, but as the wool was still damp and oily and wrapped in hemp, a material known for i's volatile nature, any movement would have caused friction and could possibly have created spontaneous combustion. At sea, that would be the end of ship, crew and cargo.

trepidation, as a cadet, at Smiths Dock, North Shields, on the Tyne, a place I well remember with my first days on the *Border Falcon*. Little did I know that Smiths was a long established name of shipbuilding on the Tyne, and back in the early nineteenth century competing fiercely with the London built Blackwallers.

By 1820-30 the major export from Australia was wool, along with its by-products of hide and tallow, from the successfully introduced merino sheep. At that time the population of Australia was very small - both to produce and use exports and imports and so trade fluctuated dramatically. Until, that is, the gold-rush to New South Wales and Victoria in the 1840s. The population then doubled within a year and continued to swell until 1860.

The sailor's lot was an extremely arduous one with sheer hard work, day in day out. Its severity cannot be overstated. They were indeed days of 'wooden ships and iron men'. Not that I have experienced such harsh conditions, but crossing the North Atlantic a few times with the usual

bad weather on a week's passage, discharging and loading and back again, was gruelling enough for me in a modern, comfortable sea-going vessel. In the emigrant ships, passengers in any class would have experienced quite an ordeal. However when the sunny climes were reached it became a more relaxing adventure.

These ships usually made one round trip a year to India. Some were built of teak and had iron components introduced into the structure, as mentioned previously, such as the 'knees' and frames, and in 1866 Green's of Blackwall built their first iron ship the *Superb*.

It was the wealth of information and detail, including ships' plans, from the the books of Basil Lubbock and Harold Underhill that I first came across when at Trinity House School in Hull, that gave me a start and introduction to sail, and they are now the basis of many marine artists undertaking of this subject. WIth that and of course the school and all its nautical traditions and customs, like salt spray, just soaked into one's skin. At that time all I was interested in was the wonderful and intriguing world of fishing that was still dominant in Hull and strangely the already rapidly declining world of steam railway engines.

From 1849, and the repeal of the Navigation Acts, to 1870, the Far East trade flourished and peaked in tea and spices. The *Cutty Sark*, along with the *Thermopylae*, came at the very end of an era which saw the finest possibly perfect development and construction of these sailing ships. Equally astonishing was the calibre and strain of the men that commanded them. My short time at sea and experiences as a navigator don't compare at all with the highly skilled generation of masters and mates that navigated their ships in all weathers, a unique pedigree that is now history, to lands and seas, some only just discovered and hardly charted.

The clipper ship was created because of the pursuit of commerce and

CUTTY SARK GREENWICH
—1985—

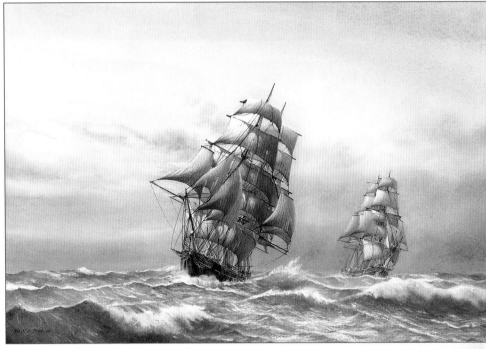

Cutty Sark and Thermopylae 1872

financial gain in trading across the oceans. In the wool-trade they would make a passage in an impressive 60 - 80 days. This was consistently achieved because of competition and pride. Clipper ships in those times held an aura in the public domain. The many other ships built, which would never gain the fame of the finest clippers, took up to a year to complete the long haul to Australia and back on what was usually, literally, a 'round the world' passage. They sailed south through the North and South Atlantics, eastwards from Good Hope following the Roaring Forties, to discharge/load at one or more ports before sailing eastwards with prevailing winds to the Horn and northwards to Europe.

The only time the **Cutty Sark** and the **Thermopylae** came head to head in a race was in 1872 when they both loaded in Hankow with tea before being towed down the Yangtze. They sailed the next day from Shanghai. Once into the Indian Ocean the **Cutty Sark**, under the command of Captain Moodie slowly drew ahead and three weeks later was over 400 miles in front when, in heavy weather, disaster struck and she lost her rudder. It took a week hove-to before a 'jury rudder' was fitted The honours may well have gone to the **Cutty Sark** in a record time if this hadn't happened because she arrived only just a week later in London behind her great rival.

The **Cutty Sark** never did win a Tea Race. Not many races undertaken had an equal handicap as, master, weather and misfortune always had some bearing on the passages and, consequently, results.

How the world changes. Two years later the ship was arriving at Shanghai this time with a cargo of coal from Sydney in exchange for a tea cargo for London. By 1875, steamers, via the Suez Canal were taking less than half the passage time than the sailing ship, and by 1877 the need for a clipper to race back to London with a cargo of tea with a 'first past the line' reward was over and the **Cutty Sark** brought her last cargo of tea home that year.

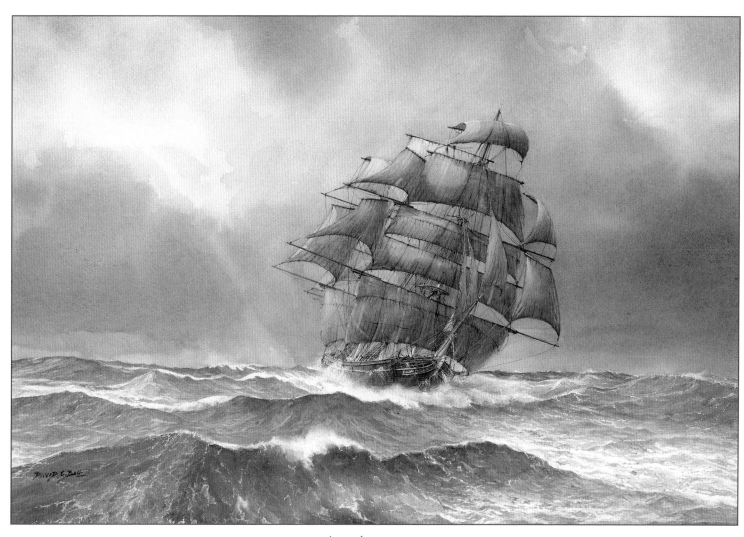

'The Glory Years'
The **Cutty Sark** homeward bound with a wool cargo

In 1879 the **Cutty Sark** took her first cargo of wool from Melbourne to New York and, after several unsavoury years trading around the world, returned to the Australian wool trade as a regular in 1883. She made fast and consistent passages; out via the Cape of Good Hope and back via the Horn. It was in this trade that the ship excelled and outsailed all others and what really made her famous. Even the **Thermopylae** could not better her on passage times and through to 1893 the **Cutty Sark** was only bettered once. Her last voyage from Sydney with wool was to Hull, my home port. Returning to Australia, this time Brisbane, she loaded a wool cargo for London arriving March 1895. From there the great Captain Woodget left for another ship as the owner had sold the **Cutty Sark** to Portuguese owners who renamed her **Ferreira.**

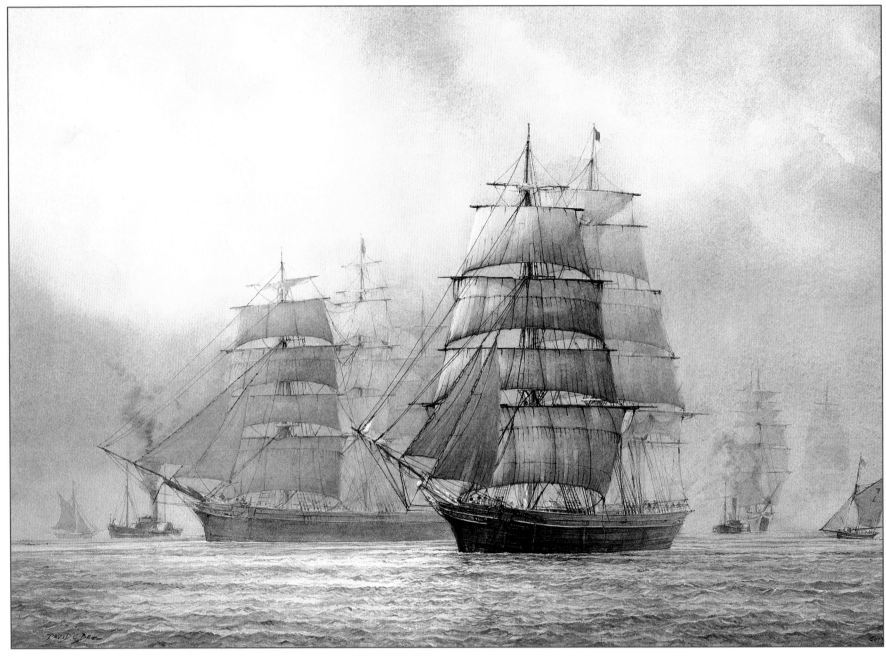

Cutty Sark *1869*
Off the Kent coast, Pilot Away and making sail for the Far East

Cutty Sark *Pilot Away and making sail for the Far East*

When you see this ship at Greenwich it is hard to believe looking at the lofty ascending masts with, huge 'yards' of steel straddling them, woven together with a mesmerising mesh of wires and ropes, that the hull below is big enough to hold them up in the dock where it rests. Even more incredible is to imagine it in its element, unfettered with sails unfurled and making headway in a tempestuous sea. In actual fact the **Cutty Sark**, though a relatively small clipper, was a masterpiece. The master draughtsman and designer, John Rennie, gave her three masts to carry 32000 square feet of canvas. These tall masts were perfectly in proportion to the finely proportioned hull, a fact borne out by her record of passages under sail in her wonderful life at sea from 1869 to 1922.

It is said that the Scottish shipowner John Willis had the ship built to rival the already famous clipper **Thermopylae** in the China Tea Races. Such a magnificent, and very successful ship, was given to Hercules Linton and partner to design and construct her at their new yard on the Clyde. With such high specifications and at such a low cost, actually £16,150, it couldn't be done and they went bankrupt. She was finished by another shipyard up the Clyde that of Denny Brothers. After launching and being fitted out at Greenock, proceeded to London, arriving on 16th February 1870, and sailed for Shanghai, China, for her first cargo of tea. After an amazingly eventful and full life sailing the oceans, surviving as a working clipper till 1922, she now stands at Greenwich as an icon of the maritime heritage of this nation.

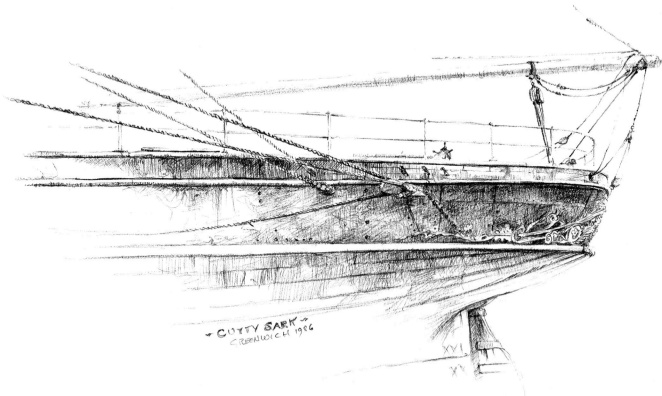

CUTTY SARK
GREENWICH 1986

As ship building increased in Britain and became more refined the result was the ultimate sailing ship the 'composite clipper'. All these ships were wood built over iron frames with metal fixings for strengthening and iron lower masts. The result was quite technical. An iron framework, which was a much easier form of construction, and a hull and all external work made from prized hardwood, which was then sheathed, the bit in the water that is, with copper plating. The steamship more and more into the nineteenth century was becoming totally iron built, or hulled, which reduced its weight overall, but adversely the iron in tropical waters quickly developed marine grows and a 'drag' which severely affected speed.

For this there was no protection available whereas the wooden ship, also on these passages, had this protection of copper or 'yellow metal', an alloy of zinc and copper, which protected the vessel's hull and lasted for many years. This combination was the 'composite ship'. This brought about the final development and perfection of those ships in the 1860s. Interestingly iron, and later steel, which made the steamship possible and accelerated the decline of the sailing ship, was also introduced as a building material in the construction and fitting of the canvassed ship. Bigger ships could be built made of iron or steel, including masts, yards and rigging and also with less rigging and mechanisation a smaller crew was needed, which made the ship for a time more competitive for the demands of the ship-owner and agent against the all powerful steamer. As improvements, patents, construction, machining tools and the like progressed it did, to a point, create the two most famous clipper ships ever built. The most famous being the preserved *Cutty Sark* at Greenwich, probably the finest sight of any nautical subject. The other, also a composite ship, and second only to the *Cutty Sark*, 1869, was the *Thermopylae* (1868).

The *Thermopylae* was designed by Bernard Waymouth and built at

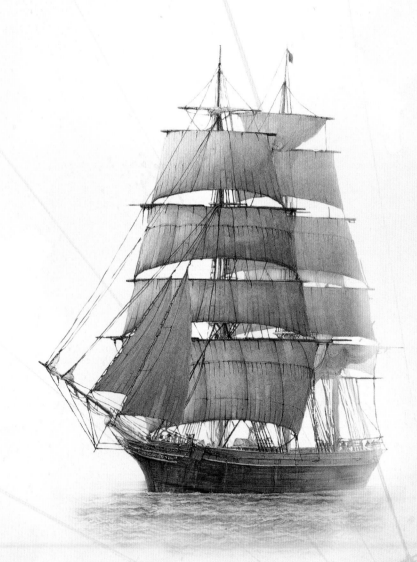

One of hundreds of initial working drawings I produce before I, though not always,
go onto the next stage. Often as not the idea creates another idea and I spend
another week doodling before returning to square one.

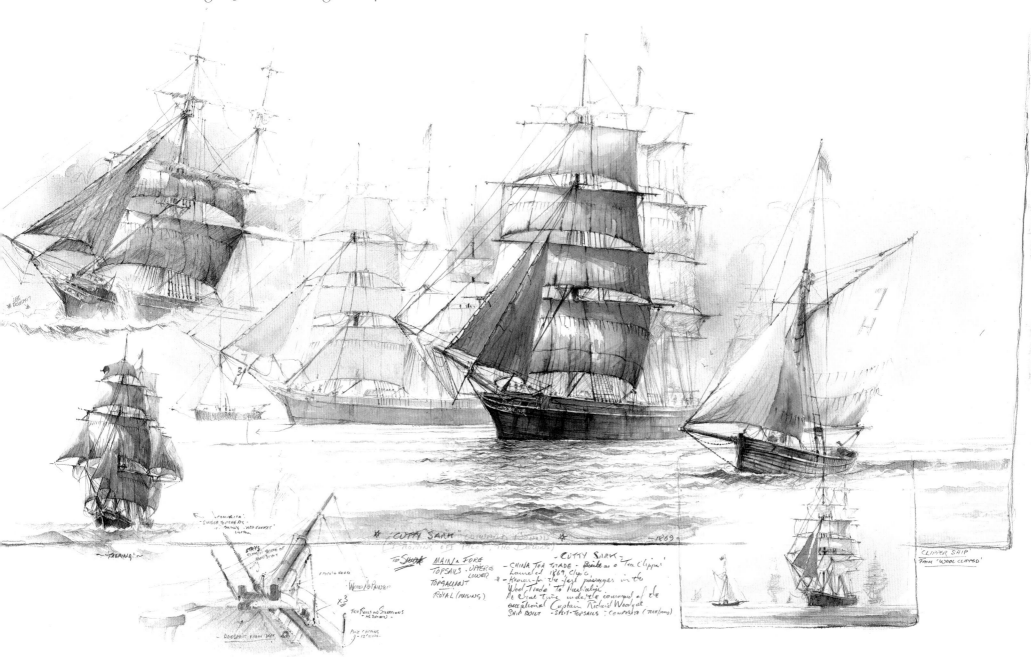

✳ "CUTTY SARK" (CONTRARY BREEZE) ✳
(COMING OFF PILOT, THE DOWNS)
—1869—

— CUTTY SARK —
— CHINA TEA TRADE — Famous as a 'Tea Clipper'
Launched 1869, Clyde.
✳ — Known for the fast passages in the
Wool Trade to Australia
At that time under the command of the
exceptional Captain Richard Woodget
SHIP BUILT — SPLIT·TOPSAILS : COMPOSITE (TEAK/IRON)

MAIN & FORE
TOPSAILS : UPPER &
 LOWER
TOPGALLANT
ROYAL (RAISING)

CLIPPER SHIP
FROM 'WOOL CLIPPED'

Walter Hood's yard in Aberdeen and launched in 1868. When I was in Aberdeen preparing a large painting of an oil-rig about to be commissioned, I visited the maritime museum in Ship Row and discovered the 'Thermopylae Room'. There was reasonable information and artefacts of the ship and its era, but also a magnificent shipyard model on show. Fully armed I set forth to render at least a fraction of this outstanding ship.

A bigger than normal depth of keel gave her an added quality when sailing to windward, the sail area was huge but not excessive. Painted green in the colours of the Aberdeen White Star Line the ship immediately made records from the first voyage to Melbourne, 63 days, to her last days in the Australian wool trade. In 1872 both the *Cutty Sark* and *Thermopylae* left Shanghai on the same day loaded with tea for London. The *Cutty Sark* though ahead by over a day's sailing lost her rudder in the Indian Ocean, the improvised repair terminating any further racing, but arrived only a week after the *Thermopylae* at London, after 122 days at sea.

Whereas the American creator and ultimate artisan Donald McKay is the father figure of clippers the British built *Cutty Sark* is the name anyone will associate with clipper ships, if not sailing in general. Designed by Hercules Linton and built initially by Scott & Linton of Dumbarton, until they went bankrupt, and then finished by Denny Brothers, also of Dumbarton. Built for the London ship-owner John Willis and said to have been conceived to compete with the *Thermopylae* and comparable in size. She was a supremely beautiful ship, and still is of course, classic in all proportions, its existence and the sight of her is a just testimonial to the praise.

She is one of the few preserved ships and as a masterpiece to observe

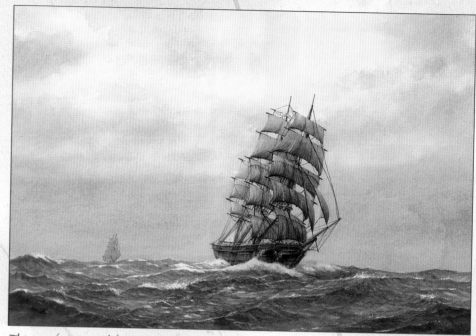

The emigrant ship **Torrens** *making a splendid day's run.*

that gives immediate inspiration to your creative hand. Unlike the *Thermopylae*, which held all kinds of records, the *Cutty Sark* does not have any 'blue ribbons' but was regarded as an unbeatable sailer in strong or light winds and was the culmination of shipbuilding. Strangely enough the ship was launched within two weeks of the Suez Canal opening.

After the heyday of shipping tea as fast as possible both ships entered the Australian wool trade and the *Cutty Sark* was here to earn her reputation for fast sailing. Making consistently fast passages until 1895 when she was bought by the Portuguese and became the *Ferreira*. In 1916 after being dismasted was re-rigged as a three masted barquentine. With great fortune was saved in 1922 by one of the ship's ex-masters, a Captain Downham, who retired in Falmouth, saw the ship taking refuge in the port, was bought by him and had her re-rigged to her original condition. Now permanently dry-docked at Greenwich since 1954 the *Cutty Sark* is a national monument.

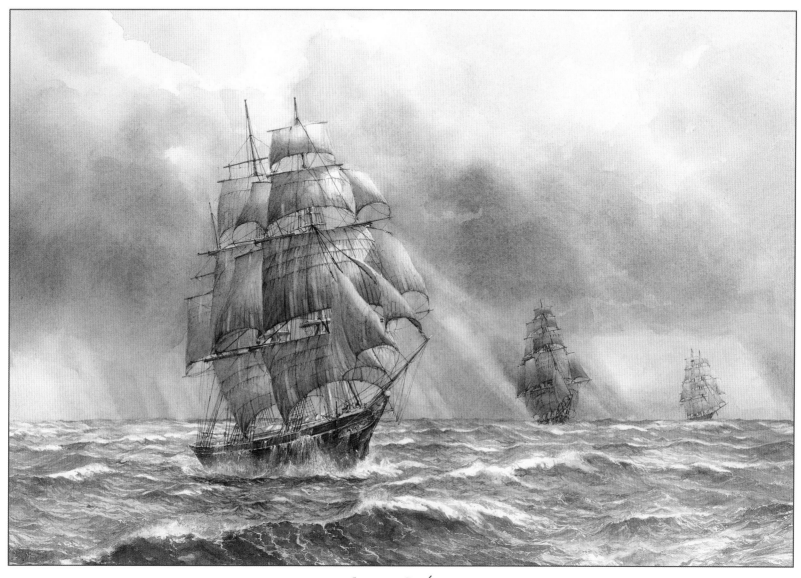

James Baines

Built and launched at Donald McKay's shipyard, Boston U.S.A. 1854

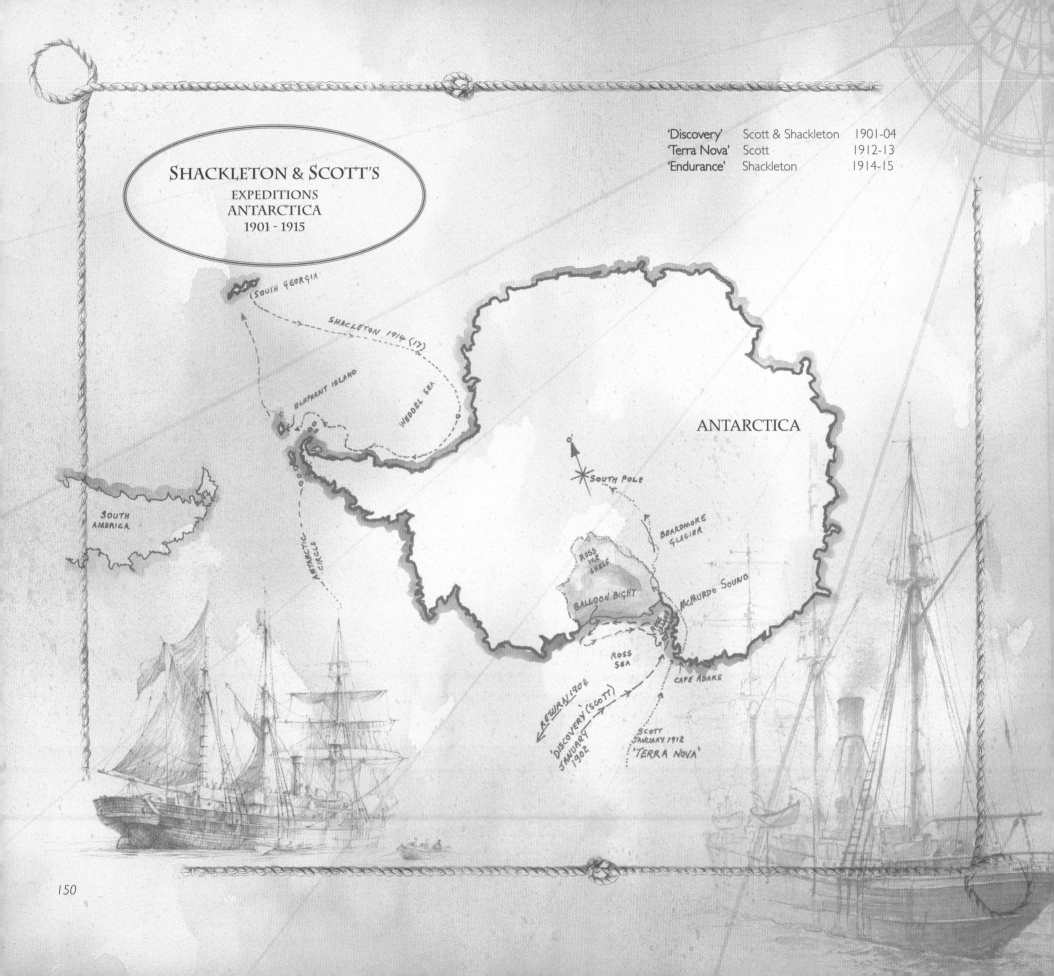

SHACKLETON & SCOTT'S
EXPEDITIONS
ANTARCTICA
1901 - 1915

'Discovery' Scott & Shackleton 1901-04
'Terra Nova' Scott 1912-13
'Endurance' Shackleton 1914-15

SOUTH GEORGIA

SHACKLETON 1914 (17)

ELEPHANT ISLAND

WEDDEL SEA

ANTARCTICA

SOUTH POLE

SOUTH
AMERICA

BEARDMORE
GLACIER

ANTARCTIC CIRCLE

ROSS
ICE
SHELF

McMURDO SOUND

BALLOON BIGHT

RETURN 1904

ROSS
SEA

CAPE ADARE

'DISCOVERY' (SCOTT)
JANUARY
1902

SCOTT
JANUARY 1912
'TERRA NOVA'

Shackleton
with Scott & the ships
Discovery, Endurance, Nimrod & Terra Nova

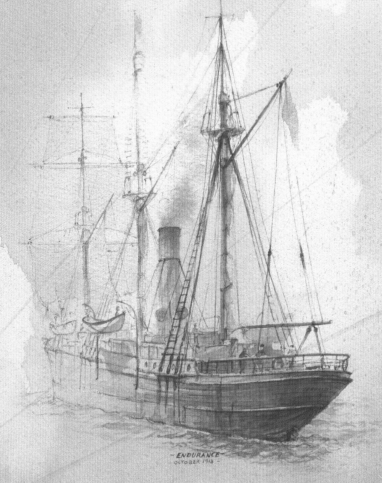

~ENDURANCE~
OCTOBER 1918

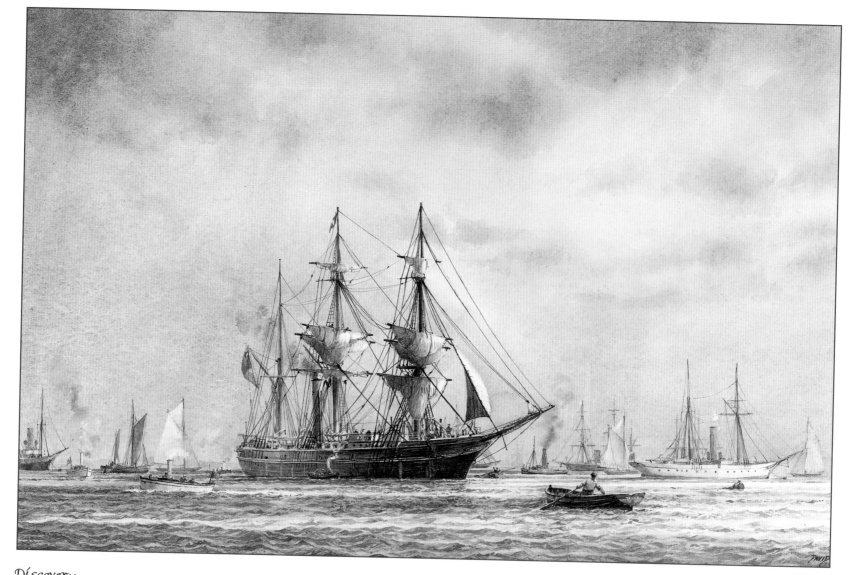

Discovery
Cowes August 1901

Built at Dundee on the Tay 1899 was purpose built for Captain Scott's expedition to the Antarctic. Launched in March 1901 she was barque rigged with an auxiliary steam engine and a two foot thick wooden hull. The first painting of the **Discovery** is based on the regatta at Cowes on 5th August 1901, a day before leaving England for an epic voyage to the Antarctic.

Ernest Shackleton 1874 -1922
with Scott & the ships
Discovery Endurance, Nimrod
& Terra Nova

It was, again, whilst working on commissions in the Falklands that I met an R.N. officer with a strong interest in Antarctic history and a curiosity for art who further enlightened me on the Falklands and South Georgia, and in particular Ernest Shackleton and his book 'South'.

It was exactly two years after the war and I was a guest on board H.M.S. *Penelope,* anchored at Stanley. I spent a few fascinating days sailing round the islands, eventually anchoring in San Carlos waters, from where the fleet was to be relieved after their long duties in the South Atlantic and head back to U.K. waters. It was purely a coincidence that the ship had finished her stint and was about to head north but via South Georgia - Shackleton's last resting place.

To be back on board a ship and at sea, as an observer, was quite different for me and exciting, to say the least. When I suggested a look around the other navy ships and their environs I was promptly suited or 'gooned' up as they say and sent airborne in the ship's Lynx helicopter for a flight of, which I can only describe as, fear! I was seated at the door with the co-pilot, my legs hanging out, the helicopter darting all over the place. I had my camera at hand but not once did I release my iron grip from the framework of the Lynx to operate the trigger! We skimmed along the waves on a hair-raising flight out to sea to meet the relieving

squadron and, with some fancy 'greeting' manoeuvres, landed on the deck of the last ship to collect the all important mail and shoot off back to the *Penelope.* With 'boy-racer' on the joystick we executed a very smart landing on a very small deck. I remained quite calm on my arrival, or should I say, survival, and do remember going into the ward room for a restorative drink with the air crew, but alas I have no recollection of coming out!

Back to terra firma and talk of the exploits of this fascinating character Shackleton, a man so complex, yet, in a way, so straightforward, set me off again to record, as well as I could at the time, glimpses of these men and their ships in the Antarctic. Unfortunately I have only saved and recorded a few images from those times, including a motley collection of preliminary drawings and ideas that do, in a fashion, bring together this section.

The complexity of Shackleton was his life ashore in England and the means for him to find and pursue some sort of exploration or adventure. The straightforward part was in the practicalities of doing it. That is not to say, as with Scott and his ships, that what he did was right or the best way to do it, far from it. As it turned out everything they did or attempted to do was so difficult to accomplish. Part of their fame was very much in the unorthodox, if not alternative, way in which they organised and went about the expeditions.

Strangely, like me, for no definable reason, Shackleton left school and went off to sea at sixteen. He before the mast, myself behind the ship telegraph. He gained great experience of working with sail when it was fast becoming a rarity, before going on to steamships as a merchant officer where to his merit he gained a master's certificate. After nine years as cadet and navigator I left the sea and went on to tread the creative path of art college.

Shackleton on the other hand, was serving with Union Castle Line, in those days sailing on regular routes to South Africa. It was 1899 and Shackleton had read about and was influenced by maritime explorers, many of whom this book has brushed upon. He perceived, in the world's exploration by heroic adventurers, that a gap existed and that this was the 'Poles', in particular the South. Through the auspicious advice and comments of friends he heard about the creation of a new Antarctic expedition and succeeded in joining it aboard the *Discovery*.

Originally built at Dundee by the famous ship-building firm of Alexander Stephens (and now back permanently at Dundee) the *Discovery* is now restored to a similar appearance to how she was as a Royal Research ship in 1925-27. Dundee lies on the north bank of the Tay. It was, at that time, a prominent whaling port known for building the best wooden sailing ships, in particular the polar bound ships built to withstand the severe Arctic conditions. The survival of *Discovery* and ships like her is easily understood when you explore her construction below decks still visible today at the Maritime Centre.

The hull is some twenty inches thick and the frames are of oak and elm all encased again with 'greenheart', a hard South American timber, ideal for marine work. Huge beams of pitch pine are placed close together athwartships forward to withstand crushing from the pack-ice. The ship had an auxiliary engine, coal and wood fired, and the propeller and

rudder were able to be hoisted inboard away from the ice. The tall yellow painted funnel almost out of place on these ships is what makes them so recognisable. Laid down at the Panmure Shipyard in 1900 the ship was launched a year later in March 1901. At the launching was the first commanding officer, a Robert Falcon Scott.

The 'British National Antarctic Expedition' had been organised to go to the Antarctic in the purpose built ship. Now Scott and Shackleton were to meet. The President of the Royal Geographical Society at the time was Sir Clements Markham, who originated and organised this new venture to polar waters. As with previous expeditions he wanted it to be a naval affair but the Admiralty did not and so it became, basically, a private enterprise run on navy lines. Markham had first met Scott in 1887 when he was just eighteen. They met again in 1899 when Scott applied as leader and was duly approved. The *Discovery* was a mixture of a sailing/auxiliary research ship with a naval commander and ten officers, ranging from his second in command, Albert Armitage the navigator, to Edward Wilson the surgeon. There were thirty six seamen including marines, cooks, stokers, all mainly of R.N. stock - and of course sub-lieutenant Shackleton R.N.R. Together they formed the British National Antarctic Expedition.

The *Discovery*, as I said ,was a purpose-built ship for exploration, but now, with Scott as the young naval commander. Whilst for the voyage Shackleton was commissioned by the Royal Naval Reserve as a sub-lieutenant, on board he was seen as the third lieutenant, the junior officer, and was in charge of stores.

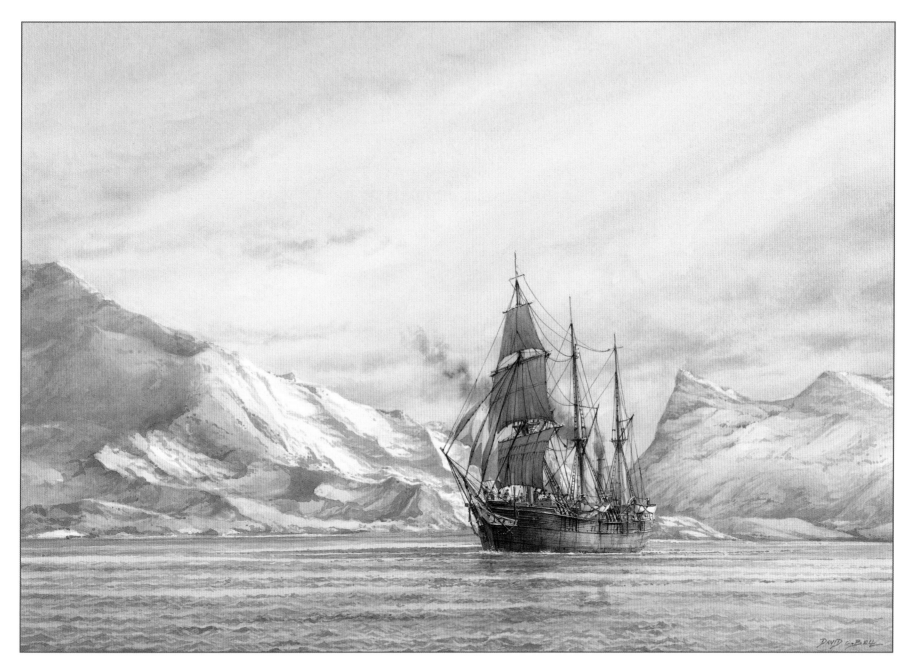

Endurance South Georgia

On board the officers' cabins, all similar in size, were tightly positioned around the saloon table, with very few places to hide. Immediately forward from this were the crew's quarters for some thirty six men in a small communal space. Even with all the masses of stores stowed everywhere it would have been altogether a sociable little set up.

Cook had ventured into Antarctic waters back in 1772 and was unlucky not to find any coastline. In 1839-43 another Admiralty expedition, led by James Clark Ross, already Antarctic experienced, in H.M.S. *Erebus* and H.M.S. *Terror*, ventured deeper into Antarctic waters. The other astounding voyage was in 1872-76 in H.M.S. *Challenger* under Captain George Nares for the Oceanographic Research Expedition. With this in mind, and with all this knowledge it is quite amazing that Scott and Shackleton both came together on this voyage with so little understanding or experience in what they had opted to undertake. 'Adapt and overcome' was soon to be the order of the day.

So, at the turn of the twentieth century, on 6th August 1901, the *Discovery* under the command of Robert Scott left the Royal regatta at Cowes, and sailed across the oceans to find a place to land in the Antarctic, establish a camp and then make the short trek to the Pole.

This slightly odd looking ship, was in Shackleton's opinion as an experienced man with sail, an uncomfortable and sluggish ship at sea. But in ice she was just the job. In Lyttelton, New Zealand, the ship was restocked and dry-docked for repairs before leaving for the south on Christmas Eve. The ship reached Antarctic waters by 8th January 1902, via Cape Adare, the Ross Sea, and along the Ross Ice Shelf, some 1000 miles to King Edward VII Land and back to Ross Island. It was here Scott informed the crew that the *Discovery* was to winter in the ice. Here in the shelter of McMurdo Sound, they had an established camp ashore. In the following summer they were to make an attempt on the South Pole.

Scott and Shackleton did not, at this time, see eye to eye by all accounts and never did. They were quite different men, from different backgrounds with opposing personalities - but both very ambitious. This was to be amply shown on the attempt on the Pole when Scott chose Wilson, one of the surgeons, and quite unexpectedly, Shackleton to accompany him.

Before that Shackleton faced his first test of leadership in February with a 'testing' trip of a few miles with Wilson and Ferra the geologist to undertake and establish a route south. Scott sent the uninitiated off, hauling their own sledges through ice and snow, to survey, to survive and test their ability to return safely, which they did. More practice forays followed and a route was determined. The three polar men, Scott, Shackleton and Wilson set off at the beginning of November for the attempt on the Pole. It was estimated to take three months. The three men, dogs and sledges found the trek too arduous. The dogs were discarded and man-hauling the sledges started. It was a huge uphill struggle for the men. Fatigue, scurvy and snow blindness affected them, not to mention the tensions between them, and they were forced to turn back at 82° 17' south. Shackleton was quite ill on the latter part of the journey but though shattered and suffering from scurvy they bravely, but only just, returned to the *Discovery*. The *Morning,* a relief ship, was at McMurdo Sound on their return.

Scott had already decided that Shackleton and he were incompatible aboard ship and this nearly disastrous icy adventure had just confirmed it. The *Discovery* had orders to return to New Zealand but to Scott's delight, the ship could not be freed from the ice and he decided to over-winter for another year, perhaps to give him time to make another attempt on the Pole, which would redeem him from his near disastrous failure. He could not compete with Shackleton's strong personality. His own strengths were in the power of naval command alone.

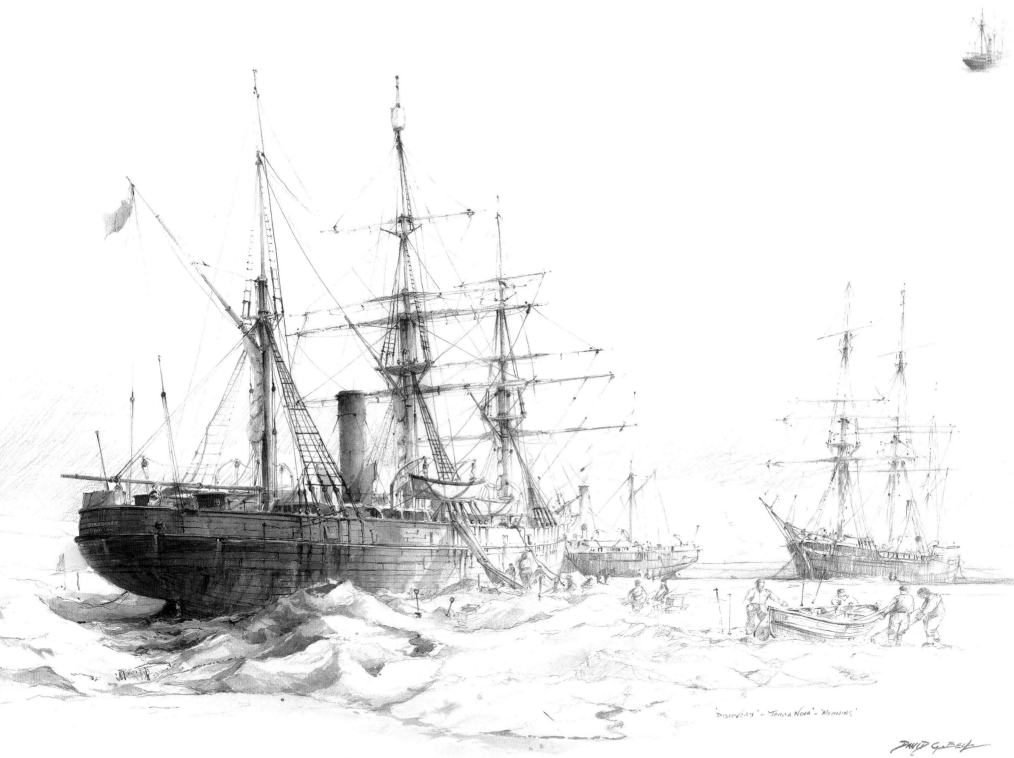

'DISCOVERY' & 'TERRA NOVA' - 'MORNING'

DAVID C. BELL

This drawing shows the stern of the **Discovery** stuck in the ice, with the two relief ships, **Terra Nova** and **Morning** in the background, with Captain McKay from the ship using explosives to force a way through the ice.

Then to Shackleton's disbelief he was evacuated to the relief ship as an invalid. This gave Scott an excuse to apportion blame for the failure to reach the Pole, which he did on returning to home waters. It was in fact scurvy that had forced them to turn back. Perhaps Scott who would not tolerate or eat freshly killed meat, or have anyone else eat it, when it was so readily available should have admitted this as one of his many shortcomings? Anyway, Shackleton resented this humiliating order to return to England, and remained unforgiving forever. However looking ahead as the saga unfolds Scott's decision may have saved Shackleton's life.

The *Discovery* was to remain locked in ice for two years, before returning with Scott to England in February 1902.

By 1906, Shackleton had made the acquaintance of William Beardmore, an industrialist, who, to be quite brief, agreed to help fund another attempt on the pole. The desire to become a public hero and experience further adventures into the wilderness of ice fed Shackleton's appetite to succeed in mounting an expedition. Though he always remained despondent about the actual gains of wealth and security through exploration, Shackleton bought an old Arctic sealer of 300 tons, the *Nimrod*, not too dissimilar to the *Terra Nova* or *Discovery*, for the voyage. Again a ship built in Dundee.

As with the *Discovery* in 1901, the *Nimrod* left with a royal send off from Cowes in August 1907, though Shackleton himself left some three months later by mail ship. He met up with the *Nimrod* at Lyttleton, the port of Christchurch, in South Island, New Zealand. This ill-equipped barquetine, left on New Year's day, and Shackleton realised, once out of Lyttelton, they were not going to have enough fuel left on board on reaching their destination. Already help was needed and the *Nimrod* was actually towed through heavy seas by the steamship *Koonya* as far as the

ice-fields. On the *Discovery* expedition, Shackleton had landed at Balloon Bight, way to the west on the Ross Ice Shelf, a place which was slightly, perhaps crucially, nearer the Pole, but, alas the land of ice had changed. The bight was now full of icebergs and the possibility of landing was denied.

I should mention here the bizarre conditions that Scott had insisted on when he knew of Shackleton's intentions for the Pole. He absurdly demanded that nobody enter or use the Ross Sea, McMurdo Sound and its environs until he himself had returned to conquer the Pole.

On paper Shackleton simply agreed to keep way to the east of McMurdo sound, to the eastern end of the Ross Ice Shelf, and to land at Balloon Bight. As it turned out he couldn't land there and turned back to McMurdo Sound and set up camp near Mount Erebus, justly breaking his promise. With the arrival of the Antarctic summer Shackleton, Wild, Adams and Marshall set off at the end of October, again ill prepared, for the 750 miles, as the gull flies, to the Pole. Their naive disregard for the use of skis and like Scott an aversion to using dogs was almost predictable and almost certainly prevented them reaching their goal. Though Shackleton insisted on going over the eighty-eighth parallel which made the pole less than 100 miles away he had to admit defeat.

Ironically had he landed at Balloon Bight they would have been 120 miles nearer the Pole. Even more ironic was the fact that Amundsen used that point for his successful assault on the Pole in 1907. Shackleton's leadership qualities and the realisation that he would not reach the Pole and return safely made him turn back from certain failure and even death, to trudge back to base camp - a courageous and reasoned decision. The physical effort of hauling sledges themselves to 88° 23' south was an incredible achievement in itself. They were now on the Antarctic Ice Cap over 11,000 feet high, in constantly bad weather

and had to get back 700 miles through the perils of ice and snow in an unfit condition and always hungry. Against all odds they survived reaching Hut Point a prepared depot 85 miles from base camp late in February. The *Nimrod* had orders to leave by 1st March if no one returned, but to the rescue party's great relief they appeared, and were taken on board. By the 3rd March they were off to New Zealand.

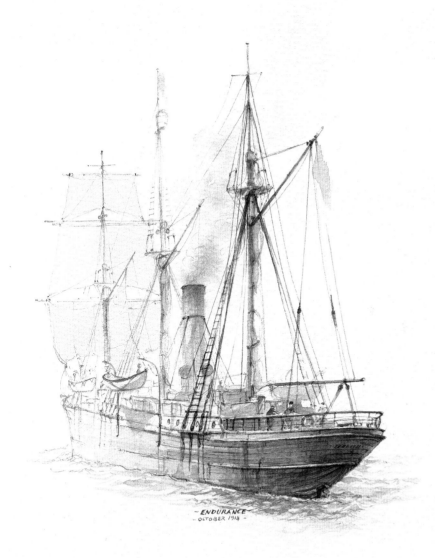

— ENDURANCE —
— OCTOBER 1914 —

Scott and *Terra Nova* 1910-13

The next and third ship built in1884 at Dundee for polar work was the *Terra Nova* (New Land). A bark of 740 tons, with auxiliary engine. She, with *Morning*, were the relief ships for the *Discovery*, under Scott, in 1902. Purchased then strengthened and refurbished for the British Antarctic Expedition or Terra Nova Expedition, she sailed from England in June 1910 for this ill-fated expedition to the South Pole with Scott in command.

This was to be Scott's response to Shackleton's near success on his second attempt. The way had been shown by Shackleton. Scott and his men conspired to travel that extra 97 miles - come what may. A scientific expedition and that alone should have been his aim, not the pointless 'I'm first to the Pole' mentality. Also, to further spur Scott on, Amundsen was just around the corner polishing his skis.
Scott's expedition is well documented including the great photographic collections of Hurley and Ponting which are immense and show only too well the technical restrictions and conditions they were under. Scott was a gifted writer and has left us with many diaries and letters. Equally Shackleton was a born romantic as illustrated by his writings in his account of the *Endurance* expedition 1914-17 in the book 'South'. All make fascinating reading.

Traditionally trained through the naval establishments of H.M.S. *Britannia* (Dartmouth) and Greenwich, Scott was not an exceptional officer and had no 'connections' to help in promotion and he himself did not see a future in the monotony of naval life. The now proposed Polar expedition of Markham gave him the opportunity to fulfil the latent

ambition in him. It is interesting that from Shackleton's diaries from the *Nimrod* he says 'we did not reach the Pole and though we did our best, had to come back to our families'. He then went on to talk of his exploits. On the other hand Scott's final letters, written whilst only 11 miles from the life-saving depot - were virtually his last will and testament - accepting the end with fine words - but he so wished he could have lived to tell the tale.

In January 1910, Scott and twelve men, accompanied by ponies and dogs, spent time in laying reserve depots of food up to 80° south (actually and crucially 79° 20') prior to the main attempt. They left, 1st November (1911), covering 192 miles in the first three weeks with 550 miles to go. Five weeks in, using no dogs or horses, man-hauling the laden sledges started. The difficult and arduous effort of hauling sledges up the 10,000 foot Beardmore Glacier to the Polar plateau was an exhausting physical effort. Scott knew Amundsen was making an attempt on the Pole at the same time and that his laborious attempt would be worthless as runner-up, so he courageously persevered on with the march south. They reached the South Pole on 18th January and sadly planted the Union Jack next to Amundsen's Norwegian flag.

Later that year, in November, a search party found the tent with Scott , Wilson and Bowers inside. One member, Evans, had succumbed to fatigue some time earlier and Oates had left the tent to make his own end. It was a sad and tragic way to die but made them forever England's heroes. In what Scott described as 'an awful place' they had laboured, constantly hungry and fatigued, against odds they had stacked up against themselves in a freezing cold and unforgiving land. Turning round and coming back, cold, hungry, despondent, seriously frostbitten and getting physically weaker by the day, Scott led them back almost to the brink of survival, just 11 miles from the last depot. Many mistakes were made.

I feel sure, though not everyone will agree, that had Scott been a more tolerant and understanding man, he and Shackleton could have been firm comrades and Shackleton may have been found frozen alongside Scott. On the other hand the two of them may well have survived together. Near the gates of Portsmouth Naval Dockyard and not too obvious is a statue of Scott. In the city gardens of Christchurch N.Z. is a far bigger and more impressive bronze statue commemorating his life and death.

The last and perhaps most memorable Antarctic voyage was that of Shackleton and the *Endurance*.

The Pole had been conquered by the Norwegians, so Shackleton decided a trek across the polar cap, a mere 1800 miles, was the next best venture. Aptly known as The Imperial Transantarctic Expedition. This was influenced by the German Filchner who had informed Shackleton of his experiences here.

I think the *Endurance* is the only ship featured in this book that wasn't built in a British yard, but as Shackleton decided on a 300 ton Norwegian built ship called *Polaris* and renamed *Endurance* (part of his family motto) then it has to be included.

Shackleton and his party arrived at South Georgia in November 1914 and by January, the south's summertime, they were approaching the Weddell Sea. However, they became trapped in this huge ice pack and were unable to get free. There the story should have ended but in fact, it had just begun. The trapped *Endurance* became the head-quarters, home and wintering station for one and all until the sun at last reappeared over the horizon. At the end of July it was gradually edging up and over day by day but equally the ice pressure intensified. The ship was doomed. The story of Shackleton's devotion to save his men and find safety is now

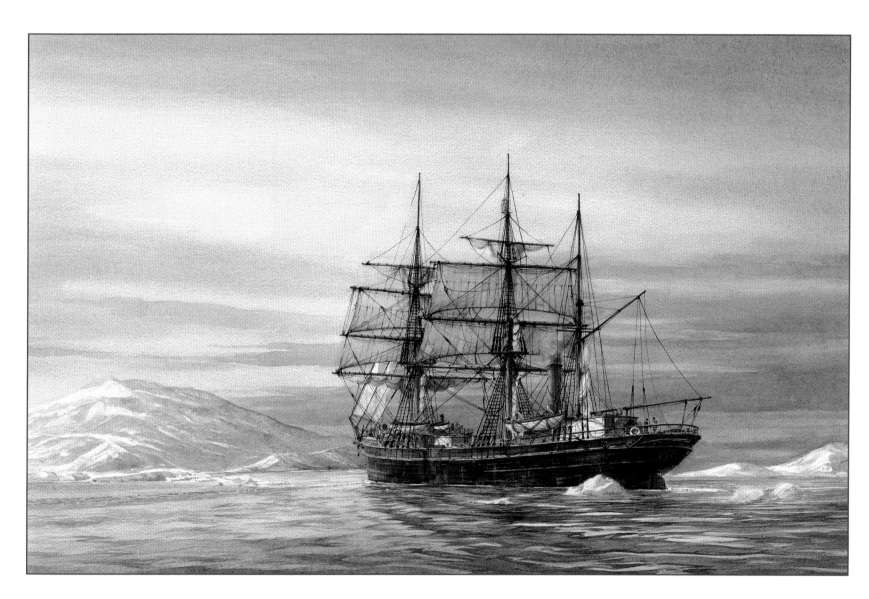

Terra Nova Scott's 1910-13 South Pole Expedition

one of history's best known human achievements of survival. Apart from an 'experience' in an inflatable dinghy once, I've never abandoned ship, though occasionally I would like to have done. The abandonment of the *Endurance* was slightly different. All men, stores, boats and vital equipment had to be retrieved from the ship and placed safely on the ice-floe before considering the options for survival and a way out.

It's quite amazing, almost fairytale-ish, to think they stayed on an ice-floe for some 171 days, almost six months, actually re-siting the camp on the ice-floe so as to stay together, drifting northwards, before realising they had to get off and make the effort to find terra firma to land on and set up a base. This was to be Elephant Island.

To cover the 60 miles three boats and twenty-eight men were launched from the floe and set sail in bad weather to this tiny, uninviting, isolated, ice-covered piece of land. This took a perilous week of sailing, rowing, and drifting. Elephant Island is actually part of the South Orkney Islands, a small chain of islands that follow on from the Antarctic Peninsula up towards South Georgia. Already eighteen months away from beer and skittles and now safe only for the moment, they were still isolated from a search party so Shackleton decided to sail, in the now famous, ship's boat the *James Caird*, 800 miles to South Georgia to find help and return to rescue his men. Six men set sail on 24th April.
The navigation of Frank Worsley brought them, as he calculated, within 90 miles of South Georgia after two weeks of unbelievable hardship and endurance.

To take sun-sights on a fine day, with the horizon clear and sharp, using super accurate chronometers, height of eye adjusted and shout 'time', and then again to get a good altitude reading is straightforward on big ships at sea but to do it in an ice-covered, water-logged boat, never on an even keel, wave-whipped and at sea level was quite a feat.

Overcoming the most frightening ocean of the world with the weather as bad as it could be right to the end, they made a landing on the west coast of South Georgia. All six got ashore. Vincent and McNeish were very ill and took a week to recuperate, whilst Shackleton, Crean and Worsley set off to transit the island to the Stromness Whaling Station, some twenty miles away, as the gull flies.

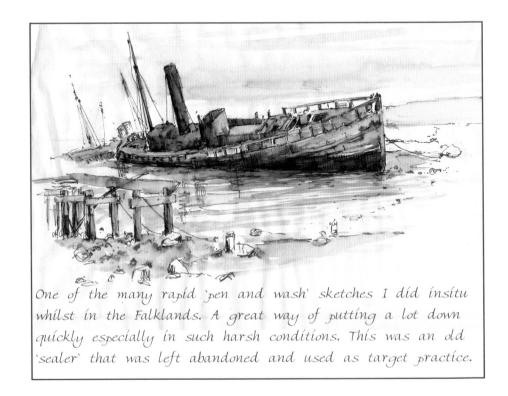

One of the many rapid 'pen and wash' sketches I did insitu whilst in the Falklands. A great way of putting a lot down quickly especially in such harsh conditions. This was an old 'sealer' that was left abandoned and used as target practice.

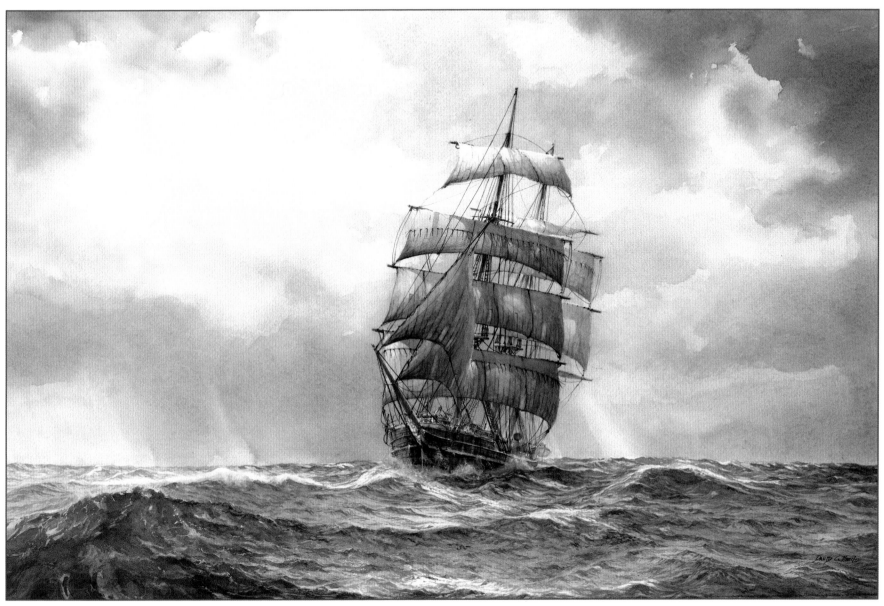

Terra Nova *Built and launched in Dundee in 1884. A relief ship in the Arctic 1894-97 and again for the **Discovery** in 1902. After Scott's doomed expedition she returned in 1913 to resume her work in the seal industry eventually becoming wrecked off Greenland in 1943.*

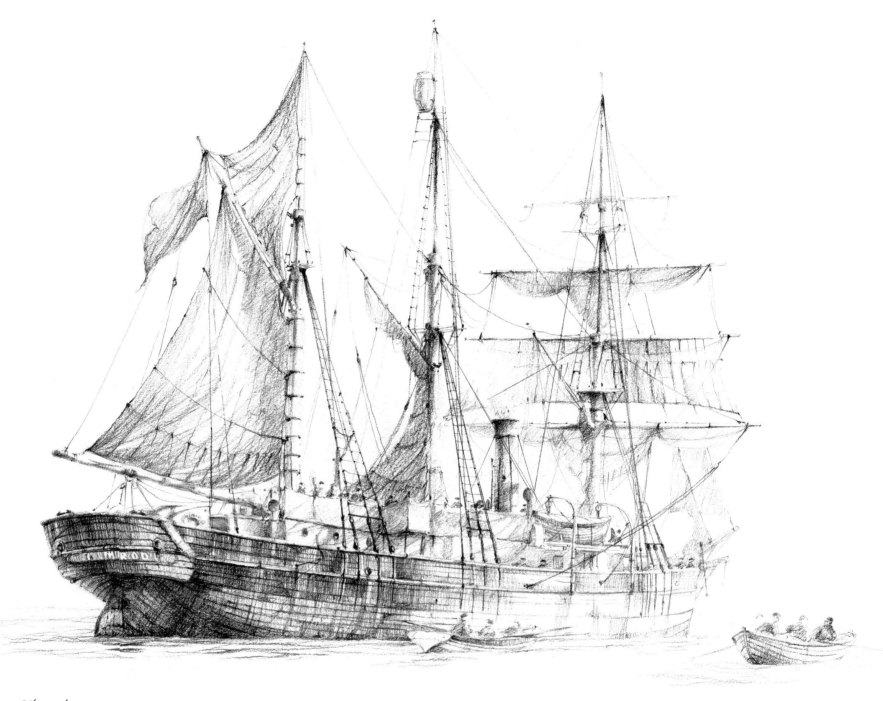

Nimrod

Another Dundee built ship. A three masted, barquentine rigged ship with an auxiliary engine. Though Shackleton failed to reach the South Pole, just 97 miles short, his compatriots, Mawson, David and Mackay, from the Nimrod, established the South Magnetic Pole only 72° 25' south.

The journey was epic. With practically no equipment, they tackled the terrain, endured fatigue and cold and showed a remarkable strength to survive. They should have perished long before they descended on the whaling station.

Worsley set off in a local whaler and rescued the other three remaining companions whilst Shackleton secured another whaler for the rescue of his marooned men. They had beached the *James Caird* on 9th May and by the 23rd Shackleton, Crean and Worsley were leaving for Elephant Island only to be forced back by pack-ice. They headed for the Falklands and awaited aid in the form of a Uruguayan fishing boat (Instutio Pesca No. 1), not the ice-breaker Shackleton would have liked. Like the whaler it could not get through the pack-ice. This time a Chilean steamer the *Yelco* was acquired by Shackleton and near the end of the Southern winter, finally reached Elephant Island. For over four months the forlorn sailors had waited, now 30th. August 1916, the steamer was off shore and within an hour, they were all aboard, heading north and hopefully towards the good life.

The return to home waters at a time when the nation was at war went well and was even a boost for Shackleton's fortunes as the story of their survival against such adversity was a welcome portent for the war in Europe.

Shackleton's last voyage was, once more, on a nondescript expedition to the Antarctic. This time he commanded an even older tub the *Quest*. In fact Shackleton died of a heart attack on arriving at South Georgia. He was buried there. As I said before my regret is that whilst on *Penelope* I forewent the chance to see his grave, and indeed South Georgia.

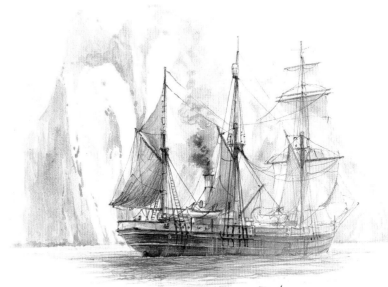

Endurance

Bibliography

Ships of the World — Lincoln Paine
Antarctica — Mike Lucas
The Sea Chart — John Blake
Merchant Sailing Ships — David MacGregor
The Tea Clippers — David MacGregor
The China Bird — David MacGregor
Fast Sailing Ships — David MacGregor
The Shackleton Voyages — Roland Huntford
To the Ends of the Earth — Richard Sale
Discovery Illustrated — J. Skelton & D. Wilson
American Sailing Ships — Charles Davis
The Colonial Clippers — Basil Lubbock
The China Clippers — Basil Lubbock
The Blackwall Frigates — Basil Lubbock
The Log of the Cutty Sark — Basil Lubbock
The Down Easters — Basil Lubbock
The Opium Clippers — Basil Lubbock
The Last of the Windjammmers — Basil Lubbock
H.M.S. Beagle — Karl Marquardt
Captain Cook's Endeavour — Karl Marquardt
Victory — John McKay
H.M.S. Bounty — John McKay
H.M.S. Bellona — Brian Lavery
H.M.S. Diana — David White
Nelson and the Nile — Brian Lavery
Masting and Rigging — Harold Underhill
The Ships of John Paul Jones — W. Gilkerson
British Sail — Robert Simper
Sail in the South — Ronald Parsons
Shackleton — Gavin Mortimer
The World of Ice — Brian John
Nelson's Fleet at Trafalgar — Brian Lavery
Deepwater Sail — Harold Underhill
Trafalgar — Clayton and Craig
Nelson — David Ross
The Race to the White Continent — Alan Gurney
Nelson's Favourite — Anthony Deane
The Age of Nelson — David Lyon
Captain Cook's World — John Robson
Trafalgar and the Spanish Navy — J.D. Harbron
Scott's Last Journey — Peter King
Het Schip — Bjorn Landstrom
Atlas of World History — G. Barraclough
Compass — Alan Gurney

The Anatomy of Nelson's Ships — C.P. Longridge
Nelson — Christopher Herbert
Nelson's Favourite — Oliver Warner
Famous Sea Fights — Green and Frost
Lord Nelson — C.S. Forester
On Austral Shores — Trevor Lipscombe
The Nelson Touch — Clemence Dane
Great Ships — Frank Fox
H.M.S. Victory — Alan McGowan
The Ship of the Line Vol. 1 — Brian Lavery
The Ship of the Line Vol. 2 — Brian Lavery
With Scott to the Pole — Riffenburgh, Cruwys
Trafalgar Companion — Mark Adkin
Tall Ships - Two Rivers — Osler and Barrow
The Line of Battle — Robert Gardiner
The Victory of Seapower — Richard Woodman
The Campaign of Trafalgar — Robert Gardiner
Naval Warfare in the Age of Sail — Bernard Ireland
South with Endurance — Frank Hurley
Nelson's War — Peter Padfield
South: The race to the Pole — N.M.Museum
Voyages of the Discovery — Ann Savours
Great Sailing Ships — Otmar Schaufflen
Nelson Against Napoleon — Robert Gardiner
The British Navy Book — Cyril Field
The Last Continent — Bernard Stonehouse
Famous Fighting Ships — Donald Macintyre
The Bounty — Caroline Alexander
Farther Than Any Man — Martin Dugard
The Silent Landscape — Richard Corfield
Captain Cook — Alistair MacLean
Captain Cook & The Pacific — Roger Morriss
The Bark Endeavour — Antonia MacArthur
Atlantic Sail — Roger Morriss
The Nelson Almanac — David Harris
In Pursuit of Pepper and Tea — Els M. Jacobs
Buckler's Hard — A. J. Holland
China Tea Clippers — George Campbell
Sailing Ships — Cedric Rogers
The 50 Gun Ship — Rif Winfield
The Great Age of Sail — Edita Lausanne
The Seventy-Four Gun Ship — Jean Boudriot
The Endurance — Caroline Alexander

A Nautical Odyssey

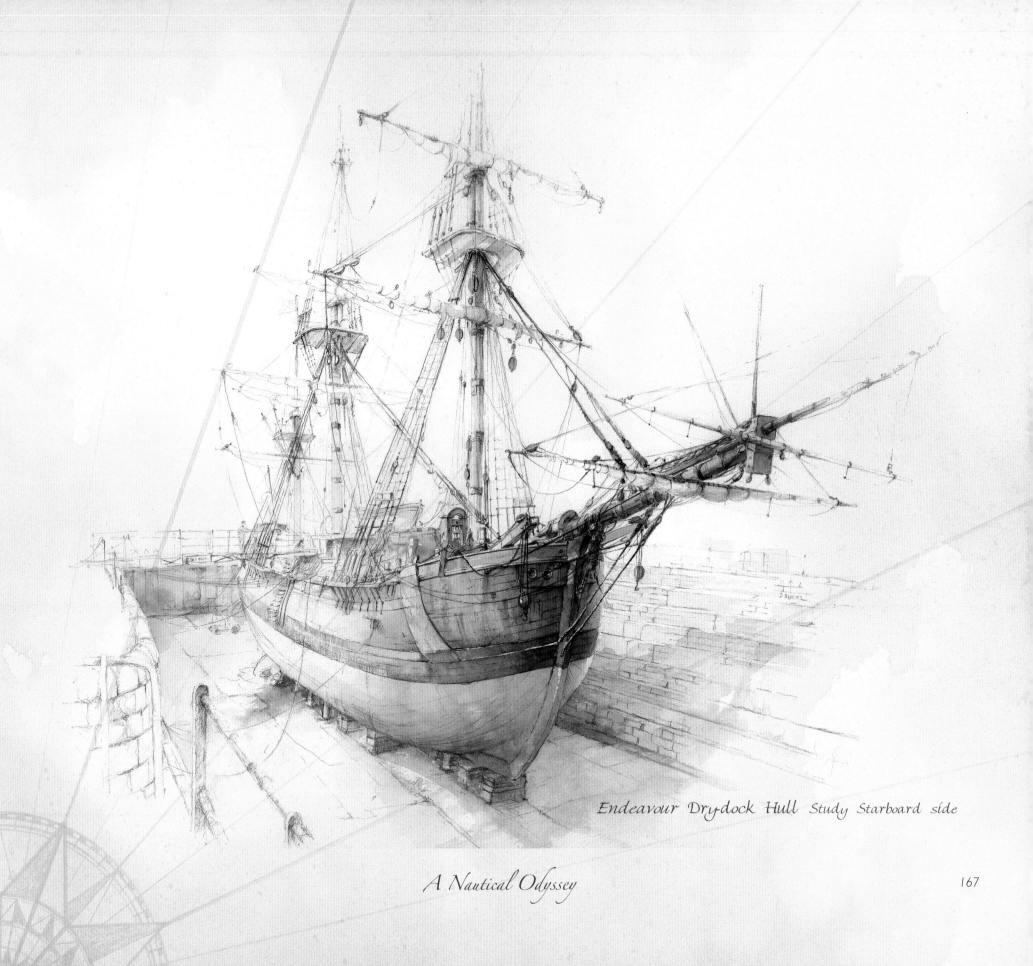

Endeavour Dry-dock Hull Study Starboard side

A Nautical Odyssey

Paintings and Drawings

All the works selected for this book are either watercolours, ink, pencil, pen and wash and some a mixture of all.
The painting surface is normally a medium or heavy water colour paper usually pre-stretched for large works. Arches 140 lb. is my favourite, but I also use a variety of other hand-made papers. I also use watercolour boards and H.P. paper for detailed pencil and sketch work. All surfaces have different qualities and produce different effects and I use that quality for the proposed work.
Sizes, some approximate, of most of the work, in millimetres, as follows:-

PREFACE

Heemskerrk 300 × 300
Prince 560 × 420
Golden Hind 270 × 310
Sovereign of the Seas 265 × 185
H.M.S. *Centurion* 300 × 200
Victoria 400 × 320
Santa Maria 470 × 300
Galleon - Ink sketch 120 × 100

COOK

Endeavour at Deptford Pencil/Wash 690 × 500
Resolution at Sheerness 370 × 320
Endeavour Plymouth 530 × 380
Ebb Tide Staithes 500 × 340
Whitby's Heritage 580 × 360
Endeavour (Drydock) 220 × 400
Endeavour (Pencil) 240 × 190
Whitby Harbour Study 510 × 330
Endeavour Doubtful Sound 500 × 300
Endeavour Bowsprit 260 × 200
Staithes 'Morning Sun' 630 × 390
Beached Ketch 510 × 330
Resolution off Tahiti 510 × 330
Staithes Detail
Resolution at Sea 400 × 400
Staithes 390 × 630
Resolution Sheerness 370 × 320
The Red Boat Staithes 390 × 330
Whitby's Harbour c1860 580 × 360
Staithes Study 400 × 400
Endeavour Dry Dock Hull 2003 690 × 460
Endeavour (Pencil) 250 × 240
Winter Sunshine Staithes 460 × 680

BLIGH

Bounty Deptford 400 × 320
River Hull C1880 510 × 330
Bounty (Sepia) 220 × 170
H.M.S. *Bounty* off the Pitcairns 510 × 340
Bounty Study (Pencil) 400 × 320

VANCOUVER

Sepia Study *Discovery* 400 × 200
H.M.S. *Discovery* 470 × 290

FLINDERS

Glorious !st. of June Study 600 × 340
H.M.S. *Bellerophon* Detail
Investigator 480 × 280
H.M.S. *Martin* (Sepia) 340 × 260
Investigator leaving Portsmouth 500 × 310
Investigator and *Le Geographe* 510 × 330

NELSON

H.M.S. *Valiant* 480 × 310
H.M.S. *Racoon* 480 × 310
Racoon Detail
Study - 74 gun Ship off Portsmouth (Pencil) 300 × 200
H.M.S. *Lowestoffe* 480 × 320
Study 74 gun Ship off Portsmouth (Pencil) 300 × 200
Launch Day 520 × 350
Frigate Study (Pencil) 220 × 120
The Launching 520 × 350
Agamemnon (Pencil) 300 × 200
Study 74 gun ship (Pencil) 220 × 120
H.M.S. *Agamemnon* 480 × 310
H.M.S. *Euryalus* Off Portsmouth 520 × 350
Daybreak at the Hard 520 × 350

A Nautical Odyssey

H.M.S. *Agamemnon* (entering Portsmouth) 650 × 400
H.M.S. *Victory* (detail)
Study 'Battle of Cape St. Vincent' 620 × 380
H.M.S. *Vanguard* 480 × 310
Battle of Cape St. Vincent 680 × 430
Battle of the Nile 1798 660 × 420
Study Battle of the Nile 620 × 380
Study Ships of the Line *Victory* (Pencil & wash) 630 × 350
Study *Victory* at anchor 600 × 450
H.M.S. *Victory* at Sea 480 × 320
Study 74 gun ship Pencil 330 × 210
H.M.S. *Victory* Dry-dock Portsmouth 520 × 520
H.M.S. *Victory* 490 × 330
Victory at Spithead 14th September 1805 650 × 400
H.M.S. *Temeraire* (Stern view) 650 × 400
Study Battle of Trafalgar 400 × 300
Trafalgar (*Victory*) 480 × 320
Study *Bellerophon* at anchor (Pencil) 220 × 120
H.M.S. *Temeraire* 650 × 400
Victory (detail)
Colossu' In Action at Trafalgar 660 × 420
Battle of Trafalgar 21st October 1805 650 × 400
Study *Colossus* In Action at Trafalgar 580 × 340

CLIPPERS
Cutty Sark Detail
Sovereign of the Seas 640 × 440
H.M.S. *Beagle* Sketch 275 × 195
Jhelum Sketch Stanley 280 × 100
City of Adelaide 560 × 420
Thermopylae Detail
Torrens 650 × 400
Study *Torrens* (Sunderland) 650 × 390
China Seas (*Taeping*) 690 × 390

Emigrant Ship Sketch 450 × 390
Thermopylae Sydney 530 × 320
True Briton Wapping 600 × 420
Ariel China Sketch 600 × 420
Detail *Samuel Plimsoll*
Thermopylae Full sail English Channel 680 × 480
Cutty Sark 'Bows' (Sepia) 380 × 250
Cutty Sark (at Sea with *Thermopylae*) 680 × 480
Cutty Sark 700 × 470
Cutty Sark 1869 off Deal 680 × 480
Cutty Sark Stern pencil study 300 × 250
Cutty Sark detail
Cutty Sark Study 660 × 460
Torrens at Sea 530 × 330
James Baines American Clipper 700 × 490

SHACKLETON

Discovery Cowes 600 × 490

Endurance South Georgia 640 × 480
Sketch *Discovery* in ice 600 × 480
Sepia study *Discovery* 300 × 180
Terra Nova 620 × 400
Falklands Sketch

Terra Nova at Sea 620 × 400

Nimrod (Pencil) 550 × 400

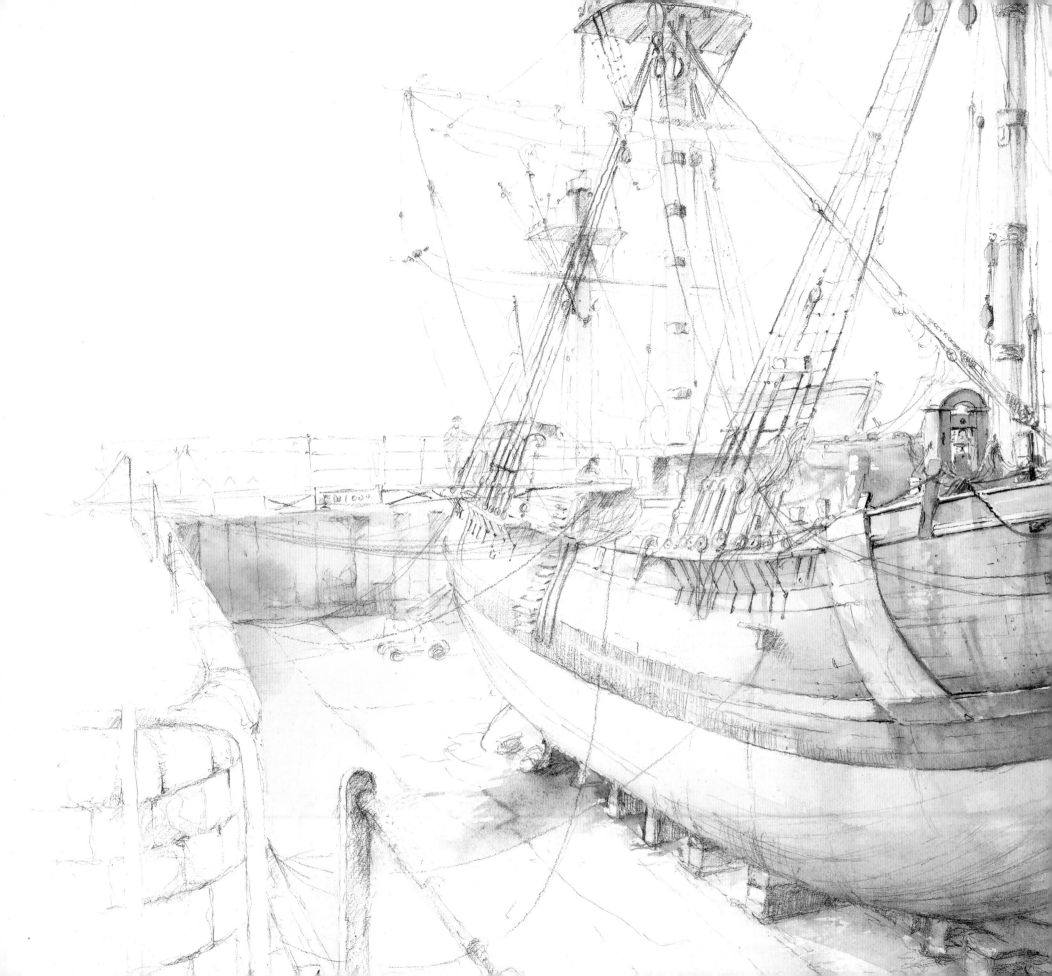